CREATIVE

TRANSFORMATION

CREATIVE

TRANSFORMATION

The Healing
Power of the
Arts

Penny Lewis

Chiron Publications • Wilmette, Illinois

Underworld shadow of Unitive reality / uncalcifies Reincarnation? Reprieve? Renewal from any penalties?

Library of Congress Catalog Card Number: 92-38693

Printed in the United States of America.
Editing and book design by Siobhan Drummond.
Cover design by Mercedes Santos.

Library of Congress Cataloging-in-Publication Data:

Lewis, Penny.
 Creative transformation : the healing power of the arts / Penny
Lewis.
 p. cm.
 Includes bibliographical references and index.
 ISBN 0-933029-66-7 : $19.95
 1. Art therapy. 2. Imagery (Psychology) – Therapeutic use.
I. Title.
RC489.A7L48 1993
616.89'1656 – dc20
 92-38693
 CIP

ISBN 0-933029-66-7

To my students and patients,
who taught me through their experience of transformation

CONTENTS

PREFACE

*I*t was the long-awaited morning on which I was to start writing this book, a book that had taken years to be formed and birthed from me. I was free from teaching and had been slowly rescheduling patients so that I could have this space. It was a beautiful July dawn, but I couldn't bring myself to enough consciousness to get up. Begrudgingly, I surrendered to the pull of my unconscious, which clearly had something to tell me before I began.

I had a dream. In the dream, men were raping more of the Amazon, huge oxygen-juicy trees were being felled, all in service to building some heinous commercial mall. I watched in quiet agony. Then I saw native children sneak out of the jungle and rip leaves off one of the trees and throw them in a pile near one of the bulldozers. They had impish smiles on their faces. They appeared as if they had never before seen this so-called civilization. I wondered what they were doing. Clearly their home was being leveled, but what was this seemingly nonsensical act?

The bulldozer moved toward the leaves. The movement of the air from the engine forced the leaves upward and sucked them into the motor. The motor gagged and seized. Then my dream ego understood; they were fighting back against the destruction of their home, of nature, and of the planet. These little children with their creative imagination were doing what no amount of international lobbying was able to accomplish.

There was no question in my mind with whom I would align myself. All the logic of these men who worshipped the gods of power, industry, and money was being foiled by these imaginative children who, out of creative improvisation, were slowly winning out. Their power and knowing came from a different source entirely. It came from living in harmony within the nature of things. They had learned through experience and had lived always with the Tao.

This dream was not telling me that I am an environmentalist, that I am deeply concerned about the survival of the planet, and that the humans who are ruining our world through pollution, territorial wars, and economic greed are deeply out of balance with nature, the child, and the feminine. These things I know already. What the dream was reminding me of concerns the very nature of this book, and that is to value our own creative imaginal realm, our own Amazon, which provides life-giving oxygen to our "civilized" consciousness.

Traditionally, the old Freudian school of thought encouraged the continuous expansion of the ego territory into the realm of the unconscious. Clearly, if there is only one jungle, forest, or ocean of the unconscious, with no ego to mediate the inner and outer realms, this would reflect an imbalance such as we

see in psychosis and other severe disorders. But I believe the old idea of slowly bulldozing the unconscious away is very dangerous, personally and for the planet. I believe this old model came from a view of the unconscious as basically a dump site, if you will, for repressed, painful trauma, relationships, and split-off parts of the self that were unacceptable. Those who follow the psychology of C. G. Jung, along with others, feel that there is also a deeper layer of the unconscious that connects us with humanity, the natural cycles of things, and the universe. Without this connection, we will surely die. The value of the material realm of the dollar seems to have more power with some individuals than environmental concerns, rights to choose about one's body (e.g., abortion and euthanasia), and the deeper significance of the soul. These people walk the planet, clinging intently to the rational and empirical, accumulating more and more material goods and not understanding why it is never enough. Such people live without real meaning to their lives. They live in a desert. Their bellies are full but their souls are starving. Everything dries up inside and out for them in the same way that the ravaged Amazon becomes a dry wasteland in a few short years when stripped of its natural riches.

I believe it is crucial to know one's own little nature children, which are indigenous to the unconscious, for they can set things right through creative play when the ego loosens its connection to the Tao or harmony of existence.

It is also clear to me that unless these little fellows of mine participate in the writing of this book, this book could dry up like a desert and the riches of the unconscious be bulldozed by an eager ego.

Thus, I encourage the reader to bring that which is creative and "native" within to the engagement with this book. In doing so, it is hoped that this material can stimulate an evolving balance between analytic reasoning and imaginative process within oneself and others with whom we interact, and in our engagement with the planet.

The Dance Between the Conscious and Unconscious

The Transformative Process Within the Imaginal Realm

Chapter 1

INTRODUCTION

*T*he dance between the conscious and unconscious is choreographed in the magical place of the imaginal realm. Here is where children play and where heroes and heroines come alive in spontaneous creative dramas. Here is where remembered dreams live to pull us from our misguided paths. Here is where all the creative arts emerge: painting, sculpting, singing, dancing, acting, composing, writing. Here is where inventions spring forth and spurts of intuitive insight erupt. Here is where a culture's unconscious is brought forth in the form of myths, fairy tales, and stories of gods and goddesses. Here is also where our histories live, where childhood emotional patterns and early relationships with primary care givers hang out and influence our present lives, distorting the moment by recreating the past in an imaginative "pretend" drama of which we are unaware.

In this transitional space exists all that impedes us from our growth and wholeness but also all that can serve to heal the wounds, bring us to balance, transform inner relationships, and direct us on our unique life journeys.

In times past, societies provided vessels for the experience of the imaginal realm through rituals, community celebrations, and rites of passage. Many of those rituals are no longer practiced and many more have lost the mystery

TABLE 1.1 **The Rational vs. the Imaginal**

Rational	Imaginal
analytic/reductive	creative
individual	communal
logos	eros
man-made	natural
linear	cyclic
masculine	feminine
empirical	magical/mythical
conscious reality	imaginal realm
yang – active	yin – receptive
reason	intuition
time as quantitative	time as qualitative
penetrating	enclosing
alchemical sol	alchemical luna
left brain	right brain

which they once had. I believe this is in part due to an imbalance between the rational and the imaginal.

Self-help books, which have flooded the market, focus on the individual rather than the communal, thus, in part, reinforcing the old patriarchal view. My focus, rather, has been to attend with a self-in-relation frame of reference. Because most individuals' splits occur in relationship to a significant other, they cannot be healed in isolation, i.e., by reading a book (Surrey 1985, Miller 1984). They need to be healed in a relationship.

This self-in-relation frame needs to be placed in a vessel that allows for the experience of the imaginal realm. This vessel is a sacred space—a *temenos*. Lately, the traditional spiritual vessels, those of institutionalized religions, have become businesses with money and power shadows that can secularize the church or temple to an extent that forces many to move away from these desecrated sanctuaries. So where does one find a relationship within a sacred vessel for the imaginal realm to aid in healing these splits?

Access to the symbolic realm is fairly easy when therapists work with children, who have not lost the ability to play. But adults are frequently a different story. Jung found that dreams were his main access to this transitional space with his analysands, but there are also patients whose defenses block access to these night visits and messages. More and more therapists are seeking other conduits to and from the *mundus imaginalis* within the therapeutic process. Here the creative arts can play a vital role. The arts provide vehicles for the accessing and reexperiencing of historical traumatic events and relationships, as well as providing a medium within which healing and transformation can occur. The expressive arts also allow an individual access to the deeper meaning of existence, to a connection to humanity, and to the divine as they journey within the archetypal through the stages and rites of passage of life.

This book is about these healing journeys. Specifically, it is about how therapists and their patients can utilize the arts within the imaginal realm through each stage of life.

Chapter 2

THE VESSELS OF THE IMAGINAL REALM

*L*et me now repeat: the dance between the conscious and unconscious is choreographed in the transitional space of the imaginal realm. Creative arts therapists have long known that transformation toward wholeness can only happen through experience within this symbolic realm. The containers are the expressive arts media, the patient's body, the therapist's body as vessel for the somatic countertransference, and the bipersonal field between patient and therapist or within a group. These containers hold this liminal space within which healing can occur.

It is within this real yet unreal space that depth psychotherapy is undergone (Winnicott 1971, Lewis Bernstein and Singer 1983). For example, a patient and I stomped around my studio office, squatting and growling at each other. Both of us knew we hadn't returned to some primordial level, but her inner, previously rejected, angry two-year-old felt that her instinctual assertion had finally been allowed expression and reflection. In this engagement in play, she was reembodying and reclaiming a split-off part of herself that was not allowed to be lived when she was a toddler.

Our patients are clearly not the first individuals in history to experience the transformative power that exists in this liminal space. The roots of this phenomenon have been depicted on caves by Paleolithic humans some 30,000 years ago. It was in the shamanic tradition that people found a link to the numinous world, where any imagined spirit, ancestor, animal, or fantastic being could facilitate healing.

Shaman initiates undergoing ancient mystery rites may have known that they were not really dancing out dying or being birthed in the womb of the Great Mother, but deep inside them, where humility and reverence resided, this experience claimed a profound truth.

Therapists who employ the creative arts know, like their ancient shaman counterparts, that it is only through experience within the symbolic, imaginal realm that there is a possibility for healing and transformation.

This experience cannot be had by teaching, however. For example, one cannot expect that a patient who has been unable to take a stand in his or her

life could learn this through repeated role playing or movement exercises of grounded assertiveness. This naive, reductionistic view supposes that one behavior pattern can be superimposed on or replaced by another. To understand the notion of transformation in psychotherapy, the elusive phenomena of transitional space (Winnicott 1971) and liminality in ritual process (Turner 1969) need to be explored.

Winnicott's transitional space in analysis and the liminal phase in ritual healing have a common experiential link. In both cases, the individual is experiencing the moment in a realm that lies between reality and the unconscious. It is akin to the world of imaginal play in childhood. As children, most individuals have engaged in fantasy and pretended to be any number of characters. During this time, they knew that they weren't really this character or that. But they nonetheless had a rich experience of being these characters in every inch of their bodies, such that their consciousness was free to utilize any relevant attributes of these archetypes.

Therapists who consider their therapy office a *temenos* or vessel for this transitional dance between the realms and who, within themselves, have a continuous connection to this liminal space of body metaphor and imaginal creativity, can constellate and encourage this realm in their patients. Costumes, cloth dummies, pillows, parachutes, foam balls, music, rhythm, sandplay figures, body positions, spatial distance, clay, paper, paints, etc., are all imbued with symbolic meaning.

An example of how special meaning can be given to external objects can be seen in the actions of an anorexic girl who picked up pieces of thread that had fallen from a fringed scarf I was wearing while we had danced in synchrony together. She placed them in a nest I had for a little ceramic bird she had brought in a prior session. She then added a few more grains of sand to a tiny sand-play plate which she had made for us. Her eyes met mine for a brief, pregnant glance, then we continued to dance and sing together. She and I were building a nest together which would hopefully provide a holding vessel for her birdlike self, so frightened of having any weight upon the earth. Grain by grain, we began to give more weight symbolically to her needed assertiveness.

Another individual sculpted three tiny figures representing aspects of herself and me. I placed them on the fireplace mantel in my studio. Each week, prior to our beginning, she spatially arranged them in relation to each other so as to articulate the present state of the self-object choreography. This rich information was received by me as an iconic representation of the needed bipersonal drama (see figure 2.1).

In this realm, patients' bodies and their movement can provide vessels of personification and a vehicle for journeying into the far reaches of the inner lands where myths and fairy tales are generated. Here the therapist, through the somatic countertransference, can imaginally rejoin split-off parts, nurture

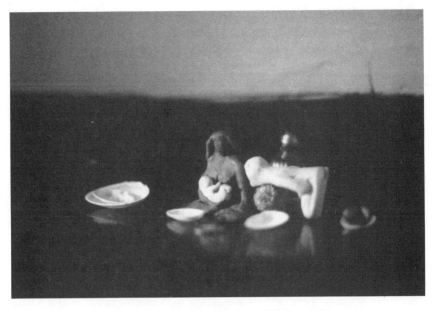

FIGURE 2.1 **Sculpted Figures of Self and Other**
(Source: Private collection)

and engender the healthy development of the patient's child self, or detoxify and heal negative complexes (Schwartz-Salant 1983–1984; Schwartz-Salant and Stein 1984).

Many of my deeply wounded patients have risked embodiment of their split-off so-called bad selves. These are parts of them that were unacceptable to their parents. Some parents don't allow their children to have their anger; others don't want their children to have needs, telling them that they are selfish, shaming them so that they will take care of the parent or literally become needless doll-like automatons. I have witnessed gnarled, creaturelike, starving, wounded mutants finally lay claim to previously defended bodies. Over a series of months, their bodies begin to be humanized. From a drooling mouth comes first indistinguishable guttural utterings and then finally words of longing and rage.

In the bipersonal space, patient and therapist can be time-warped into the choreography of the mother–child drama. Groups can become beacons for the numinous, which draws upon universal themes and images, bringing them to life to transform people again, as they have for thousands of years.

For the remainder of the chapter, I have selected examples which all

address a similar theme: that of claiming one's power, assertion, and anger. The variable will be the containers.

The Vessel of Expressive Arts Media

The use of the arts media as a vessel can be seen with one school-phobic child with borderline symptoms who participated in a family therapy session. She was the identified patient in an emeshed dysfunctional family. A suggestion was made for the family to do a diagnostic group art panel with pastels. No matter where this child drew on the panel, her mother eventually followed, first embellishing and then altering the subject matter of the child's creation so that the child lost grasp of her idea, statement, and identity in the family panel. Bewildered, she eventually gave up. I thought perhaps an embodied experience might bring this dynamic to greater focus. A structured movement exploration called the movement web was adapted to heighten the family's awareness of how powerful the mother's control was over the family and specifically over the identified patient (Bell 1984). The family was to stand erect in a circle and hold hands. I instructed the mother to move. Family members could either fall, act out in aggressive defiance, or follow. Each time the child stood her ground, she was pulled and lost her stance. I could feel the needed assertive anger finally begin to brew in her. She eventually dropped her mother's hand. Her mother turned with an astonished look. I hoped that this child would be able to employ this newly found separating energy. Returning to the original medium of family art panel allowed me to see if there was any difference in the interaction. Not saying anything about their movement experience, I allowed the art medium to "hold" the experience. I tacked up a blank brown paper panel and suggested they finish the hour by letting their "imagination speak through the chalk" again. The child in question began by etching a black and red border around what was to be her space on the panel. The message was clear. "This is my space. No one enter!" The school phobia disappeared; no other direct interventions were made with the child. Expecting the mother to sabotage her daughter's steps toward separation and self-assertion, I saw the mother individually for a number of sessions and, finally, her reluctant husband was called in for long overdue couples' work.

Another medium that can be used is sand play – a Jungian technique in which an individual moves and shapes sand in a box and/or selects and arranges tiny symbols in the box. The process is guided by the imaginal realm rather than the reality-based ego. The therapist has available numerous small symbols placed on shelves in various categories: animals, domestic and wild; people, various

ages and personas; edifices and materials for building edifices; dollhouse furniture and small items such as keys, weapons, and containers; vehicles – cars, boats, planes, etc.; natural objects and those representing nature – stones, shells, seeds, trees, etc.; mythic and religious symbols, e.g., unicorns, Buddhas, Christ; and parts of the body – hearts, skeletons, etc.

One woman, who knew well the power of the arts in her personal journey, engaged in sand play as follows. She placed a crystal heart in the sand, then covered it with boxes and layers of balsa wood pieces. On top of the barriers were zombielike creatures and snakes who faced the fortress, presumably trying to get in.

I encouraged her to embody one of these figures and to allow him to speak. He says, "We've come from the jungle, we're tired of waiting around. We're going to storm this barrier. We're starving and angry." I ask, "Have you always been kept out?" He responds, "For a long time. I can't remember how long."

I then suggested she embody her heart. She covered herself in a blanket and rolled up in a ball. She was silent, frightened. I asked, "Are you afraid?" Her head nodded in affirmation. "Can you talk?" Her head moved from side to side. "Can you draw what is scary?" I placed a small pad and some markers under the blanket. She quickly scribbles black attackers stabbing her heart.

Now I asked her to embody once again the sand-tray zombie figures. "Did you attack the heart?" "No!" they said. "We got kicked out, we didn't hurt the heart. It kicked us out."

"Why did it do that?" I inquired.

"Because we were always getting it in trouble. We'd ask for things, ya know, like attention, and that guy over there (pointing to another figure), he would get angry. We were bad."

"Who told you that?"

"The heart."

"Was that the heart's idea?" I asked.

"Well, yeh, we were always wanting stuff, ya know, and then when we'd get angry, well, my mom was so angry; no one else could get angry. Then you'd really get in trouble."

"So your heart sent you away so it wouldn't get abused any more by your mother. You are her natural needs to be loved and attended to and to feel angry when those needs aren't met. You are needs and feelings that are born into all children and their right to have.

"Listen, the heart has been unprotected since it sent you guys away, so it has to wall itself off so as not to be hurt, but that also means it can't feel loved either. If you were allowed to be let in, you could give words to the needs and feelings of the heart, and the angry fellow could provide assertion and protection."

She thought for a short while and then went back to the sand-play vessel and

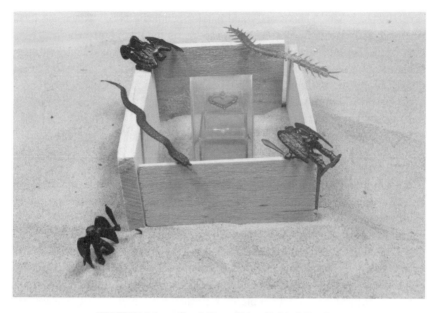

FIGURE 2.2 **Sand Play: Heart Behind Barrier**
(Source: Private collection)

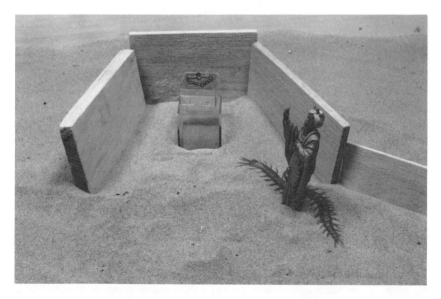

FIGURE 2.3 **Sand Play: Open Protected Heart**
(Source: Private collection)

slowly began opening the balsa wood barriers until the box in which the heart was encased was exposed. She placed a magus figure close to the heart and then, with tears in her eyes, she opened the box and exposed her heart (see figures 2.2 and 2.3).

The Vessel of the Individual's Body

An example of utilizing one's own body as the vessel for transformation can be found in the use of the dance therapy technique of authentic movement. This technique allows the unconscious imaginal realm to fill an individual's body, consciousness, and movement (Lewis Bernstein 1982). Usually those who engage in this find a comfortable place in the therapy room and body positions, such as lying down, sitting in a fetal position, or standing. Then they wait and empty their mind as much as possible, similar to preparation for meditation. By creating this space, the unconscious begins to have more room to manifest; feelings, sensations, images, and/or trace body movements may begin to enter. Some people find themselves in an imagined environment within which they move and engage. Others have a more introverted experience in which the focus is the internal viscera of their body and their observer self engages in their own "fantastic voyage." Still others will imagine other people in the room as projected parts of themselves, external significant others, or archetypal-mythic figures and move in relation to these group members or myself as if they were this figure or that aspect of themselves.

A man entering into authentic movement in my office later described having imaged going deeper and deeper inside himself until he came upon a dark, unfrequented place in the basement of his torso. There was a door which had been locked for a long time. He knew there was something on the other side. With a great deal of trepidation, he opened the door. Something rushed out and possessed him before he had a chance to see it. Now he was it. He felt a surge of energy. His eyes felt like they were conduits for vast amounts of energy like "two laser beams." This fellow had previously described himself as depressed, unable to feel pleasure in anything. He had reported that he felt numb inside; he hated work and felt controlled by everyone—his boss, his wife, his inner judge. But now he felt like he could torch anyone who came near him. Rage swelled up in his muscles. Group members gave him a wide berth. A deep rumbling sound came from his belly as he crouched on the floor. That evening, prior to his authentic movement experience, he had told the group that he felt he "didn't want to be mothered." Now he reported that he was actually seeking someone out to engage and vent this heretofore pent-up power and rage. The rumble

began getting louder and fumed into a roar as he squatted in a vertical position with his hands palms up, ready and waiting. He moved in a way that clearly outlined his borders and boundaries.

The manner in which he was reporting this experience was clearly different than his drab feeling-toned response early on in the session. He had begun to claim his power and assertion through a direct, embodied, imaginal experience.

The Vessel of the Therapist's Body

The Use of the Somatic Countertransference

In the imaginal realm, it is possible for the therapist as shaman to receive from and transmit to the body vessel of the patient. I came to know this phenomenon gradually, my curiosity having developed in the late seventies. Finding no rational reason for why I felt certain sensations or feelings or found myself imaging during sessions with patients, all of which proved to be exceedingly useful in my embodied understanding of the patient, I began asking fellow dance therapists about their own experiences. I purposely chose individuals who had been working for a number of years from a variety of theoretical approaches, had worked with various populations, and were from all over the country.

All of them affirmed that they, too, had had and utilized such experiences. This exploration resulted in a phenomenological research study I later presented at the American Dance Therapy Association Conference in 1981. Further affirmation came when I began training as a Jungian analyst and discovered that Jung discussed this unconscious-to-unconscious connection in "The Psychology of the Transference." Since then, it has become clearer that certain images, sensations, and feelings are characteristic of certain discrete diagnostic populations. Thus, I have learned to trust my body wisdom rather than operating solely from an analytic knowing when diagnosis or progress needs to be ascertained. But more important, this phenomenon has been deeply helpful in the therapeutic process of transformation. For the therapist not only receives in this imaginal synchronistic realm but can transform and transmit back to the patient as well (Schwartz-Salant 1983–1984).

What is received clearly varies with the uniqueness of each individual and, I believe, with the linking of receptivity of the therapist. Sometimes what are received are physical sensations of, for example, heat or cold, knotlike tension,

dizziness, or nausea. Other times, feelings are received, such as deep sadness, agonizing pain, rage, fear, eros, or joy.

In other instances, whole images, story lines, environments, and memories can be received. I have, for example, imaged prisoners in towers or behind walls, rageful monstrous creatures, hungry dehydrated bodies, wounded figures, or witchlike Medusa mothers. On occasion, a patient's dream, images evoked from authentic movement, or early childhood experience have been received by me.

Needless to say, patients do not need to be engaged in any form of expressive arts process; but their connection to the unconscious through these media often facilitates the unconscious-to-unconscious link.

The therapist can prepare for this experience by emptying the mind in much the same way that someone meditating or engaging in authentic movement would do, and then creating an imaginal inner vessel within, which lies ready to receive and give birth when ready. The walls need to be elastic but also sturdy thus protecting from contamination from either side, i.e., so the therapist's personal countertransference doesn't interfere nor does the patient's material ooze into the therapist's life.

Psychotics and Patients with Psychotic Cores

Individuals without a viable ego, such as psychotics or patients with large psychotic cores, literally fill the therapist with their psychoses. Countertransferentially, the therapist can feel dissolved, bodiless, dead, mechanical, dizzy, dumb, or sleepy. She or he may feel merged with the patient or filled with thousands of chaotic pieces of the patient's fragmented self or overtaken by a frantic pervasive fear of impending doom.

Schwartz-Salant (1983–1984) feels even the capacity to hold and contain an individual's psychoses and not flee or fall asleep or split off from it is crucial in the patient's development of trust in the therapist. With the experience of the fragmented self, the therapist can utilize the imaginal realm and imagine remembering the pieces or solidifying the dissolved individual while maintaining clear body boundaries. Calming the patient's frenetic fragments by imaginally standing firm against the psychotic layer of the unconscious can prove to be a powerful bulwark against further attack. All of the above interventions are carried out nonverbally and imaginally. On a conscious level, the therapist is, of course, facilitating the patient's creation and claim to space for ego formation through the use of reality-based dialogue and expressive arts activity.

Narcissistic Characters and Patients with Narcissistic Wounds

With narcissistic personality disordered patients, the therapist frequently feels as if she or he is literally being flattened or squished by the patient's inflation and grandiosity. Countertransferentially, the therapist can feel that there is no room to breathe or speak. The therapist may also receive the split-off monster infant self of the unloved patient. The image of a deformed, fetally unborn, creaturelike figure often imaginally appears in darkened empty environments. On other occasions, the therapist may somatically receive the empty bottomless pit inside the patient, the etiology of which stems from the inability of the maternal object to provide a sufficient holding container. With these individuals it is vital to mirror and reflect their grandiose self and to imagine choreographing, holding, nurturing, and attuning to the wounded monster self, thus providing a secure holding container—one that does not leak and has soft sturdy walls.

With narcissistically wounded patients whose mothers physically or emotionally abandoned them, the reverse is often the case. The therapist may feel much larger than the vulnerable unattuned infant self seeking merger. At these times, the therapist needs to allow his or her body to dissolve and merge in a symbiotic dual unity with the patient (Mahler 1968, Mahler and McDevitt 1982). No actual touching or holding is necessary. Even though the therapist may receive similar sensations in the countertransference from an individual with a psychotic core and a narcissistically wounded person, the imaginal response is different. In the former, the ego is weak and requires containing the psychotic fragments, but in the latter case there is a sufficiently formed ego, thus this powerful early undifferentiated psychic energy is less problematic and more beneficial as there is less concern of flooding.

Schizoid Characters and Patients with Schizoidal Defenses

With schizoid characterological defenses, the therapist's use of the somatic countertransference will frequently result in feeling the split-off wounded self of the patient or the wall or shield itself, which cuts the patient's body-felt experience off from expressing or receiving. At other times, the therapist can experience the projected transferred negative mother who was so abusive that the infant was forced to encase itself in a protective shield.

If the therapist receives the wounded child inside his or her belly vessel, it is possible not only to hold and care for the infant self imaginally, but with some patients to reflect this part of them verbally. For example, one could say, "Even

as I hear you speak with no apparent intense feeling, I am also aware of a little one in you hidden or imprisoned who feels deeply and yearns to be known by you." I might then suggest to such patients that they draw their attention deep inside themselves to that darkened, cold place and find their little one. I can modulate this body active imagination through the somatic countertransference; if a larger wall is erected to defend against reclaiming the split-off self, I will frequently feel this and comment on it by asking, for example, "What just happened?"

When the individual connects to the infant self, the imaged sensations in me are reclaimed as well, and they will shift from me back into the patient. If the negative mother is put into me, it affords me a rich understanding of what the patient has had to endure. I may reflect empathetically my sense of how my patient must have felt. While the negative mother is projected in me, I also inquire and comment on what the patient must be feeling in relation to me. I encourage as much negative transference material as can be gleaned in the moment. For while this is being received by me, I am also busy imagining how the poisonous witch mother could be healed or how her power could be diminished. I do this in much the same way I would imagine a happy ending to a fairy tale.

Borderline Characters and Patients with Borderline Defenses

With patients with borderline characteristics, the therapist may receive self and object splits within the somatic countertransference. The idealized good mother and the withholding or engulfing bad mother can be alternatingly received. The therapist needs to provide imaginally a quiet vessel for the former and neutralize and provide maternal boundaries for the latter.

With self splits, the therapist receives the "good infant self" seeking merger and/or the rageful "bad self" seeking separation and independence from the mother. When these splits are received, the therapist imagines holding and attuning oneself to the "good" infant. When the "bad self" is received, the therapist needs to feel pride in the accomplishments and independent behavior of the patient. Bringing these split-off parts together is vital to an individual's experience of wholeness (Schwartz-Salant 1983–1984, Mahler 1968).

An example of my attempts to join such self and object splits can be seen in my work with a young woman. Even while she was choreographing the alternation between intimacy and merger, by sitting close to me or in my lap, and separation and independence, by trashing my room or demanding I leave my larger room to give her more space, I would reflect the existence of both sides of her and of me. "You are the very same person who wants to be seen and

loved for who you are and to be valued for your assertion and independence, and I am the same person that can both nurture and hold you and value your stance, separateness, and accomplishments." Although she frequently struggled with believing the possibility of this statement, she gradually grew to experience its truth within the transitional space.

Patients with an Ego and Realistic Self and Object Internalization

With an individual whose ego, self formation, and object internalization have been sufficiently organized, the projective field increases. The therapist can receive various aspects of the individual's psychology. There is an infinite variety of possibilities here (Racker 1982, Searles 1981).

From a woman, the therapist can receive sensual sexual *hetaera*, or her powerful Amazonian side; can feel deeply receptive and receive her medial aspect; or knowing and receive her wise woman. A woman may also put aspects of her masculine side into the therapist. The therapist may feel like a judging patriarch, or a guide that lights the way.

From a man, the therapist can receive bellicose Mars, instinctual, naturally impassioned Dionysus, or rarefied artistic Apollo. A man may also wish to put his anima into the somatic container. The therapist may then feel beautifully adored, mysteriously wise, or, on the negative side, moody, brooding, and castratingly seductive.

What the therapist does with all of these experiences within the somatic countertransference is fundamentally similar, in that she or he "holds" them for the patient to experience and gives them back when the patient is ready to reidentify with them. In the case of shadow material, the therapist frequently needs to assist in the civilizing or parenting of this previously rejected part of the ego. Since these parts were shoved into the unconscious early on in childhood, they have not gone through the maturing that the rest of the individual's psyche has. Painted images, authentic movement, or improvisational drama may turn up creatures from the forest, jungle, ocean, cave, basement, or attic, which can be projected into the therapist for parenting (see table 2.1).

With the projection of contrasexual aspects, a more complex relationship may need to take place. I will be describing an example of this in chapter 10.

An example of the use of the somatic countertransference in the area of claiming assertion, power, and rage occurred one day when I was working with a woman who was describing recurrent memories of abusive events from her childhood as if she were reporting the weather for the upcoming week. In the beginning of the hour, I had settled myself and imaginally created a vessellike space in my womb, which had impenetrable but elastic walls (Lewis 1988a).

TABLE 2.1 **The Somatic Countertransference with Various Populations**

	Images, feelings, and sensations received by the therapist's somatic unconscious via splitting and unconscious projection	**Therapist's imaginal nonverbal internal response**
Psychotics and Patients with Psychotic Cores	• dissolving, lack of boundaries, or merging with the patient • bodilessness, being dead, or mechanical • dizzy, mindless, or sleepy • pervasive fear of impending doom or aggression • thousands of energized fragments of the chaotic self • psychotic archetypal energy	• hold the image of the patient as whole, integrated and surrounded by a buffer • remember the patient's fragmented self • be a buffer by standing firm against the psychotic archtypal unconscious of the patient • maintain a wakeful consciousness and contain the patient's complex assault on the patient's own consciousness
Narcissistic Personality Disorders (NPD) and Patients with Narcissistic Wounds	• with NPD being flattened or squished by patient's inflation and grandiosity • with NPD no room to speak • split-off "bad" monster infant self of the patient. Images may look creaturelike, be starving, or brutally wounded • empty bottomless pit which is either the patient's inner emptiness or that of the patient's mother	• mirror and reflect the grandiose self • choreograph holding, nurturing, healing, and attuning to the needy infant creature self • image a secure, soft but sturdy holding container • image a protector that will buffer the infant self from a hungry devouring mother

TABLE 2.1 (continued)

	Images, feelings, and sensations received by the therapist's somatic unconscious via splitting and unconscious projection	Therapist's imaginal nonverbal internal response
Schizoid Personality Disorders and Patients with Schizoid Defenses	•split-off feelings of the patient, i.e., anger, hurt, fear, longing for love •split-off wounded self •wall or protective shield which cuts the patient's body-felt experience off from expressing or receiving •transferred negative mother	•hold, nurture, and foster growth and assertion of patient's split-off self •dissolve or penetrate the schizoid wall through love •neutralize and detoxify the negative mother
Borderline Personality Disorders and Patients with Borderline Defenses	•self splits, i.e., the assertive rapprochement self or the symbiotic infant self •object splits, i.e., the merged smothering or angry withholding object	•hold and attune to the symbiotic infant •feel proud of and confident about the assertive striving for independence rapprochement self •contain and subdue the engulfing object •neutralize the angry withholding object who never wants the patient to be independent
Patients Who Have an Ego and a Constant Inner Realistic Sense of Self and Object	•as-yet conscious or transformed aspects of ego (shadow aspects) •as-yet conscious or transformed contrasexual aspects of personality (animus for women, anima for men) •archetypal numinous energy for the patient's personal quest	•be a receptive container and reflector of these aspects the patient can reidentify and integrate them through projective identification •be in relation to the self (the organizing energy which moves the patient toward balance and wholeness) •be a still and stable conduit for the passage of this archetypal energy

First I sensed a burning in this container. Then an image came of a smoldering fire, and finally an intense rage exploded in my gut. At this point, I had a few choices: I could continue to hold her split-off rage; I could let the rage speak through me and express fury at this horrific abuse; I could point out the incongruity of her lack of feeling and the content of what she was saying, and/or I could tell her of the feelings and sensations in my vessel and explore having her reclaim them. I chose the latter.

I responded, "Even as you're speaking of this horrible abuse with no apparent feeling, I am feeling a lot of anger and outrage in the room. Can you begin now to feel this?"

"What do you mean?" she said. "This is all in the past. It wouldn't do any good at all to get angry. I have an okay relationship with my father now."

"It is not so much the external father and your present relationship that is problematic, but these childhood memories which keep cropping up like unwanted weeds." Although she did not disagree with me, she continued to be disinterested in my tack. I proceeded. "There is a part of you that feels very strongly about these events, and unless you claim this part, you will continue to be riddled with these memories interrupting your intimacy with your lover and keeping you from your own sense of safety and power." She became more interested. "What did you as a child feel when he was abusing you?"

"I was scared."

I persist. "I am sure. But there are also angry feelings in this room."

"Oh," she said, "I couldn't get angry—he would have really killed me then."

"Yes," I said, "for sure, you split off your anger for purposes of survival. You were so small and he was so big and out of control. But now you have a grownup as an ally—your own adult self. Go back to one of the abusive events, and this time imagine removing your child self and let your adult let him have it."

It took a few moments, but I felt the boiling rage in me funnel out as my patient began to yell, "You bastard! You call yourself a father! You alcoholic son of a bitch! You'll never abuse her again!" Placing a dummy in front of her was enough to suggest to her that she stand, grab it, and hurl it across the room. Kicking it repeatedly, she finally opened the therapy room door, threw him out, and slammed it shut.

The Vessel of the Bipersonal Field Between Patient and Therapist

The imaginal realm may be constellated between the patient and therapist. In this transitional space, both participate in the unconscious-to-conscious choreography toward healing (Lewis Bernstein 1985). The therapist can join in the patient's actual imaginative process through personifying characters or embodying figures in art, sand play, or dreams. Through the enactment of transferred parental complexes or split-off aspects of the individual's psyche, the individual may explore and eventually reinternalize transformed parts of their psychology.

My work with Claire may provide an example of the use of the imaginal in the bipersonal field. Claire, narcissistically wounded, had spent much of her life reflecting others' needs. She hoped in vain that they would respond in kind and feed her starving infant self. Now, after many therapy hours, she sat near me on my L-shaped sofa. Deep inside her there smoldered an unrelenting rage.

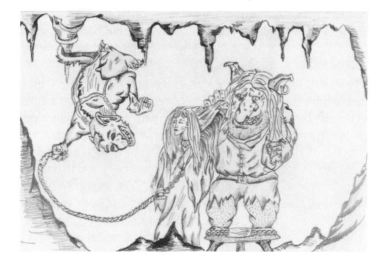

FIGURE 2.4 **"A Slave to Monsters"**

(Source: Marc Croteau, illustrator; private collection)

Claire reported a dream of being a slave to monsters that insisted on absolute obedience. She tried to escape but to no avail (see figure 2.4).

I suggested she explore who the leader of these collective monsters might be. Claire imagined a huge, Nazi-like, angry, fully armored, furry creature. Understanding that all parts of a dream represent aspects of her own psychology, she somewhat reluctantly agreed to enact the monster abuser while I role-played the dreamer. As I began to approach the monster with curiosity and openness, he became fearful of love, imaginally ran to a fence and feeling caught, began to get very "grizzly."

Claire then reassumed the role of herself in the dream and with my suggestion began to look for his soft spots. She reported that his eyes, breath, heart, and loins appeared vulnerable. At this point, she and I sat very close, leaving only a corner space between us for the imaginal monster. "I can't get any nearer, but he trusts you," she whispered in my ear.

Still in this bipersonal imaginal realm, I whispered back to her, "I'm going to put his head gently on my chest."

"Yes," she responded, "he's sitting down, he feels safe." Then I reached for her with my other arm to draw her into this tender moment. I gently stroked her head while she cried quietly.

The capacity to heal the split between her good and bad self first needed to be embodied by me, before it could be internalized. Like the good mother object who loves and receives the so-called good and bad child self, so the therapist within the imaginal realm can begin to civilize and humanize the exiled part and heal the schism.

In the next hour, she reported that when she began to feel angry and grizzly, she imagined my touching and healing an oozing wound that the monster had. She also reported the following dream: "This same bearish monster was mutilating people, ripping them apart. I was supposed to go and deal with him. Friends said to me, 'Be careful; it's not safe.' But over a phone, you, Penny, were telling me what to say and do. So I went up close to him to reach out, and he began to change to become more like a man." The imaginal monster began to evolve developmentally and oedipal and pubertal themes appeared. Now, like "Beauty and the Beast," she began to humanize a rejected part of her relationship to the masculine in order for a future imaginal union to occur.

The Vessel of the Group

The power of groups to evoke the transformative force of the imaginal realm has been well documented in ethnographic studies. Community rituals utilize the arts through dance, dramatic enactment, singing, and chanting. They can bridge the human world with the sublime. They would enact the metaphoric thus aiding the society and its members through seasonal cycles and developmental rites of passage.

Group ritual, which had all but lost its presence in our culture, is starting to make a comeback through men's and women's groups, Native American sweats, vision quests in nature, and with those who employ the arts in groups.

An example of the power of a group to provide a vessel for the transformation of anger can perhaps be found in an ongoing authentic movement, sound, and drama therapy group. This particular three-hour session began by each person engaging in authentic movement. Each found their own space in the room and turned their awareness inward. After a short while, one of the male members began mumbling, then I heard, "Fuck this. This is ridiculous, this means nothing!" I moved over to him and began reflecting his frustration and rage. We began pacing around a large pillow. Looking at me, he said, "You don't know what you're doing. This is all a bunch of shit! This is stupid."

I responded, "Stupid, stupid! This is dumb. What the hell is this anyway? Just a waste of time!"

"Yeh," he retorted, "a fucking waste of time! It's all a waste!" He flicked a smaller pillow on top of the larger one.

By this time, two more group members found us pacing around the pillows. They added their comments, "This sucks, work sucks!" and another, "I'm sick of relationships, the hell with men!" Now the rest of the group joined. "Yeh! The hell with men, they can't commit themselves." Another man responded, "And women just want marriage and control." "Yeh, fuck them!" "Fuck everything!" Now all the pillows in the room were being thrown, picked up, and thrown again into the center pile. The group had evolved from pacing to stomping. The words became more poetically nonsensical. "Fuck muck! Shmuck! Yuk! Smeary yuck. . . ."

The group's developing frustration and rage now had an instinctual expressive quality. Group members began hurling themselves onto the pillows until everyone was on top of a big metaphorical pile of anger-charged "shit."

Gradually people began becoming snakelike in their movements, almost as if everything, every image, every hope of humanity, had been trashed and they needed phylogenetically to evolve anew. Like the phoenix rising from the ashes and Pegasus flying from the blood of the decapitated Medusa, group members

began to slowly ascend, standing and reaching, moving with slow, buoyant qualities, rounding, carving, and shaping the space around them.

Members spoke at the end of being cleansed, reborn, revitalized, and spiritually touched.

Summary

The dance which occurs in the imaginal realm can be contained in various vessels: the arts media, an individual's body, the therapist's body through the somatic countertransference, the bipersonal field between patient and therapist, and/or within a group. In this realm, we can begin to heal the splits and find the Tao within ourselves.

The use of the expressive arts can engage all of us in the dance toward wholeness. Songs, poetry, literature, musical compositions, dance, drawing, sculpting, the micro-drama of sand play and macro-drama of stage plays can all move us in the natural direction toward individuation.

With the Self guiding an individual's experience in the imaginal realm, self-actualization is enabled. No matter what art media is selected, old wounds and patterns and relationships can be healed and an individual's progress through each developmental phase can be facilitated.

Chapter 3

INDICATIONS FOR THE SELECTION OF ARTS MEDIA

*B*efore beginning Section II, the specificity and appropriateness of the various art media will be explored. Following this, developmental phases of males and females will be addressed with examples of how the creative arts can be employed to assist in the transformative process. Mythology and fairy tales will be employed as road maps and strategies, if you will, in the individuation process within the imaginal realm.

Arts Media and Internal Psychic Structure

When to select or suggest one art medium over another is particularly relevant when working with certain populations and in specific developmental phases.

From a cognitive point of view, the most fundamental level of organizing and integrating developmental phases is through enactive cognition in which body-felt experience and movement interaction are the prime sources of learning (Johnson 1982). Long before an infant understands what is being said verbally or responds to visual cues on an iconic level, the infant feels the nuances of the mothering person's physical ministrations. Memories of these early experiences are on a preverbal level, since the central nervous system has not sufficiently developed for more sophisticated verbal memories during the early months of life. Winnicott wrote of this early symbiotic phase that it is "preverbal, unverbalized and unverbalizable" (1971, p. 130). Thus, unconsciously derived body sensations and movement rather than more traditional verbal responses have been found to elicit the needed remembering and reexperiencing of in utero and early childhood phenomena (Lewis-Bernstein and Singer 1983, Greenson 1967).

For example, during authentic movement, one patient found her somatic unconscious moving her into a closed fetal position. She rocked with the sooth-

ing rhythm used by infants when they suckle. Then the rhythm changed as she found herself banging her head on the rug in my office. Agonizing tears filled her eyes, and she reported remembering being alone in her crib, empty, frightened, and angry. This memory was not of a single incident but of a repeated painful pattern of adaptation that had not previously been remembered by her.

In another example of embodiment, a man, having been selected to role play a rapist in a woman's dream, engaged in a plot reversal in which the woman, now empowered, chased him and pinned him down. Lying on the floor, he felt the full power of the woman's domination and was time-warped into his early childhood with an overpowering mother. Prior to this experience, he had been aware of his difficulty in sustaining physical intimacy with women, but through this enactment he was able to link his bodily sensations of repulsion to his boyhood feelings about his mother and his current reactions to women.

Through research (Zwerling 1979, Stern 1985) music and vocal therapists have come to recognize the power of sound and tone as well. The rhythmic flow of voice and music, the rate, vibration, volume, and manner in which the vocal chords or instruments create sound can express affect and drive, mirroring and counterpointing an infant's movements and tones. All of these sound qualities are also held in auditory memory. Because sound permeates through body boundaries and intellectual defenses, it is often considered the most basic form of connecting and communing with the imaginal realm.

The volume and tone of my voice became particularly important to one women with whom I was working. She had begun to delve deeply into herself to recover the experience of her childhood. Gradually she began to embody her wounded child and cautioned me not to make any loud or abrupt noise (her mother would make jarring sounds which would disrupt her self-soothing movements). I responded in soft, lyrical tones which resonated with her nurturing rocking.

Those therapists who work with art, poetry, and sand play have come to value that, at times, external representation of the unconscious is particularly helpful. These are times when the patient can benefit from a separation from conflictual material for the purpose of viewing it as a totality without it so infusing the ego structure that it is impossible to have sufficient distance to see (Lewis 1985). For example, a woman with whom I worked realized that much of her culture's ideas about women continuously invaded her ego and made her feel that it was she herself who devalued and kept her from her evolution as a woman. With the use of sand-play figures, she was able to view with much more clarity what happened intrapsychically. First, she selected a large garbage bag filled with styrofoam to represent the negative collective object. Next, she selected several aspects of her own shadow feminine nature — an infant self, an earthy Indian, a sexual woman, a dancer — and placed these parts

of her inside the devouring "mother bag." Now she understood what must be done and, in imageful drama, she sent the internalized mother across the room. Now the ego could claim more of the psychic energy that heretofore had been hoarded by this complex. After this session, her posture began to change as did her voice projection. From a shrunken, slumped position, she sat straighter and claimed more space for herself. Her voice became louder and had more resonance and breath support. She related that she felt more in control of her life and understood more clearly what she wanted.

An embodied experience may be too emotionally potent for some patients. Seeing the object-related dynamic first on paper may provide the needed step toward acknowledging and reexperiencing emotionally charged phenomena. An example of how the visual arts can be a helpful transitional vessel can perhaps be seen with one man who was intensely afraid of his own powerful split-off rage in relation to his mother. He was concerned that if he expressed this dramatically, he might pick me up and "hurl me through the window" in my office. Drawing his rageful monster provided the needed transitional container and insurance of ego mediation. He was ready to feel this anger in his body and express it without fear that he would lose his sensibilities and attack me. In the drawing of his angry self, he had felt more in control. Perhaps now he could see that his personified anger had shape and limits on the paper, and that he had shaped it. Perhaps he began to connect the premise that if he could shape it on the paper, he could have control over shaping its expression in his body.

Embodiment may also be inappropriate for persons with severely impeded ego development, for it can produce a flooding of the ego by unconscious material that cannot be readily assimilated. Such was the case with one woman, who was exhausted and distraught from repeated nightmares. With my encouragement she wrote in poetry the script of an abusive part of herself which appeared in her dreams. This provided the needed distancing and conscious "drying out" of her anger which she had turned back on herself because her mother impeded her expression. This process was further helped by me reading the poems to her. She said, "It's important that you read to me so I can listen. I feel calmer with you. I know this may sound silly, but your reading what I wrote . . . it doesn't take you over like it did me when I wrote it or, rather, when 'it' wrote through me." After the reading, I acknowledged and valued her split-off aggressive instinctual side which she had not been allowed to embody in her toddler days for fear of her mother's ostracism. In the session, she felt able to begin to risk enactment through taking on the role of this part of herself while I "interviewed" her. In this way, she began to claim and mediate her aggression, rather than her aggression, arising nightly from her unconscious, "claiming" her.

With those who have a lack of impulse control or a confusion between reality and symbolic enactment, the possibility of violent or undifferentiated responses

directed toward themselves or others should be curtailed. Psychotic individuals, for example, frequently require reminders in role playing situations that the other patients and staff are just that – other patients and staff. For example, one psychotic patient known for impulsive outbursts repeatedly smashed two pieces of clay together. For him, it was important to wait until he had sufficient ego development to interpret his clay activity as having meaning other than the release of air bubbles.

In some instances, the ego is sufficiently differentiated, but the internalized negative object with its arsenal of resistances initially may not allow the power of embodiment in movement or drama. This was the case with one woman who, through the use of imaginal work, had delved into her inner well to reclaim her split-off, healthy maternal side. She was unable to enact this potent and crucial experience. Putting a pad and pastels in front of her, I encouraged her to draw. She would begin, then stop. Knowing her negative mother intimately (she had transferred her onto me for the purpose of neutralization and transformation), I responded, "Your inner mother will try to stop you; don't let her. She will tell you it's not artistic enough; she will devalue it; she will even try to make you go blank and freeze your arm, but you can do it!" With much struggle and determination, she drew the figure of a woman standing with her arms reaching for the child. Her negative inner mother knew how powerful embodied experiences were for this woman, but even the patient didn't know, until she began, how profoundly significant it was for her to be able to complete this drawing. Afterward, deeply moved by the fact that she had completed the drawing, she expressed gratitude at my battling along with her against what she had referred to as her "inner Medusa mother."

Developmental Stages and Arts Media Selection

As mentioned earlier, sound and body movement are the most basic and potentially primitive of the expressive arts. When working with individuals whose inner unattuned infant needs soothing and early nurturance, I am more concerned with the tone of my voice then the actual content. The rhythmic, clear resonance can be equated with the rhythmic rocking or humming of a lullaby. Even though the adult ego may be hearing the content of what I am saying, it is the inner infant self who is my prime focus and who must also feel accepted and held as part of the relationship.

Singing and instrumental music having simple melodic quality, such as is found in music by Satie or many of the so-called relaxing "new-age" pieces, are really also soothing the abandoned inner child of the individual.

Just as auditory tone and rhythm can reflect early infant phases, so can the body posture, breathing, and movement of both the therapist and the individual. (This will be elucidated in detail in the Section II.)

Dramatic enactment can also be employed at this early phase, but it is not verbally dominant. Rather, the focus is on the rechoreography of early object relations between the primary care giver and the individual (Lewis Bernstein and Singer 1983, Lewis 1987).

The child's use of the fine arts develops slowly as the child gradually develops more sensual interest and tactile pleasure in the various media. This can be found in the use of finger paints, smearable pastels, and the movement of sand in sand play. Here high-chair food "creations" come to mind: "smushy" potatoes, applesauce, yogurt, all blended into a pleasurable abstract expressionist table relief.

A patient puts her feet into a floor-level sand tray after "exploring her toes" in authentic movement. She then takes pastels and scribbles and smears different colors on a large art pad. I put a huge plastic sheet out on the floor for a group of overstressed, hardworking adults. Finger paints, shaving cream, soap suds, and water-filled balloons are available. Hand and finger painting make way for toe and foot painting. Pretty soon all are dancing with each other, gushing the media through their toes. This developmentally based experience of pleasurable letting go has been identified by ego psychologists such as Anna Freud (1966) as the anal libidinal phase.

Anna Freud describes how, progressing developmentally, interest in harder media that offer resistance evolves. Issues of autonomy, independence, and power and control over media dominate. Modeling and potting clay, play dough, and wet sand in sand play are all relevant art media. Clay may be molded and shaped into "doo doos," containers, or higher-level abstract or representational figures. Or the media may be utilized for the experience of gaining control over making shapes and destroying them and recreating them anew. These media may also be filled with the rage of an individual who has not been allowed full expression of his or her anger or assertion.

One adolescent drew a life-size picture of a parent. We tacked it up on the wall, and he threw clay "shit balls" at the target. He felt great pleasure when they stuck on the picture in significant places.

An adult group played with clay each in their own internal imagined realm. They were then asked to arrange their pieces in relation to each other. A group world was created that infused each individual with reverential awe.

Developmentally, issues of power and control give way at three and a half years of age. Now the door opens to imagination on a grander scale. Children actually engage in dramatic play, embodying various characters, exploring instinct and impulse control.

Watercolors, sand play, and greater interest in musical instruments develop.

Here there is a focus on fluid media and exploring the themes of holding on and letting go. Costumes for dancing and acting or just exploring roles become figural. Animals are embodied as the instinctual realm is experienced for the purpose of claiming and civilizing aspects of their psyche.

For example, a group selects plastic animal noses from a basket and spontaneously improvises a drama with "good and bad guys" and themes of saving the "little helpless ones who wander off."

On a movement level, individuals move out into space, exploring various ways of moving and stopping.

Dramatically, other themes evolve at age four through five. Initially, with the identification of the mother as creative, the child is interested in role play which entails child care and nurturing. Sculpting or constructing with three-dimensional media develops.

Themes of killing the monster, saving the weaker creatures, penetrating into dark realms, or oedipal stories in which two individuals are engaged in an activity together and the third tries to join them evolve in sand play, puppetry, play therapy, and drama.

Latency issues of mastery, same-sex peer group interaction, and the integration of rules come into the foreground. Here individuals become interested in learning to utilize new art media which require mastery over tools and techniques. Involvement in art as a craft involving a useful product develops.

One improvisational movement drama therapy group gained great pleasure in spontaneously separating and grouping according to the sexes. They developed a game of keep away with the props available in the room. This experience helped many feel a sense of acceptance within their peer group. One woman in particular had isolated herself from other women; having had a competitive, brutal, abusive mother and no sisters, she had felt judged and unsafe with girls in her childhood and needed to experience a developmentally charged therapy process that could give her, as Winnicott relates, "a host of meaningful memories" (1971, p. 75).

Progressing further developmentally, journal writing as well as poetry and story writing and reading are added to the creative arts media. Pubertal rites of passage along with issues of dependence and independence, sex-role orientation, identity, and future role and work choices need to be explored.

One man wrote his own personal quest story in which all the characters represented either internalized parental complexes, shadow aspects of his ego waiting to be claimed, or contrasexual aspects or various animas with whom he needed to engage. Each chapter was enacted and explored in the imaginal realm in service to his individuation process.

By adolescence, all art media are available for use (Rubin, Irwin and Lewis Bernstein 1975) (see table 3.1 for summary).

TABLE 3.1 Developmental Indications for Arts Media Selection

AGE	PHASE	THEMES	ART MEDIA
In utero	Prenatal	Safety in container	Sound with a heartbeat rhythm; movement within a contained space.
0–6 months	Oral; symbiosis; first maternal phase; uroboric pleromic paradise	Trust, merging, mirroring, dependence, nurturance, attunement, holding and handling, horizontal plane dominance	Sound (music and voice) and movement with an oral sucking and inner genital feminine rocking rhythm. Body awareness: inner and outer eye contact, breathing together; nonverbal dyadic drama.
6–18 months	Oral aggressive separation and individuation, differentiation, separation of world parents	Me/not me boundary eating and being eaten, separation, being seen and not seen, grabbing and growling	Music voice, and movement with an oral aggressive biting and chewing rhythm. Dramatic embodiment of creatures with teeth and carnivorous animals, straw blowing with food coloring pictures, chewing and bubble gum.
1½–3 years	Anal libidinal and sadistic; separation and individuation; practicing and rapprochement; second maternal phase	Autonomy vs. shame, power and control, assertion, destruction of authority; split self and object, vertical grounded stance, self-presentation, pleasure in producing	Music, voice, and movement with an anal libidinal or sadistic rhythm (high intensity holding, straining, and releasing in the vertical plane); art media of finger paints, sand, clay, plasticine, play dough, dramatic expression of assertion, independence, and control.

Age			
3–4 years	Urethral libidinal and sadistic; toward object constancy; chthonic	Holding on vs. letting go; pleasure in being, pleasure in doing, starting and stopping, impulse control; assimilation of instincts	Sound, music, and movement with/without libidinal and sadistic rhythms (pleasurable languid flowing and sagital quick operating, respectively); art media such as watercolors, dramatic play, themes of filling and emptying; liquid environments; embodying various animals, monsters, and creatures; sand play with animals.
4–5½ years	Oedipal magic, warlike and magical creative	Oedipal themes, inclusion and exclusion, rivalry and competition, killing the dragon, mediating the dragon, sex-role identification, creating, penetrating, pleasure in creating	Sound, music, and movement with inner and outer genital rhythms (swaying; rock and roll and ballistic penetrating, respectively); art media modules used for collage and sculpting.
5½–10 or 11 years	Latency	Industry; mastery; same-sex peer group; integration of rules, pleasure in mastery	Sand-play environments; drama: dress up, role play and/or puppets in sex-specific roles; use of various instruments in music; arts media – use of new tools, media, and techniques for mastery; art product joins with craft (a product that also has use); poetry, story writing, and reading.
12–16 years	Puberty; solar warlike and lunar cyclic	Second oedipal themes; independence from parental authority; sex orientation; movement from childhood into adulthood; identity; claiming of one's power and strength	All arts media including journal writing.

Summary

It should be clear by now that awareness of the target developmental age for specific art media is important to have, not only when working with children, but also when working with any age individual who is exploring and reexperiencing earlier developmental phases. For example, if an individual is connecting to his inner infant self for the purposes of remembering the past or rechoreographing the early parent–child relationship, suggesting that he draw or write might be less appropriate than encouraging body awareness and mirroring his movement.

It is best to let individuals know what is available in the therapy vessel. In most cases, if they are connected to their process, they will make just the right choice for themselves.

Section II

THE POETRY OF LIFE'S DRAMAS

THE PHASES OF DEVELOPMENT AND THE TRANSFORMATION PROCESS

Chapter 4

ONTOGENY AND THE THERAPEUTIC PROCESS

Introduction

From birth to death, we humans engage in the poetry of life's great dramas. Sounds, movement, images, characters, and plots interweave constantly into a complex tapestry. Part of the work of the patient and the therapist who employs expressive arts is both to view the fabric of the drama, image, sound, or movement as a gestalt and also to identify the thematic threads. When the threads are traced back to their etiological origin, roles, settings, and thematic scripts can be grouped in developmentally based constellations.

Through the theories of ego psychologists (Erikson 1963, Freud 1966), therapists have grown to understand that with each stage of life there are specific themes which manifest and dominate an individual's way of viewing and interacting in the world, requiring specific roles for that person and significant others to enact. For example, the role of an individual playing out the drama of establishing trust (Erikson's first stage, trust vs. mistrust) is very different than the role to be played in Erikson's second stage of autonomy. Dysfunction and pathology emerge when these stages have been unsuccessfully integrated due to improper setting or thematic or role deviation. Although ego psychological theory proved to be an important step from Freud's original constructs, further sophistication of developmentally influenced theory emerged with the work of object-relations therapists and neo-Jungians.

Most therapists would agree that much of their patients' dysfunctions originate in the first three years of life. Ego psychologists certainly covered these years but not with the specificity of object-relations theorists such as Melanie Klein (1975), Margaret Mahler (1968), D. W. Winnicott (1971), Ronald Fairbairn (1976), and others who held a magnifying glass up to the intrapsychic and interpersonal threads. What they found were subtly changing roles within the mother–child drama which, with "good-enough mothering," served to provide the child with a realistic sense of self and a constant, internalized, supportive and enabling object or inner mother.

Once object constancy has been achieved, life's drama expands. Here, other theoretical constructs need to be introduced. Once again, although ego psychologists have provided therapists with developmental lines continuing throughout life, the thematic dramas are far more complex and diverse given the sex and dominant characterological structures of the individual. Here the work of Jung and post-Jungians (Neumann 1973, 1976; von Franz 1978, 1982; Harding 1971) have taken culture's externalizations of universal life themes and characters found in myths, fairy tales, religious ritual, and stories of gods and goddesses and provided a rich view of the powerful archetypal themes in the life quests and cycles of individuals.

Awareness

Individuals' dramas are played out in their lives through repetition compulsions or repetitive childhood patterns, originally utilized for survival but which, in adulthood, inhibit their individuality and wholeness. The threads of the themes and roles are gradually revealed to the patient with etiologically based exploratory questions and comments, such as, "I bet this isn't the first time you have found yourself in this type of situation with these very same feelings" and "What is your very first memory of this experience?"

In this first state of awareness, the individual needs to get a fix on how these behaviors and interactions are internalized and projected onto their present life. For example, an analytic patient felt that I would be judgmental of him. Since the role of judge is not within my way of being as a therapist, we pursued an exploration of its origins. His mother had enforced a Protestant ethic that would have humbled the Puritans. Clearly this man, with adult children of his own, was not responding to his external mother but rather to the internalized negative object (object relations) or mother complex (Jungian). The pervasiveness of the projection of this complex and its incessant inner vocalizing, which depotentiated his sense of self, was explored. Further awareness of the motivation of the mother complex was brought about by me role playing her.

Complexes are seen as a feeling-charged constellation of memories and experiences surrounding a universal archetypal core. Thus, this man had, surrounding the archetype of the Mother, a history of dramas in which his mother berated and shamed him, curtailing any access to experiencing the core Mother and hence the world as benign and supportive.

There is another fascinating factor about complexes: although they are, in part, created by the individual, they are autonomous from the ego and self and are entirely interested in their own survival. Thus, complexes, such as the

inner parental judge, want to claim as much psychic energy as they can, typically siphoning it off from the ego or self. They become what gestalt therapists would refer to as the "top dog" which parasitically feeds off anything the ego or self may receive from their own creativity and the outer world. These complexes are also very manipulative and conniving. They will change shape and personality just to convince the ego that it needs them.

Returning to my patient and my role playing of his judge mother complex, I aided his awareness by saying, "You need me; if I weren't around telling you what you do wrong, you might shame yourself, and then everyone would be disgusted with you and leave you." Like many patients, this fellow nodded his head in affirmation. I then proceeded to reveal the belly side of this complex, which showed its vulnerability. I continued, "I need to feed off you. I've got a big appetite, so I don't want you to realize that your creativity and other's goodwill toward you is for your satisfaction. Then you would become bigger than I, and I would lose my power over you. So you must continue to listen to me: to want anything for yourself is selfish and to feel good about what you do is prideful and vain!"

The Transformative Process

Expressive arts therapists have long known that it is only through experience in the imaginal realm that any transformation can occur. Many patients come complaining that they have talked about their problems with other therapists but to no avail. These problem patterns would be simple to change if they only existed in the empirical realm.

Winnicott's transitional space and the imaginal realm described by Jung (1955–1956) as the *mysterium coniunctionis* can transform the therapy room into a nursery for old pathological scenes to be reexperienced, a stage for new object-related dramas to be played, or a jungle for a hero to confront his or her inner instinctual beast.

From a Jungian archetypal perspective, this means that numinous energy can enter the room through the embodied personification of a goddess or spontaneous enactment of an ancient ritual or rite of passage.

The therapist's repertoire of roles extends to all possible enabling and destructive characters in human development as described by the individual in their personal history or by individuals through culture's history in myths, fairy tales, religious liturgy, and other manifestations.

In this realm, my patients recall and reexperience childhood abusive events, but instead of their child being abused again, they, as an adult, dramatically

enter the scene, hold or place the child in a safe space and let the parent or other perpetrator "have it!" As the negative layers of the inner complexes slough off, the archetypal core becomes more available. Then rechoreography of healthy development is possible between the patient and myself or within a group. Reparenting cannot successfully occur until all the history is reexperienced and transformed. Here, classic psychodrama techniques and structure are exceedingly helpful, particularly in the recreation of history, confrontation, and antagonist transformation.

An individual's further development is, of course, also curtailed when early phases have been disrupted. In these situations, it is not so much reenacting but providing a developmentally based setting for the patient to integrate higher levels that is needed. Again, this is provided not so much empirically as liminally and imaginally.

Improvisational movement, sound, drama, and dream work, sand play, poetry, and story writing provide rich avenues for further development. Being cognizant of adult stages of development allows the therapist and patient to encourage and give meaning to themes that emerge from the imaginal realm. For example, understanding the death, dismemberment, and putrefaction cycle of the heroinic quest can provide the needed support and encouragement for the patient to undergo this sometimes frightening but necessary rite of passage.

Through the somatic countertransference, the therapist can participate in the transformative imaginal realm by imaging holding and healing the wounded child self or detoxifying the negative parental introjects. The themes of separation, assertion, and autonomy found in the rapprochement phase can be countertransferentially supported in various imagined dramatic scenarios and sent from the therapist's imaginal realm to the patient's without a word spoken. This imagined enacted dialogue has a powerful effect and is always received by the patient. I have had many confirmations of this through patients' dreams, poetry, drawings, or statements such as, "I know you've been holding me all along" or "my inner child feels your constant encouragement of her assertion."

It is also through this unconscious-to-unconscious connection that I receive the complexes, or split-off shadow parts of my patients and allow them to "speak through me." This process also allows me to open myself to the deeper layers of the unconscious. Jung discovered that not only do individuals have a personal unconscious, which is filled with their repressed history and split-off parts of themselves, but they also have access to a universal pool of knowing from which archetypal movements, sounds, themes, and images emerge.

It is possible for the therapist to receive roles and themes from this universal collective unconscious and to allow the archetypal to speak through and dramatically move him or her in service to the patient's healing. In this realm, both the patient and therapist are held in a state of grace. In this realm, both

are healed. In this realm, a group can be transformed. The archetypal can shake loose old roles and themes, stripping each member to the essence of their being in the presence of a higher power.

Being in the Moment with the Creative Void

The third stage in the therapeutic process unfolds naturally. Patients observe, sometimes in retrospect, how their behavior has changed. They no longer are playing a fixed role of, for example, care giver or controller; they have choice as to whether or not they want to repeat an archaic dramatic theme. They live in the moment and spontaneously respond to life's drama.

They are able to speak and sing freely, fully supported by breath; their voice moves upward and outward, projecting it into space to be received (Brownell and Lewis 1990). Their body moves uninhibited without blocks, tension, discomfort, or pain. Posture, freed from imprints of dysfunctional primary care giving, adapts to the moment, aware of the environment. Boundaries allowing vulnerability with protection are present, and a full range of instinctually and effectively supported movement is adaptively available.

The capacity for play and creative expression allows image and metaphor in art and writing to provide continuing access to the deeper realms of knowing, always maintaining an open pathway to receive what is meant to be as the unique individuation process unfolds.

The Seeker

It should be clear by now that not everyone has the courage to go on life's journey. Not everyone is a hero, pilgrim, or alchemist. I have said to many patients who initially come into depth work, wanting this spiritual journey, "Be careful what you ask for, you may just get it."

For when the archetypal is awakened in an individual with sufficient ego, the universal themes, sounds, images, and movements will infuse patients from the inside out and compel them toward transformation and wholeness.

Archetypal energy will break loose archaic resistances in patients and free them to proceed further in their individuation process. But committing oneself to being a seeker, whether the therapist or patient, is no easy venture. Edinger

in his discussion of the opus or alchemical work quotes from an old text entitled "The Ordinal of Alchemy":

> Anyone who gives himself up to this search must therefore expect to meet with much vexation of spirit. He will frequently have to change his course in consequence of new discoveries which he makes. . . . The devil will do his utmost to frustrate your search by one or the other of three stumbling blocks, namely, haste, despair, or deception. (1978, p. 8)

To be seekers, alchemists, the therapist and patient must thus with humility seek and maintain a relationship to the Source, the Self.

The Self, the organizing archetype of wholeness and individuation, slowly moves the individual in the journey, often resulting in great sacrifice and hardship for the ego. But once surrendered to, there are very few that can tolerate going backward; the momentum becomes so powerful and the level of consciousness so profound that individuals can no longer disregard their individuation quest.

Chapter 5

THE UNDIFFERENTIATED ARCHETYPAL AND THE FIRST MATERNAL PHASE OF SYMBIOSIS

*W*e are about to take a journey into the dream cycle of ancient Egypt, through the pantheon of Greece, through Genesis and the story of Christ, through fairy tales and the lexicons of alchemy. Since mythology and folk tales are a culture's externalization of the unconscious of its societal members, they can both address the individual in his or her quest toward their developing wholeness and connect them with all of humanity through the universality of their message. Thus, creation stories reflect the origin of consciousness of the peoples who compose them. What is selected to be said about gods and goddesses reflects the issues that a culture needs to address and the rites of passage its members need to undergo. Since these universal or archetypal images, movements, sounds, and themes emerge from the imaginal realm, they can influence and help facilitate transformation. Through the expressive arts, individuals can experience these archetypes and, in doing so, be powerfully healed and brought further in healthy development.

In mythology, a connection to the ancestral is maintained, thus keeping us in relation to the Self—the energy-charged source of wholeness within. In this way, we may proceed with grace on the quest toward individuation. In knowing the inner myth, any internal battles or resistances become more figural and can be more readily worked through. Then the path becomes unencumbered, allowing the journey that is meant to be to emerge from moment to moment, in its own time, toward the greatest treasure that can be surrendered—the gold of Selfhood.

We will trace the origins and evolution of consciousness through these myths and symbols and ground them in clinical examples, in sound, song, movement, art, drama, sand play, poetry, story telling, and expressive arts dream work in depth transformative process.

Birth and the Undifferentiated Archetypal

From chapter one, verse one, of Genesis, we hear:

> Now the Earth was a formless void, there was darkness over the deep,
> and God's spirit hovered over the water.

Milton writes of creation:

> First there was chaos, the vast, immeasurable abyss, outrageous as a sea,
> dark, wasteful, wild. (Hamilton 1969, p. 63)

From the *Egyptian Book of Knowing the Evolutions of Ra—The Sun God of
Consciousness* comes:

> From out of Nu (i.e., the primeval abyss of water) from a state of inactivity
> not found in a place I could stand. (Budge 1969, p. 309)

Here is the image of the Great Mother unconscious, oceanic, endless, and
eternally deep. Here is where all life sprang forth in our phylogenetic origins as
well as intrapsychically in the origin of consciousness (see figure 5.1).

From the Greek Pelasgian creation myth:

> In the beginning, Eurynome, the Goddess of All Things, rose naked from
> chaos but found nothing substantial for her feet to rest upon, therefore
> divided the sea from the sky, dancing lonely upon its waves. (Graves 1984,
> p. 21)

The water may be turbulent ocean or a calm, pristine lake upon which one
floats or sinks into its depths in authentic movement. Or it may be the swamp
in which life *in potentia* is teaming, waiting to manifest itself into consciousness.
At times such as with beginning groups of individuals sharing a desire to access
their unconscious, I have made the following suggestion: "Find a place in the
room and a body position that feels right. Now allow yourself to focus inward:
rather than listening to the external sounds, listen to the sounds inside your
bodies. Allow your mind to empty. Let thoughts enter and dissipate without
holding on to anything or editing. Imagine a body of water and allow yourself to
enter into it. It has something to offer you. You may need to sink into its depths
or it may float you to a special place. Let your body experience being moved by
these images, feelings, and sensations. And receive what it wants to offer
you."

One woman drew and wrote after such a journey, "I am the earth, its
elements, the beginning, the essentials, the struggling of birthing, the mother,

FIGURE 5.1 **The Oceanic Unconscious**

(Source: Etching from a painting by
J. M. W. Turner; private collection)

motherings." She had experienced the archetypal. As it entered her, she felt a
deeper connection to the Great Goddess.

It is important to note here that this technique is only used for those
individuals with an ego that is like an island with good ocean walls around its
perimeter. Without good ego boundaries, the oceanic unconscious floods the
weak ego. Absorption and assimilation of unconscious material are impossible
as too much passes over the flood gates. Those whose egos are not sufficiently
strong dream of drowning into psychotic preconsciousness. Others dream that
parts of themselves represented by different dream figures are being washed
overboard or emerging from the water—lost in their unconscious until
retrieved by the therapy container. An example of this needed retrieval from
the liquid unconscious can be found in one man's exploration of a dream. In the
dream, his daughter, symbolizing his young (less developed), warm, interper-
sonally related, inner feminine, was washed overboard. I encouraged him to
reach down imaginally and rescue her. He then leaned over, reached for her,
and brought her imaginally to his heart. Weeping quietly, he became aware that
she was growing into womanhood in his arms.

The Snake as Midwife

Frequently it is the snake image, primordial and without differentiated body parts, which emerges as the first life form. For the Egyptians, the snake was one of the original life-creating powers, the most sacred of which was the Uraeus, depicted wound around herself on the pharoah's diadem. Uraeus means "She who rears up" to protect her king and people.

Snakes of all forms appear in sand play, art, and, most particularly, in dreams. They invariably ask the dreamer to become conscious of some aspect of his or her self or prevailing life theme. Such was the case with one woman who dreamed that she couldn't tolerate the mosquitoes around her (i.e., the parasitic, blood-sucking aspects of her greedy existing complexes) and so decided to descend into a swamp which she knew was filled with snakes. One reared up and faced her, seeking differentiation and consciousness.

I suggested she imaginally dialogue with the snake to find out what it wanted. I further suggested she embody the snake and said I would role play her. I began, "What do you want of me. I'm just trying to get away from these awful mosquitoes."

She, as snake, said, "Yes, you're always running away from them. They have you on the run. You need to do something else."

I, as the dreamer's ego, said, "Like what? They've been around since I can remember."

The snake dreamer paused, "Then you need to go find the source of this infestation."

I responded, "Where's that?"

The snake again pauses, "It's that cess pool . . . your mother. . . ."

This snake who reared up out of her unconscious was helping her become aware of the origin of these parasitic, destructive, internalized complexes. These complexes were viewed by her as the inner judges, critics, and shamers which craved her psychic energy (symbolized by her blood). In the past, she had allowed this life-sustaining energy to be siphoned from her ego consciousness and sense of self.

The Egyptians are not the only culture who have employed the snake as a symbol of individuation. In the Judeo-Christian tradition, as seen in the Garden of Eden, the snake manifests, in a paradoxical, ambivalent form, both that which assists in movement toward consciousness and knowledge of the polarities of life and as the tempter devil in his chthonic aspect. Unlike the Egyptians and Greeks, the Christians tended to split their archetypes, making God all good and sending his dark side downward into the earth. Here in the tree of knowledge of good and evil, which was significantly placed in the middle of the

garden, the serpent informed Eve, contrary to what God told her, that she would not die if she ate the fruit. He said, "God knows in fact that on the day you eat it, your eyes will be opened and you will be like gods, knowing good and evil" (Genesis 3:4).

The alchemists, too, filled the image of a snake with symbolic meaning. To the outsider, alchemy was considered not an art but rather a science, which sought by a chemical process to change baser materials or *prima materia* into gold. Alchemy, however, like the great myths and religious liturgies, was a form of psychic projection or externalization of the life themes which move all individuals in the process of their personal journeys. Jung (1944) wrote, "the alchemist projected what I have called the process of individuation into the phenomena of chemical change" (par. 564).

These processes are universal and thus have a numinosity about them and are steeped in mystery. When an individual is moved by universal themes in authentic movement, sound, or drama, in dream work, sand play, or art, it is very different from being moved by the personal unconscious. These thematic and imageful experiences emerge from the Source, the archetypal unconscious. When this occurs, not only the artist seeker but the witness/therapist will feel the numinous energy through the somatic countertransference.

The uroboros is the oldest symbol in alchemy, representing the *opus* or work itself (see figure 5.2). Jung writes,

> He is the hermaphrodite that was in the beginning, that splits into the classical brother-sister duality and is reunited in the *coniunctio* to appear once again at the end in the radiant form of the *lumen novem*, the stone. He is metallic yet liquid, matter yet spirit, cold yet fiery, poison and yet healing draught—a symbol uniting all opposites. (Jung 1944, par. 404)

An example of Jung's belief that each individual has access to a pool of universal knowing through their collective unconscious is seen in a batik by a woman in treatment who knew nothing of the uroboros, but in the expression of the beginning of her journey, she pointed to the end as well, as can be seen in the center. Here, out of the core spiral of the work, emerges a butterfly symbol of psychic transformation (see figure 5.3).

Perhaps an appropriate evolution to the first maternal phase is the next batik this woman created in which the uroboric snake is beginning to differentiate into the female figure of a merged therapist/patient. In my/her belly is the developing flower of the experience of selfhood (see figure 5.4).

FIGURE 5.2 **Alchemical Uroboros**

(Source: Jung, *Psychology and Alchemy*, p. 457. Reprinted by permission.)

Symbiosis and Trust

Gradually from the oceanic uroboric paradise of the unconscious evolves two crucial psychic complexes: the ego and the self. The former will become capable of mediating drives, feelings, and unconscious material with internalized parental complexes and external reality. It helps an individual know the difference between the inner and outer realms. The latter will provide the child with a sense of inner substance from which wants, needs, and beliefs can emerge from a central core.

FIGURE 5.3 **Uroboros: The Healing Therapy Container**

(Source: Private collection)

FIGURE 5.4. **Developing Uroboros: The Evolving Mother–Child Drama**

(Source: Private collection)

An experience of a sense of self forms in relation to a significant primary care giver, usually the mother, referred to in object-relations theory as the primary object. The typical concepts of mother and father will be used along with primary care giver. This should not suggest that this author supposes that all family units are composed of both a female mother and a male father. Children are being raised with all possible combinations. But regardless of the sex or presence of the actual blood parent, the elements for healthy development need to be supplied. This process occurs over three to four years and goes through subtle but crucial dramatic role changes in the process of individuation.

Initially this relationship is choreographed through sound, body posturing, and movement (Mahler 1968, Stein 1984). Margaret Mahler describes the first stage of development of objective relations as symbiosis, in which there exists a dual unity between mother and child. The mother's role is to merge with her infant, to attune to the body, to hold and fondle the baby, giving him or her a sense of entity and existence, personhood and uniqueness. The mother mirrors and reflects the child with love and acceptance through the sound of her voice and her body movement.

Where this doesn't occur, pathology replaces a positive sense of self and a trust in the environment as safe and need-satisfying. How the mother shapes her body to that of her infant is crucial in giving the infant a sense that there is an environment that can hold comfortably without smothering, sensitive to adapting to the infant's individual rhythms and flow of breath, reassuring that the infant will not fall, that this holding vessel has resilient walls and floor, that is, that the infant is supported and thus will be supported in the world.

Patients whose mothers were emotionally unavailable, abandoning or ragefully witchlike in their wish to siphon the child's sense of self, need a therapeutic holding container in which they can deposit the withholding or smothering mother and rechoreograph the needed basic trust phase of symbiosis. Since how they were held remains in the imaginal realm and manifests in both their body posturing and in their projected externalization of their undifferentiated mother onto the rest of the world, I receive much information through observing how and where my patients sit.

Such was the case upon observing one woman who elected to sit in the middle of my blue rug. She drew her knees up in a closed, shortened position, wrapped her arms around her legs, her curved depressed torso suggesting a lack of inner substance. She was holding her empty self and precariously balancing as she could not maintain a vertical position, which is developmentally at a higher level. The object-related transference message to me was that her mother had not adequately held her in the symbiotic phase (Kestenberg and Buelte 1956, 1977). She thus could not trust that I and the extensions of me in my environment, such as couches, many pillows, etc., could hold her. She had

to struggle to hold herself. Noting this, I began to converse and occasionally nod my head in a gentle maternal rocking movement identified by Kestenberg as an inner genital rhythm (Kestenberg and Buelte 1956, 1977, Kestenberg and Sossin 1979). I also widened my body position horizontally and symmetrically so as to receive her, and to mirror what minimal breathing I could detect.

It wasn't long in the work before she would come in and elect to lie down near me on a mat, surrendering to the horizontal symbiotic pull. I would sit with my arms resting in an opened position on the arms of the chair so as to receive her. Her psychic energy had redistributed itself from the childhood pattern of viewing the world as supposedly giving but really starving (her real mother) to seeing the therapy container as potentially safe and nurturing (healing mother).

Another woman came into my studio-office and sat as far away from me as she could, taking up as little space as possible. Countertransferentially, I began feeling huge and was aware that I would have to raise the volume of my voice in order to reach her, thus taking up auditory space. I formed a silent hypothesis that perhaps she had had a narcissistic mother who literally took up all the physical and expressive space in her family.

Based on this hypothesis, I attempted to heal the negative mother transference by diminishing my body shape and softening my voice, saying very little. I also began encouraging her to take up more physical and expressive space in the room. It wasn't long before her latent healthy narcissism was carving out space with her whole body while vocalizing more loudly in deeper tones.

Other patients tolerate actually rechoreographing the symbiotic holding and attunement (Kestenberg and Buelte 1956, 1977; Mahler 1968; Winnicott 1971). Some choreograph this by asking for a hug at the end of the session which can last for several minutes of attuned rocking and breathing together, while others will sit in my lap and rock for extended periods of time. Because of the fact that many individuals have only been this close to another during sexual intimacy, it is vital to be sensitive to the possibility of stimulating an erotic transference. Even with children and heterosexual patients of the same sex, confusion can enter. Early drive theorists have suggested that if one drive is combined with another, for example, if oral needs are mixed with genital (sexual) impulses, neither can be successfully satisfied (Freud 1966, Kestenberg and Sossin 1979). It is also easiest for an older heterosexual woman to hold heterosexual women or children, as the mother transference is clearer.

In any case, the myth that recreation of early developmental phases only gratifies impulses and does not serve to help individuate the patient does not hold water in my experience. If the patient isn't progressing, the therapist may need to look at personal countertransferential issues which may deliver the unconscious message to the sensitive patient that the mother-therapist does not have the needed sense of self within to encourage the patient's separation.

The rocking described during holding is crucial as it reflects the dominant body movement of this symbiotic phase. Rocking is reflective of the rhythm infants employ to suck, over which all babies need to gain control in a pure (differentiated) and localized (in the muscles of the mouth) manner. If the mother cannot attune to her child's sucking (oral) rhythm through her vocalization or body movement, she may derail or disrupt the child's intake of milk. This not only causes great frustration in the infant but also gives him or her the message that the world is not sensitive to or interested in his or her needs. This is the beginning of abuse for many who later grow up being needless and wantless. This is the phase that provides the foundation for future self-nurturing, the experience that others can nurture, as well as the self-esteem which provides a feeling of being worthy of receiving from others. Thus it becomes clear that so-called codependent behavior (behavior derived from child abuse that suggests that other persons, needs, wants, thoughts, etc., are more important than the individual's) begins forming at birth.

I watch carefully with these patients to insure that they are not mirroring me. Sometimes who's mirroring whom dissolves when the symbiotic phase is being choreographed, but their willingness to receive any and all interpretation, to engage in any task and their marvelous ability to "follow" the therapist, whether it be in a group dance therapy session or a verbal dialogue, needs to be scrutinized. Countertransferentially, when the therapist feels she or he is marvelous and doing a great job, it may be the codependent people-pleasing patient trying to heal the sense of self of the mother-therapist and repeat the early mother–child dysfunctional dance.

During this rechoreography of this early symbiotic phase, patients may want to experience the good mother with the senses of early infancy: smell, touch, taste (one patient asked to taste my hair), hearing (the tone of voice or heartbeat), as well as the kinesthetic senses. Allowing this sensory reinforcement, providing it feels nonabusive, allows, as one patient put it, "an imprint" to be fixed in the kinesthetically stimulated portion of memory.

Soft music which sounds soothing and comforting can assist in the rechoreographing of this phase. One woman, with a controlling mother, brought in her own tune which she had found herself subliminally humming for years. Its soothing maternal (inner genital) rhythm was apparent as we both hummed it in mirrored synchrony. She interrupted and reported that there was a movement that went along with it which originated in her hips and pelvic girdle. This self-nurturing rock was also reflected by me. The peaceful safety we created was interrupted by an uncomfortable feeling of being sick to my stomach. Picking up on this form of somatic countertransference, I asked her what she was feeling. She said, "I feel like I'm being smothered by my mother." I responded, "This experience is being contaminated by your internalized experience of your mother's desire to keep you merged with her." Here, her psychic energy

distribution shifted from experiencing the moment to that of the empowerment of the negative internalized mother and her childhood emotional pattern of survival, that of feeling sick to her stomach in an attempt to eject the toxicity. While I was interpreting and clarifying the somatic response, I shifted my position, moving further away from her, vertically lengthening my torso, and increasing the tension in the muscles of my body. In this way, I was countertransferentially choreographing a mother who was responding to a higher developmental stage of separation and independence. She affirmed my interpretation, and because of her high level of health and ego strength, she was able not to have to curtail her movement while I continued to contain her mother projection in a rapprochement body, thereby providing the needed boundary (Grotstein 1981). Although we did not speak of this, she responded derivatively, with much positive affirmation that I was just the right therapist for her.

Another patient dreamed that she was pregnant but couldn't tell. Her emerging child self was still undetectable by her, but nonetheless beginning. I asked her to journey inside her body to see if she could locate her child self. She discovered a growing but imprisoned infant. I pointed out that she was not fully breathing, i.e., there was no lengthening downward in her inhalation. She then became aware of how she had colluded in the imprisonment of the child self through asphyxiating her in order supposedly to protect her from her volatile devouring mother. This childhood survival pattern had continued to siphon much of her energy into so-called protection of her split-off infant self. Breathing into the gestating child self, she then gave the infant more of the energy distribution. Now she could loosen the prison by reducing the tension in her belly. But this placed her in an exceedingly vulnerable position in relation to me. She said, "Please don't move abruptly." Her mother's use of quick, jerky, sudden movements would derail or disrupt her early (oral) sucking rhythms.

Many of my patients journey into their inner physical self in which the staging and scenery is a huge black bottomless empty pit. Here the lack of proper holding from the mother is clear. And it is here that the patient recreates the drama of abandonment with me. These scripts appear in dreams in which wounded starving creature selves are ignored by them. In one such instance, I asked where the creature was imaginally in the room, went over, and picked it up to hold in my arms. It wasn't long before this patient, like many others, risked enacting her split-off unloved creature self. A monologue of gutteral sounds emerged, as this creature self was preverbal. I sat with my arms and legs resting in an open position and imagined myself as the loving mother. She moved closer to me and finally crawled into my arms to be held and rocked as she softly cried. Within a few weeks, embodying this part of her self and recreating a healthy mother–child drama, she began noticing that her

creature self began becoming more humanlike and transformed into a beautiful, round, happy baby, one that she herself could love.

Because this first stage is such an instinctually based one, some, particularly children, will suggest that I role play a mother animal with themselves as my baby.

This maternal animal symbol is present in ancient Egyptian mythology with the mother goddess Hathor. As the mother of the sun god, she was depicted as the sky cow. In her bovine form, she was to have raised the child sun god upward into the heavens cradled in her horns. Hathor and later Isis were also the goddesses of music and dance and have emerged as an archetypal guide for those therapists who understand that, in the imaginal realm, maternal holding, music, and dance are all intertwined.

Abused patients frequently struggle to claim the needed early nurturing in the symbiotic phase. The lack of an attuned holding environment was painfully clear with one man who imaginally experienced his negative engulfing internalized mother as a slime covering his entire body. She allowed him neither to receive what others had to offer nor to reach out to get what he wanted.

He sat slouching down as if totally enervated, pulling the sides of his body toward his body center. He physically closed himself off from the environment around him as if protecting himself from some unknown danger. His arms lay flacidly at his side. I encouraged him to embody his inner child self. Although he understood what I meant, he could not locate him. I then suggested I role play his slimed closed hopeless self. I exclaimed, "I can't move, I have no energy, I give up." My enacting his resistance allowed him to find the inner child. This became clear when he began to move his legs in oral rocking rhythms, discussed earlier.

After a while, I asked, "What should I do with this persona?" He responded, "Throw it in the garbage." I got up, and using dabbing gestures, brushed the imaginal slime and the resultant deathly despair off my body.

Another man who also had an abusive mother brought in a tape of soft music. This act occurred after months of therapy which focused upon ridding himself of her hostility, which he carried with him and projected onto everyone. In this hour he related, "My mother used to wake me up either by screaming or hitting me. I was riddled with nightmares and never felt safe sleeping. I want to take a nap here and have you wake me up." This man was suggesting a dramatization reflecting a healthy parent–child relationship which now could replace the abusive experiences of his boyhood. He took a blanket, lay down, and closed his eyes. I sat very still and imaged a large protective ring around him and invoked Mother Mary to enter my being for the purpose of healing this man (see figure 5.5). When the hour was nearly up, I gently called his name in a maternal, soothing tone and stroked his head and back until his eyes opened. He awoke with a smile.

Eye-to-eye contact is vital when healing this early phase. Typically, an abusive mother either abandons (never looks at) or smothers (is too close to see). An example of such a visual focus in therapy occurred with one man who, week after week, required total eye-to-eye contact while sitting cross-legged about three inches from me. The only alteration of this would be when he would begin to rock his head or torso from side to side in an oral rhythm, used by infants for the integration of the sucking reflex, which I also mirrored in attunement.

Another man was amazed that I could receive him without judgment through my eyes. He related that his mother would shame him every chance she had, pointing out other siblings and children who were better than he.

Much of my work in this phase is done through the somatic countertransference. I will frequently imagine holding the wounded or unloved infant self of the

FIGURE 5.5 **Madonna and Child**

(Source: Albrecht Dürer, woodcut, from M. and J. Arguelles, *The Feminine Spacious as the Sky*, p. 80)

individual. No mention is usually made of this, but it is known through the unconscious-to-unconscious connection.

Because this early symbiotic maternal phase is one in which no boundaries are in place for the infant as well as the patient who is struggling to receive what he or she never got, the unconscious-to-unconscious connection is a powerful one. This can allow for the somatic countertransference really to heal and rebuild a healthier holding vessel for the slowly emerging sense of self.

However, it is also clear how devastating this could be for an infant whose mother is filled with negativity and toxicity. Rageful, bitter, or envious mothers do not provide the needed holding environments (Winnicott 1971, Mahler 1968). Their holding vessel is not filled with love, good will, and an interest in attuning to the uniqueness of the infant before them. Without the required teeth to chew over and spit out the negativity, the infants must swallow whole all of what the mother unconsciously sends them. Many a codependent mother whose own mother was abusive has come to the distressing realization that even though they tried consciously to act and be different to their infants, if they had not healed their own child within, they sent their horrifying infancy from their unconscious to their infant's unconscious.

I recall a family with whom I worked who pondered why their son was so anxious and frightened when they had raised their children with love and support. Their child's anxiety attacks had come from the unconscious unresolved fear and abuse of his parents' inner children. When this adolescent realized that the fear was carried from the parent's childhood, it became more understandable why it appeared so overwhelming and out of control. Drawing it, naming it, and imaginally sending it back to the source, the grandparents, in a ritual in session overcame most of his attacks of dizziness, rapid heart beat, and hypertension.

The metaphor of a holding vessel/mother/therapist filled with nourishment and love is crucial in this early undifferentiated phase. The image of the fountain found in the alchemical text of the *Rosarium Philosophorum* (Jung 1946, par. 402–409), which sprouts forth "the milk of the virgin" and the "water of life" or poison, is a powerful example of the potential of the mother vessel who can either give life and good will or depression and darkness. Here the snake is two-headed, representing the dual nature. This *serpens mercurialis* can manifest the positive good mother or the toxic bad mother.

An example of the poisonous side of the mother came into somatic clarity with a woman who was riddled with chronic epigastric pain from early infancy. Her mother had psychologically poisoned her milk with confusing mixed messages which did not convey the needed environment for the integration of the early oral phase (Stern 1985, Kestenberg and Buelte 1956, 1977). In treatment, she realized she could no longer stomach these negative introjects from her mother and, in a series of authentic movement experiences, found herself

regurgitating the poisoned love. In this way, the transference was no longer soured and the needed recreation of a facilitating environment could occur.

Another woman complained of a heaviness in her stomach, like a congealed hard lump. It became clear that this density was composed of compressed layers of "force fed" mixed messages that her mother spewed forth upon her. The idea of imaginal regurgitation was repugnant to her, but she thought she might be able to "poop" it out or give birth to it, although she didn't know how. This woman was a sculptress, so I suggested to her that she treat the density in her stomach like a lump of clay and shape and form it in any way she needed to in order for it to be released from her and for her to have her stomach free to receive what she chose.

Often I will make a suggestion to an individual in a manner which allows them to interpret it in a number of different ways. This woman elected to embody the clay. In this way, she became both the sculptor-creator and the *prima materia* which was to be transformed.

She asked for drum music, folded her body into a closed shape, and then bounced on the rug as if to wedge the air bubbles from her personified "clay body." This repetitive, rhythmic action allowed her access to her unconscious and having it move her.

I meanwhile took my Tibetan bowl bell and placed it in front of me as a symbol of an open holding vessel. I sat vertically tailor fashion, with my arms resting on my knees, as if I were placing myself in a "holding readiness." Countertransferentially, I invoked the great goddess and imagined an eliminating-birthing process. She gradually moved herself from a horizontal position to a vertical stance. She then danced toward me and took the bowl. She said later that this was when something really transformative happened. She placed the bowl at her belly and began tapping a creative improvisational beat to the tape that was playing. She, I believe, had identified with the Mother as Creator and had been able to dispel some of the toxic layers of her negative internalized mother complex.

Groups are often just the right holding vessel, particularly if an individual feels too vulnerable and shameful initially to claim and express his or her needs alone. Sitting or standing, holding each other, and rocking allows each individual to be both the care giver and receiver—sometimes easier for codependent individuals who can only feel comfortable giving and have to receive in indirect or very structured controlled circumstances.

In groups, individuals struggling to heal this phase may either take up more than their share of time and space or, more frequently, withdraw, isolating and insulating themselves, recreating their childhood family system by projecting it onto the group. Group members may find themselves playing out the family roles, delivering messages such as "you're not important" or "you don't have needs and feelings that we would attend to." They may be totally unaware

themselves that they are repeating this childhood pattern until the group asks this individual's inner child how she or he is or could she or he come out and play.

Sometimes group members can enact the wall-like barriers which were put in place to keep the child's needs, wants, and beginning self formation from being attacked by projecting family members. These assaults were carried out through ignoring, shaming, smothering, or rage attacks designed to kill the soul of the child.

As one member enacting the isolating wall cautions the withdrawn group member, another can encourage the child self to play. Further psychodramas can begin to heal the wounds of this phase by providing a good mother, father, and/or sibling(s) that hold the member and confront the person's abusive family of origin.

Summary

An individual's consciousness, ego, and a sense of self evolve out of the undifferentiated archetypal. In the first maternal phase, mother–infant symbiosis creates an environment of trust in service to the integration of the oral drive to take in and manifest in movement as sucking (described here as the oral sucking rhythm). Here, in an attuned holding container, the infant feels filled with love and a sense of self which is both positive and unique.

Where abuse from the primary care giver has occurred, either consciously or unconsciously, an individual may grow to feel fearful, bad, or very dependent. She or he may compensate by becoming narcissistic and grandiose, or needless and wantless, projecting their wounded child self onto others and caring for them instead. A sense of powerlessness and depression may rule their lives.

Through the vessels of 1) the somatic countertransference (holding the inner infant and/or detoxifying the negative mother); 2) the patient's body (e.g., imaging the inner child or counterattacking the invasion of the negative mother); or 3) the bipersonal field between patient and therapist or group (restaging pathogenic symbiosis and transforming it through rechoreographing a healthy holding environment), an individual can establish a solid joyful foundation for further development.

Chapter 6

THE SECOND MATERNAL PHASE OF SEPARATION AND INDIVIDUATION, BOUNDARY FORMATION, AND AUTONOMY

Differentiation Subphase

Mahler (1968) describes the next phase in development as separation and individuation, beginning with the subphase of differentiation in which the infant moves from the *participation mystique* of the dual unity into a process of the me–not-me boundary. This gives the child an experience of being seen and seeing the other for the first time. Here, a body image shift from an interoceptive belly focus (Winnicott 1971) toward a sense of body periphery – a needed requirement for body-ego formation – occurs (Mahler 1968). Internal belly sensations from the symbiotic phase have now become the origin of the feeling of self around which a sense of identity gradually establishes itself.

Patients who fear sustained intimacy and who repeat themes of separating and pushing away in their interpersonal dramas did not have a mother and/or a developmental setting which allowed for them to integrate separation successfully. This warding-away dance is frequently due to a smothering or narcissistic mother or primary care giver who has no real inner sense of self and so keeps "glued" onto the emerging toddler in the hopes of siphoning off the child's developing sense of self. Figure 6.1 is a picture drawn by an analytic patient of herself and her mother clearly depicting this devastating bond. The vacant eyes point to the mother's empty self and thus inability to instill a sense of self in her daughter. The umbilicallike line connecting their eyes depicts how her mother's glare would drain any of her daughter's emerging sense of self. When this woman began her therapy, she complained of overwhelming nightmares of the earth opening up and of having no ground to place her feet. Powerful dark

archetypal voices would try to call her into psychotic devastation. She began, however, to incorporate me into her dreams, advising her not to go with the voices but to talk about it in our next hour. Because the death pull was so unconsciously powerful in her mother, who had a psychotic chaotic core (she had said her mother's home was like a Bergman movie), there was very little memory of her mother on a human personal level. Thus the dark side of the archetypal mother, for example, the devouring Kali or Rangi, dominated in her unconscious attempt to attend to this devastating relationship.

As we dried out some of the oceanic unconscious material and reduced it through interpretation, relating it to the early drama with her mother, the nightmares diminished (here the alchemical process of *sublimatio* (drying out) and *coagulatio* (solidifying) apply).

FIGURE 6.1 **Empty Self and Devouring Mother**
(Source: Private collection)

Ego and Skin Boundaries and the Personal Unconscious Buffer

With differentiation from the mother comes the formation of the inner ego boundaries as well as an awareness of one's skin boundary. Because the mother of the woman described above did not encourage this phase, her ego boundary was not as strong as it should have been. This resulted in her being flooded by the unconscious. Its power was overwhelming, at times causing an inability to wake herself from dreaming because in addition there was very little buffer of the personal unconscious present. The personal unconscious acts as a reef or jetty, if you will, to the potency of the collective. In the course of therapy with this woman, she and I worked on her development and expansion of a personal unconscious. The archetypal images of omnipotent killer mother goddesses got reduced and humanized to her personal mother, placed in the context of her own history. In doing so, there slowly developed a personal history "reef" or "buffer" in her psyche.

Lack of strong ego boundaries means that negative complexes can also enter and possess the ego such as the inner bad parent, shamer, judge, or taskmaster. An example of such a possession occurred with one woman who participated in a group designed to aid in the recovery from codependence. In the group, she complained of incessant self-esteem attacks by an inner complex—a phenomenon very familiar to the other members. She was also aware that she was an easy victim to the verbal attacks of significant others. I suggested the group enact this drama to bring this phenomenon into heightened figural awareness. The woman played her ego while another member played her inner abuser—taskmaster-judge. She watched how this complex waited for an external person to piggyback (be projected onto). She felt helpless without protective boundaries to ward off the verbal accusations.

I took on the role of her ego boundary and another member became her skin boundary. As ego boundary, I held her and confronted the shamer, saying, "She's not going to listen to your incessant attacks."

The abuser complex responded, "But if you don't listen to me, you won't get things done, people will find out you are really stupid and bad and not like you and leave you."

I, as the ego boundary, returned, "You're just saying that so she'll keep giving you over her power (psychic energy). You only care about yourself. You won't let her enjoy being with anyone anyway. Go away!"

Somewhat panicked that her real motives had been found out, the complex looked around for someone external to her victim to reinforce her case. She attached (projected) onto the husband of this woman, and the two of them started berating her.

This time the skin boundary shielded the woman and said to the husband, "Who are you kidding, your life is falling apart and you want to distract your wife from your own lacks. You just figure because she'd been abused as a kid you could just move into the role. Why you're nothing but a . . ." She turned to the woman as ego, who was beginning to sit up straighter as she began to realize what these boundaries were telling her. She finished the sentence: "a charlatan!" I encouraged her to stand. I and her other boundary now stood on either side of her facing her inner shamer and abusive husband. She never cowered again, even through a painful divorce process.

Dysfunctional Boundary Formation, Addictions, and Addictive Ruminations

The ego without sufficient boundaries can be barraged by incessant ruminations and obsessive thoughts such as found with individuals with sex or love addictions. Thousands of "what if" scenarios can fill an individual consciousness such that the ego becomes totally preoccupied and the inner child self is overwhelmed with the excitement and/or fear. These ruminations can devastate the child because they address basic foundational phenomena such as love, nurturance, being seen, valued, and/or abandoned. Without the needed boundary to aid in discriminating and filtering out what is relevant from what is dysfunctionally serving only the power-hungry complex, an individual is forever victimized. I have seen adult egos figuratively disappear into unconsciousness, resulting in the inner undeveloped child self having to handle their adult responsibilities.

I reassure the overwhelmed inner children of my patients by talking to them directly, telling them that they are not supposed to handle these situations. I then attempt to retrieve and confront the egos of these individuals.

An example of such a confrontation occurred with one man who looked at me with childlike panicked eyes. "Where are you, you have left your kid to handle this, and he's not supposed to. We can figure this out and coparent your child while we do it." He had been bloblike and numb. Now I had the feeling that he was literally moving out to his skin boundaries. His eyes came alive and he started to converse with me in rational adult language.

Differentiation: The Body and the Devouring Mother Witch

The whole area of lack of body boundary due to a mother incapable of assisting in differentiation becomes clear when looking from a body perspective. Abused codependent patients frequently feel thin-skinned. Thus, they tend to demonstrate higher levels of muscle tension like body armoring and diminish their body movements. Many have difficulty filtering out other individuals' needs. Being required to mirror their mothers, they do not have a developed sense of what their own needs are. Thus, too much psychic energy is utilized for the care and healing of others. Others' thoughts, needs, and wishes overshadow their own.

The following sand play arranged by an anorexic adolescent clearly depicts the dysfunctional mother–child relationship (figure 6.2). The mother frequently played the role of the martyred virgin who had to "suffer" her children's dysfunctional behavior as if she had nothing to do with their unsuccessful life

FIGURE 6.2 **Sand Play: Anorexic Adolescent Depicting Dysfunctional Differentiation**

(Source: Private collection)

adaptations. One after the other, she attempted to control her children in order to acquire their sense of self to fill her internal void, and one after the other, each became drug, alcohol, or sex addicted, with the last becoming addicted to perfection through anorexia. Her choice of addiction, I believe, was a poignant one in that her lack of food intake suggested that her mother's nurturance was toxic, resulting in a bodily emptiness.

Returning to the sand tray, this mother's real shadow side can be seen by the patient placing a vampire bat around her. She, in turn, selects a porcupine as her emerging instinctual self, attempting to ward off her life-sucking mother with a prickly boundary.

Another anorexic/bulimic adolescent drew a series of pictures in order to identify and isolate her emerging self and the internalized "self stealer." In figure 6.3, the inner thief in black offered her a flower in exchange for her soul/self. This dark figure is akin to the narcissistic stepmother in "Snow White and the Seven Dwarfs," who offers the ego an apple which results in her loss of consciousness. Still floating from her grounded assertion, she struggled not to give over her sense of self. She realized as well that she was afraid of getting close to anyone for fear they would rob her of her identity. This understanding resulted in her awareness that her heart and eros relatedness were hiding to protect themselves. But a closer imaginal journey inside her body drew her to

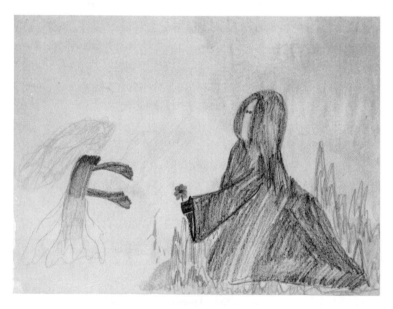

FIGURE 6.3 **Self Stealer**

(Source: Private collection)

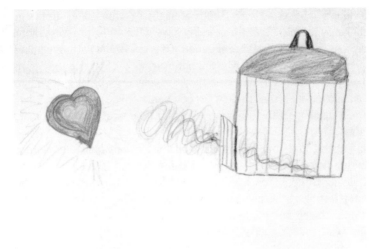

FIGURE 6.4 **Self Freed from Cage**
(Source: Private collection)

the real image of where her heart was: the protective shield boundary had become a prison. The soul/self stealer would encourage her to stay in the cage, "Don't trust anyone, just stay with me." Now the complex began to sound like the witch from "Rapunzel." Finally this girl fought back and freed her heart from the cage. Figure 6.4 depicts her release as she said to the self-stealing witch, "No, I want to be out!" Shortly after making this drawing, she entered into a lengthy relationship.

Differentiation: Biting and Chewing

The establishment of boundaries and the resultant separation is assisted physiologically when the infant teethes and develops the capacity to bite and chew. This new evolution means that the baby no longer has to swallow everything whole, it can discriminate, break down material to its finer elements, take in what is nourishing and spit out what it finds disagreeable. I can remember how pleased and fascinated I was that my nine-month-old daughter was able to sort through the mixed vegetables in her mouth and spit out the lima beans! I would pick her up from her nap and she would pat/tap my back in the same rhythm she employed teething. I would respond by patting her back. This served to stimulate the skin boundary and reinforce that we were two separate entities.

Individuals who grind their teeth at night or who suffer from temporal mandibular syndrome (TMS) frequently have difficulty expressing themselves verbally and dysfunctional differentiation. Overuse of the patting/tapping biting rhythm can be seen in others who fear intimacy either because they transfer an emeshed parent into the other or they are concerned that the neediness of their abandoned inner child might be detected. These are people who, when embraced, quickly pat the other person's back to indicate an initiation of a swift separation.

One patient, in recovery from an abandoning, nonstimulating mother and a smothering mate, dreamed she was loosing her teeth. The dentist replaced them, saying to her, "You have to stop doing that to yourself," meaning she must stop letting go of this early form of aggression in service to differentiation. I encouraged her to show her teeth. I did the same. We then began to playfully snarl and snap at each other like large felines.

Differentiation: Spacial Distancing and Body Postural Shaping

Besides themes of loosing one's teeth and the decrease or overuse of these biting movements, other indicators of the lack of body boundaries can be detected in the patient's distance in the room. Because I have a large office in which the distance between the patient and myself can be choreographed by the patient, relational spacing can become part of the therapeutic process. Where the patient requires more boundaries, I will tense my muscles and speak and gesticulate in a sharply punctuated biting rhythm. One woman told me to go into the smaller sand-play room next to my large office. She closed the door and danced freely. Then she called me back to dance with her. Another patient spatially distanced me before she began regressing. In this place, neither her skin nor her muscles provided adequate boundaries. Her movements were fragmented. She asked me to move closer and touch her. I patted her back using the biting rhythm. In the following session, she used the same patting/tapping movements in her legs and shoulder girdle. Once again she asked me to touch her, and once again I patted her back in an attempt to connect the rhythmic expression. This time she responded by moving toward my hand when I touched her and moving away when I removed my hand. Sharing this tempo together, moving toward and away from each other, simultaneously, we achieved a heightened synchrony together (Kestenberg and Buelte 1956, 1977; Kestenburg and Sossin 1979). Now she was able to stand and fling pillows at me, the same quality of movement which helps integrate differentiation and separation from the object.

The struggle to separate and therefore have the potential for intimacy was

choreographed by a couple I saw in treatment. The husband lay on the floor like a beached whale. The wife sat upright like a brick wall. Every time he moved to approach, she increased the tension in her muscles. He sought confluence, she difference. She had projected her borderline mother onto him and was doing everything in her power to encourage separation from her spouse. Her favorite tack was to seduce sexually any friend he would make and report her conquests. He, meanwhile, would try to "understand," for he had split off his aggression due to an early childhood trauma.

With some level of reluctance, he agreed to stand and engage in a vertical expression of oral aggression with his wife. She screams, "wimp!" while he struggles to find the counter-retort of "bitch!"

In the next session, she explored putting her merging mother into me: she brought in a list of what was wrong about the former session. With some patients, I would have received these complaints with much empathetic reflection. What she needed, however, was a differentiating response emphasizing my capacity not to wimp out in a boundaryless desire for confluence. I acknowledged that it was important to end the session on time, not three minutes late, thereby reinforcing the appropriateness of boundaries, but regarding my interventions, I responded that if she did not like my therapeutic style, I could refer her elsewhere. She seemed pleased with my response and never requested the referral.

Ever so slowly, she began to reinternalize her smothering mother, while her husband understood that his intellectualization not only split him from his feelings but from receiving hers as well.

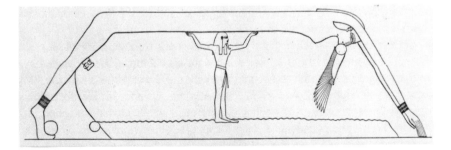

FIGURE 6.5 **Nut Being Separated from Geb by Her Father, Shu**

(Source: Line drawing from Egyptian ceiling, New Kingdom, Dynasty XIX, reign of Seti I, from S. Giedion, *The Beginnings of Architecture* (Princeton, N.J.: Princeton University Press, 1964), pp. 131–133. Reprinted by permission.)

Metaphorically, Erich Neumann (1973), a Jungian developmental theorist, relates the following regarding this phase: "Space only came into being when, as the Egyptian myth puts it, the god of the air, Shu, parted the sky (Nut) from the earth (Geb) by stepping between them. Only then as a result of his light-creating and space-creating intervention was the heaven above and earth below, back and front, left and right—in other words, only then was space organized with reference to an ego" (1954, p. 106–107) (see figure 6.5).

These emergent concepts are relevant. First, on a body level, to understand laterality and dimensionality, to gain ego comprehension of the flow of shape of the torso in breathing, provides the basis for a relationship to the general environment. When the breath supports the movement of body parts succeeded by movement through space, internalized self and object representation form the basis for relating to the world with greater specificity. Thus, the foundation for these growing neuromuscular developments is a realistic body image which is transmitted through the bodily relationship with the mother.

Once an experience of initial separation begins, the drama between mother and child can be choreographed and enacted. Likewise, when spatial relations are confused in art, we know that serious pathology reflecting early childhood trauma may be present.

A man had been engaged in individual depth work and couples therapy with me. He had initially complained of a growing passivity in his work and rage toward his wife. Lying down on the studio floor, he drew his attention into his body. He became aware of a growing inability to breathe and imagined a huge amorphic toxic creature filling his lungs and suffocating him. It then entered his consciousness, and he found himself growing tired and dizzy. Through the unconscious-to-unconscious connection of the somatic countertransference, I, too, found myself becoming more and more disoriented. My thoughts began to fragment. Both of us were clearly being possessed by the very complex that had overpowered him in his life.

In the next hour, I allowed the complex to speak through me while my ego listened and gained more of an appreciation for his dilemma: "Be passive, leave your wife, get fired, come home, and live with me. I will take care of you." My patient's torso slumps downward in a lifeless state, save for his jaw protruding. I/the complex continues, "All you have to promise is that you have no important relationships with anyone: no friends or lovers, and no enjoyment from anything you do . . . and of course one small operation: I want you to give me your manhood . . . just hand it over." He nods his head in affirmation and responds, "God, that's it. That's what it feels like!"

I don't believe it was a surprise to either of us when, through exploration of his childhood, we discovered the origin of this complex to be an anxious, unfulfilled, smothering mother—now internalized.

Week after week, both he and I engaged ourselves in the bipersonal imaginal

realm. In this liminal realm, his breathing changed; his body tensed and occasionally writhed, for inside him was this creature who was glued onto him parasitically. First I encouraged him to breathe and imaginally expel the creature from him while I joined him by imaging his battle. His movements became like waves of regurgitation as he exuded her from his chest. Slowly, within his freed thoracic space, he began to visualize his inner child (Lewis Bernstein 1980).

As it formed and grew, he imagined that his head had become skull-like with glaring red eyes. I encouraged him to enact his inner split-off angry child self and reflected clawing motions on the rug. This primary expression of aggression became localized in his jaw, and he related a desire to eat, bite, and chew. He then asked me to come closer and put my hand up for him to press away from and experience object-related differentiation. He then needed me to touch simultaneously and physically his chest and back. I reflected that he needed to feel his dimensions and depth and know his own material boundaries. This hour had a significant effect on his capacity to be loving and intimate with his wife. Since he had had a new object-related experience within the imaginal realm to counteract the negative mother, he was not compelled to project it onto his present intimate relationship with a woman.

Over the course of months, he allowed himself to embody his child self. "I want to be loved, I want to feel." Pillows representing his poisonous invasive mother complex were placed around him which served as a prop-symbol of how his mother contaminates every relationship he could have. I sat on the other side of the pillows. If I would reach my arm across, it would get contaminated by the mother and appear to be her appendage seeking to demand from him devouring symbiosis. He felt helpless ever to receive love and relationship from anyone. I, meanwhile, opened myself to the archetype of the all-loving mother who could love without smothering and help her child separate without feeling abandoned.

He then began having running dialogues with his mother complex: "You want me to believe that Penny is you, but she's not. Stay out of this relationship!" Finally he pushed himself out of the pillows with the intensity of a woman's labor contractions. I became a midwife as he reached for me to help pull him out. Finally he was freed and a tearful glow came over his face. After fourteen months of work, he had achieved separation—the same length of time taken in normal development. He said playfully at the end of this hour, "How do you spell relief? N-O M-O-M."

Separating Inward: Isolation and Insulation

Some individuals adapt to abusive primary care given during this phase by disappearing inside themselves. Instead of feeling safe to live in their skin boundaries, they retreat into their bodies and hide so that the ego can't find the self and frequently forgets that it exists. This insulation isolates these people not only from the world outside but inside as well. Feelings, wants, and needs are unknown to them. They live locked up in a huge impenetrable castle in quiet desperation that even they have difficulty sensing within themselves.

Most begin this survival pattern in childhood, many learn it from their primary care givers. This familial learning seemed apparent with one child who engaged in a kinetic family drawing ("draw a picture of your family doing something"). She drew a schema of a house with each family member in a separate room doing something alone.

These people are frequently readers, spending hours in someone else's fantasy. Often this isolation is associated with parents who have an intense need to control everyone's thoughts and feelings. Explicit messages are given as to what could be conversed about and what was taboo. These codependent individuals frequently have difficulty remembering their childhood. They will describe years of their adult life disappearing without meaning. Others are addicted to food as a means to add physical layers to hide their vulnerability or to "stuff down feelings" as one woman described it. When asked to draw her inner self, a food-addicted woman scribbled a black smudge on the paper surrounded by a "sea of darkness."

Another woman described a numbness to the world and lying in authentic movement imaged her body sheathed in a death shroud. This death shroud had attacked her capacity to link with her needs and get what she wanted in the world. She had all but given up in hopeless despair. She recalled a childhood fairy tale in which a woman's task was to walk around the world in ironclad boots. She felt that her capacity to go forward in her life was curtailed by such an intense heaviness. She gained a deeper awareness of the shroud when I personified it, making it clear that the shroud was not protecting her, but rather imprisoning her. Subsequently she drew and then related the following active imagination: "I am in bed in the morning. There is a knot in my stomach. I have no energy, the shroud is around me, and the ironclad boots are on my feet. Then the rain from the heavens comes and washes the shroud away from my body and rusts the iron boots off. I arise from my bed and walk to the sunlight at my window. The sunlight enters me and releases the knot."

This powerful symbol of the falling dew connects this woman to the archetypal alchemical process of *mundificatio* or purification depicted in the *Rosarium Philosophorum* as a figure lying in an open casket. The translated Latin on the picture reads, "Here falls the heavenly dew, to the soiled black body in the

FIGURE 6.6 **Aurora Consurgens, "Battle of Sun and Moon"**
(Alchemical Sol and Luna: *Separatio*)

(Source: 14th-century manuscript,
Zentralbibliothek Zürich, Ms. Rh. 172 f. 10
verso. Reprinted by permission.)

grave." Jung (1946) writes, "The falling dew signals resuscitation and a new light: the ever deeper descent into the unconscious suddenly becomes illumination from above" (par. 493).

Separatio *in Alchemy*

In the alchemical process as well, a separation or *separatio* was required in order to separate often opposing chemical elements. In this 14th-century depiction, Sol, the sun-headed man, is doing battle with Luna. "This motivation struggle of opposing forces is the necessary drama for the transfiguration and elevation of the corporeal substance of the alchemist into a better substance, the substance of the soul" (ARAS 5FO.058, p. 1) (see figure 6.6).

Allowing opposites to be embodied and enacted in movement or drama therapy work provides the patient with an experience of separation and perspective, as well as relationship to polarities. After the initial battle, whether it be between the good self and the bad self, or the ego and animus/anima, a new

union, or *coniunctio* as alchemists name it, can take place. From this, a transcendent androgynous birth or alchemical hermaphrodite can emerge.

An example of this dynamic process occurred with one woman who lay on the therapy floor, arms outstretched in agony from a negative mother complex. One pole was intimacy, which felt like engulfment and death by smothering; the other pole was being alone, which felt like abandonment and death by falling into a dark, bottomless pit. Her body was held in tortuous anxiety, I encouraged her to stay with it. She stopped breathing and then a transcendent image emerged: she sobbed deeply and reached for the image of her father who could serve in the needed differentiation process.

Practicing and Rapprochement Subphases

Practicing and rapprochement are the final subphases in separation and individuation. The practicing subphase is characterized by active locomotion. The toddler crawls and eventually walks away from mother, and then checks back to ensure mother's presence and love. Here, artistic and spatial distance is the dramatic mode of practicing actual separation from the object. Through this constructive use of aggression, the infant develops a separate sense of self.

Having patients choreograph spatial placement gives them the freedom to approach and distance from the therapist. In this way, this drama can be reexperienced with a good care giver that can respond to and confirm what Kohut refers to as their "innate sense of vigor, greatness and perfection" (Kohut and Wolf 1978, p. 414).

Use of finger paints and other flowing art media, as well as a sand-play box for wet sand, can stimulate a re-creation of this early phase. Themes of holding on and letting go and smearing in the presence of the affirming therapist give the patient permission to explore "messy" feelings. In this way, the patient's sense of self-worth through freedom of expression and product formation can develop.

An example of an individual's exploration of this phase could perhaps be seen with one woman patient, who rarely spoke the first year of treatment. Well into the treatment, she had gained enough trust with me to trash my room by throwing pillows everywhere. She then took a container filled with plastic baby spiders, dumped them in the sand, and rapidly mixed them. She was delighted when I told her it took some time for me to locate and pick each spider out!

Rapprochement, beginning around eighteen months, is the third subphase. It has been called by some the "terrible twos." Assertive straining and releasing

movements used in bowel control need to predominate here, as autonomy from the object is expressed through the capacity to hold and retain for the purpose of eventual expulsion in service to production, power, and independence. Here, dramatic themes of power and control, autonomy, external boundary formation, and self-presentation dominate the parent–child relationship and need to be encouraged. Art media such as clay, play dough, and papier maché can facilitate a patient's impulse control in the presence of the therapist. In dyadic drawing with the therapist, assertive jagged red lines can come up against the doodles of the therapist. In an expressive arts therapy group that was going through this phase of counterdependence, an art panel was suggested in which I participated. Warm colors were selected and put on the paper with pressure. I was angrily confronted by one of the group members for using blue. Words such as *claiming, emphasis, power,* and *energy explosion* were used along with many "no's!" blaring in reds, oranges, and blacks.

Secondary narcissistic formations, serving the need to maintain mother as providing the environment for growth gradually split the self and object into good and bad parts (i.e., good self and bad self, good object and bad object). They are finally reintegrated and internalized to provide a realistic sense of self and a supportive inner mother.

Adam and Eve's expulsion from the uroboric paradise of the mother realm by the angry god Yahweh is the Judeo-Christian creation myth that demonstrates this phase. Now, with slowly emerging ego consciousness, they are sent, as the Bible says, "to till the soil." In terms of object relations, this is a movement from all needs being provided for by the undifferentiated mother/ father into autonomy and industry. They will both now experience suffering and hardship, but they will also know their own capacity to give birth and produce. Thus, they have internalized some of the God within.

This boundary line between paradise and independence is a struggle so many codependent and borderline patients face. One woman patient says to me, "Being with my mother is like I'm in a huge bowl of ice cream. It's so good, but I can't climb out." To be expelled means that she will have to taste the fruit of the knowledge of good and evil and dramatically claim her own rage at not being allowed to separate and at her mother's evil destructive side that keeps her forever feeling helpless on her own without the all-powerful parent.

Another patient alternated between being held by me and spatially distancing herself. We ended the session by dancing together using our whole bodies in strong karate-like movements.

Phase Related Addictions

The pull to dependence and passivity and the fight for a sense of self and autonomy is the eternal battle of the codependent. Addictions such as food, alcohol, drugs, and gambling draw the individual back to infantlike states. One man allowed his addiction to be personified by me. I said to him, "Oh come with me, you won't have to think or work. I will take care of you in the paradise of oblivion. You can be passive, I'll do it all. All I ask is for a few things. You won't need them. I'm very jealous, you can't have a relationship with anyone else but me—no family and no work life, of course, but you don't want that anyway. Just give me over your sense of self; oh yes, and I want your soul—fork it over now!" I reached out my hand in a persistent manner.

The man got up and paced. One side of the room represented the pull to the addiction, the other a developmental step to health. It took him several weeks to make the decision and confront his own Mephistopheles.

Individuals will frequently confuse their addiction, whether it be love, sex, buying, money, power, or perfection, with the good mother that they need to move toward for refueling. Thus it becomes vital to clarify to the patients that their addictions are not really caring for them but are more like vampire complexes which parasitically want to siphon their psychic energy for themselves.

Split Self

Split self difficulty can be exacerbated when aspects of the self get split off and tossed into the oceanic unconscious. In some families, it becomes very clear that certain thoughts and feelings are unacceptable. This may even be sexually determined, for example, men can get angry, be self-centered and competitive, serving differentiation and boundaries, but they are not allowed to cry or be fearful or care too much about the next guy. Women, on the other hand, have been encouraged to hold the more tender feelings of love, compassion, sadness, pain, and fear; they have been reinforced as care givers, and competition, power, self-assertion, and anger have been discouraged and labeled as bad or "unfeminine behavior" (Surrey 1985, Miller 1984). Consequently, men have a great deal of stored-up love, sadness, and fear which frequently get projected onto and into the significant woman or a more "feminine" or anima-possessed male. They will then admonish the other for being too soft or hysterical. By the same token, some women project their anger, desire for self-serving separation, and competitive hostility onto a male or an animus-possessed woman and then feel abandoned and abused.

Reclaiming these splits becomes vital in experiencing a whole sense of self. In some families, all feelings, needs, and wants are split off and unacceptable,

producing needless and wantless individuals who are intellectual workaholics or who project their needs and wants onto others and then become supreme care givers and people pleasers. In others, sexuality is split off and repressed or given over to the incestor or molestor, producing in later life body blocks to sexual feelings in some cases and, in others, sex addictions in which the unintegrated sexual self compellingly goes after as many liaisons as possible to try to fill the void inside. One woman said of her addiction, "This vamp gets the men in bed then leaves, and my inner child wakes up with a stranger and panics."

Another woman descended down into her unconscious to reclaim her split-off self which was crucial in her beginning capacity for boundary formation. Her "beasty," as she called it, insisted on integration via biting and chewing (see figure 6.7). The following poem is her "Ode to my beasty."

> *Oh beasty*
> *What a familiar friend*
> *So easy to feel the glint in my eye*
> *Your glint shining through me.*
> *My teeth look for something to bite.*
> *Your smile comes over my mouth.*
> *You tell me what do I need of the land of the living*
> *They don't want you*
> *You never belonged with them anyway*
> *Come stay with me*
> *Well beasty, no question I am here for a long visit*
> *But I can't see me staying here for my life*
> *I'm here for the duration however*
> *The eator or the eaten*
> *It's all the same down here*
> *It's so dark no one can tell anyway*
> *All one slime you and I*
>
> *Now I and I*
> *The Eator and the Eaten*
> *I consume my own flesh*
> *Only to be devoured again*
> *Like a never ending torture*
> *My own personal hell*
> *With my very own beasty*

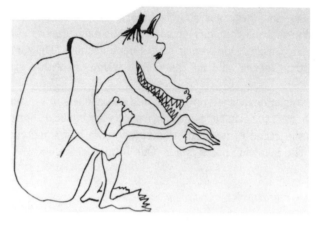

FIGURE 6.7 **Toothy Split-Off Beasty Self**
(Source: Private collection)

Yet another woman seeks through dream exploration to claim a split-off part of herself. Her dream was of a tunnel that must be gone through, filled with the decaying stench of bodies and human excretion—all the split-off aspects of her own instinctual feminine nature and anal assertion kept hidden from a narcissistic mother. A dog with its abdominal viscera cut open lay at the threshold.

She was unwilling to relate to the dog. I got up and put the entrails back into the dog that lay in between us in the transitional space. I wrapped him in a shroud and asked her to come look upon him. She came over and began to cry, "He's still alive, I can feel his suffering. I've always lived in a kind of glass bubble to keep me from feeling, and now I feel like I've just stepped out."

As she walked into the cave and lay down, she was aware that the stench was gone, along with the bodies. Now she described green moss. "It is dark and damp in here . . . and sacred . . . not like church, but sacred." I respond, "Yes, this is not the sky realm of the Father, but the womb of the Great Mother." She lay down for a long-needed gestation.

Themes of fullness and emptiness frequently emerge in expressive arts in which the split-off self is composed of the individual's vulnerable aspects of the early needy infant self. These themes can be explored initially through attending to inner belly sensations and feelings. This inner attending often produces

images of a wounded, deformed, or emaciated creature self, which may then be embodied or depicted.

An example of such an emaciated depiction is shown in a man's sculpture of his split-off, empty self. The emaciated figure with his head upon his knees is curled up in a prisonlike barred cell. He would want to bring me gifts of dreams in order to fill his projected empty belly. Meanwhile, this patient would flatten me and put me in what he called a compartment so as not to feel my genuine care for him. To receive this would constellate his negative mother whose love was contaminated with guilt. My reflecting his split-off, empty self within the somatic countertransferential vessel enabled him to connect with his deep sadness. After this experience, he moved toward me for a hug. He then remarked that he felt my heart beat. I responded, "Yes, now you can know for sure that I have substance and am not empty; and that I have a heart that can care without enveloping or depotentiating." He reflected silently for a moment, then smiled knowingly and nodded (see figure 6.8).

Often the split-off, vulnerable, fallible human is hidden behind tense, wall-like muscles or body armor for protection from cold, unavailable, primary care givers. Such was the case with one woman who constantly tensed many of the

FIGURE 6.8 **Split-Off, Caged, Empty Self**
(Source: Private collection)

muscles in her body. She complained of muscular pains and an inability to express herself. She was ruled over obsessively by her compulsive addiction to perfection. The only body part which moved were her feet, the furthest from her head and control. Her feet moved constantly in a straining and releasing pattern. She would contract and tense her calf and foot muscles, hold this tight foot flexion, and then release and relax, only to repeat the same movement sequence. I encouraged her to allow the movement in her feet to involve her calves, legs, torso, etc., progressively. This movement continued toward her torso where her feelings were stored, the straining rhythms gradually changed to rocking, self-nurturing, soothing movements. She then responded, "I knocked my aunt over once trying to hug her. No one in my family knows about affection or how to hug." This split-off needy infant self could then be mirrored and attended to by me reflecting her rhythm in synchrony.

Some individuals are encouraged to split off the human, fallible, imperfect self by a mother who wants to bask in and devour her child's perfection and greatness. An infant's sense of omnipotence is normal and encouraged in the symbiotic phase but needs to be relativized by the primary care giver in later stages of separation and individuation. When this does not occur, an individual can develop a narcissistic character (Schwartz-Salant 1982). These are individuals, more frequently males, who take up a great deal of space and time. They literally require more space to move around in and fill the air with their stories of greatness or their rage at how someone imperfectly mirrored them. Their key issues vary but usually have to do with money, power, status, and/or beauty. Other individuals around them feel squished and flattened. Their energy is monstrous. Two such narcissistic characters together will always result in an eventual clash to the death or dethronement of one or the other.

In Greek mythology, Narcissus, for whom the diagnostic category was named, rejected the love of both men and women. One of his spurned pursuers invoked a curse upon him: "May Narcissus love one day, so himself, and not win over the creature whom he loves." And so it came to pass that he gazed in a calm pool one day and fell in love with his own image, thinking, in Ovid's words, that he "found substance / in what was only a shadow." A victim of the Great Mother, he was stuck in the phase of mirroring so demanded by narcissistically wounded individuals. They seek neither the real substance of the other nor can they experience their own substance, as a realistic sense of self was never internalized.

These individuals are less apt to stay in treatment unless they receive perfect mirroring (Kohut 1977). Some become the heads of organizations so that they may be seen, attended to, and wield power. The acting world is filled with these wounded, thankless individuals who have no capacity for intimacy. They use people and then drop them when they have no more need for them. They cannot mourn loss because they never experienced a mutual relationship.

They have a sociopathic core and have no real defined sexual preference as they have not developed beyond the bisexual symbiotic phase.

Demanding perfect attunement, they are not the easiest clients to work with, as it is difficult for them to let you experience their starving, split-off, wounded selves whom all their self-referencing never feeds. My own struggle with perfectly reflecting was brought home to me by one woman who was enraged at early improper mirroring. In one session she complained, "I thought this was dance therapy; why haven't I moved?" I responded, "This is your hour; would you like to move?" She came in the following week, after having moved the week prior: "I don't like that you make me move; I want to talk!"

Verticality, Calcinatio *and Self-Assertion*

More often what is split off is the angry and assertive toddler self. One woman, for example, complained of tension in her legs. Without the use of one's legs, it is impossible to take a stand, to assert oneself in verticality, and eventually to move forward to get what one needs.

I encouraged this woman to stand. She realized that she could not express her anger in her family, "put her foot down," because of an out-of-control, alcoholic, abusive father. Now, as an adult, she was able to image the pillow on the floor as the abusive side of her father. She stomped on it and kicked it/him away, saying, "I don't need to hide my power any more; you're out of my life now!"

Another woman stood in my office with her legs spread. She had selected a red cape and, with some level of caution, began to claim her split-off aggressive self which had not been permitted to manifest in her childhood home. From deep in her core came a growl. She hovered over the space, her eyes wide and teeth bared. Now she could say "no" to all those around her that she had mirrored to the exclusion of her own needs like she had for her mother. Because she had risked this rapprochement stance, she subsequently felt lost in an abandonment panic (Masterson 1976). In succeeding sessions, she described feeling queasy and expressed a fantasy that she was dissolving into a whirlpool. In this imaginal realm, she heard her inner negative mother try to pull her back rather than encourage her by saying, "Stay here, this is all there is, you will die if you leave."

Finally, in one session, she lengthened her torso and raised her arms and with a downward moving, full-bodied karate-like slash, she imaginally sliced her mother in two. She then imaged flowers emerging from her blood. Now she had a maternal image of creative flowering with which to identify. Sessions later she squatted vertically in front of a pillow, punching with breath support. Out of her came, "I'm not going away anymore! All of me is here! I'm all together!"

This powerful joining of the split self resulted in her feeling a rich capacity to be fully in the moment. During this analysis, she lost twenty-five pounds as she found no need for body fat as a buffer nor had she desire to substitute fattening foods to fill an empty self.

Alchemically this is the process of the heating up or burning of elements called *calcinatio*. It can be viewed as an experience of drying up portions of the oceanic unconscious thus augmenting more "land" mass to the ego through steamy condensation. The fire may be purifying, such as in the symbol of purgatory in which baser attitudes are burned off prior to rebirth through resurrection. Frequently, however, such as with the claiming of the split-off angry self, this fire is associated with the emergence of aggressive assertion. It is decidedly felt as an embodied "No more!" to old patterns of victimization and boundarylessness.

An example of the claiming of this assertive "no more" capacity evolved in an improvisational dance of a woman. She asked me to join her. Through rhythmic body action, we invoked the archetypal feminine. In the process, both she and I began to menstruate—considered by some societies to be the most powerful time for women and associated with the experience of *calcinatio* (Edinger 1978, 1980, 1981).

Another woman who reported that when she gestured or danced in her mother's presence, her merging mother would imitate her movements, brought in many angry dreams of saying "no" to her. Gradually she diminished the actual phone calls and visits, and in many ways told her mother to mind her own business. With real strength of character, she suffered through an abandonment depression, feeling as if she had been ejected into outer space and was drifting alone in an endless emptiness. She dreamed finally, "I am in a desert at the bottom of a huge pit. I see emerging at the bottom a growing red root." I suggested she take this root into her body. She was seated, and I encouraged her to stand, i.e., to claim verticality. She moved into the center of my office and squatted down. Straining in a grounded assertive movement, she drew the root upward with both hands, rising as she moved the root through her pelvis, solar plexus, heart, chest, and head, raising her arms upward and outward. From this session, she knew to repeat this full-bodied action, adaptively, every time she felt a loss of sense of self. She reported doing this vertical self-claiming movement prior to seeing her mother and at times of stress with her family. She found that both her mother's and husband's attitudes toward her changed significantly. Before, she reported feeling infantilized by both of them, and now she felt that she could present her ideas and control her own life. With the aid of this newfound verticality, with its developmentally based movement, her psychic energy had shifted from a negative to a positive self-view.

The body as vessel for the *calcinatio* experience is a frequent manifestation

of this process. Patients complain of heartburn and acid indigestion (an acknowledgment that there was something swallowed that has sat undigested and blocked in their belly). One patient came in with a body rash in her second hour and reported a dream in which she burned down her childhood house. She had suffered horrible physical abuse from her father and was finding herself, not too surprisingly, in abusive relationships with men.

Another woman reported, after an authentic movement experience, "I went down into a dark place. There was an alter with niches; and in every niche was

FIGURE 6.9 *Calcinatio:* **Self-Portrait**
(Source: Private collection)

every experience that has haunted and shamed me. I exhale and fire comes out of my mouth and they are burned and become inconsequential."

Frequently, individuals will employ the color red. It will appear in paintings, dreams, their clothing, and in their choice of costumes or props. The wearing of red is like the creation of an outer *temenos* or alchemical vessel within which the fire can brew or express itself (see figure 6.9).

Patients also need to know that *calcinatio* can be akin to Moses and the burning bush, i.e., the experience of a fire that doesn't consume. Many patients fear that if they ever let their anger out, it will consume the ego and/or externally do damage. In these cases, the therapy vessel, whether it be the transference or the group, can assist through providing a safe container.

Such a fear of the expression of anger was expressed by one man who was told in so many ways that this feeling toward his parents was unacceptable. In authentic movement, he came up with an image of a rageful rhino. He expressed concern that his rage might be hurtful to people, so I suggested a structure in which group members held him so that he could have full expression of his anger and not fear that he would hurt himself or anyone else. Loud gutteral roars were emitted by him and the group members who were holding him. Slowly, as his energy diminished, group members would move away. Finally, one man was left with whom he wrestled, and then, in exhaustion, embraced. Afterwards, fearing abandonment, he said that he felt lonely. I requested that group members gather around him. He asked if anyone else had a rhino within. He quickly received powerfully lively reassurances from fellow members.

Split Object

The primary care giver is also split into good and bad object. Abusive dysfunctional mothers want their children forever under their control so that they can siphon the child's sense of self, reward the child's regressive pull to symbiosis and punish, typically through withholding, when the child moves toward separation and independence.

Such was the case with one borderline mother who hovered over her anorexic daughter in a family therapy session. As long as her daughter was the identified patient, she thought no one would see how ragefully needy and controlling she was. The father sat isolated and in a closed position, having an unspoken contract with the mother: "I won't help our daughter separate from her merger with you if you don't bring up how unavailable I am to meet your endless needs."

I watched how the child mirrored and blended her thin lithe body into her mother's, begging her to let her separate and take dance classes in a large

tones, warmth, and love. She neither infantilizes nor expect muc he
knows just what her son or daughter can explore and ac lish ar an
protect them if need be.

 All too often this is far from the case. Fairy tales depic e of the c
realities. A witch mother may want to smother the chil eping the d
debilitated and infantile, as in "Rapunzel." She may deman t only part o
self be allowed to come out into the light of consciousnes le the other "
parts must remain in shadow, submerged in the ocea nconscious, a
"Cinderella." Or she may inflate the child self to a grand tate of narciss
to feed off the child's accomplishments, as in "Hans Gretel." One r
reported the following recurrent childhood nightmare coming downsta
to my kitchen. My mother has the oven on and the open. She is going
put me in."

 With generations upon generations of dysfunc l abusive families, mo
and more children grow up with shame cores a equently perpetuate th
dysfunctional relationships of their childhood by rying other codependen
individuals. This results in progressively more nctional families incapabl
of providing healthy object relations.

 A shamed or guilty parent will instill their s and guilt in their child, who
in turn will, whether they want to or not, cr shame-based child (Melody
and Miller 1989).

 What many individuals end up with is lo steem or they compensator-
ily create grandiose false self "better th sonae. They will be without
healthy boundaries, either too open or w They will cling dependently to
others or pretend they need no one. T have too much feeling or too
little. Males have been usually encour assume the latter adaptations,
while females often align with the f blitting among gender, making
heterosexual intimacy quadruply dif er 1984). Thus, earlier recon-
structive work is vital, requiring th ography of the first two stages
even where the issues appear to b o higher phases of development,
such as issues of identity, intimac k.

 If, however, a toddler has eno ndation in these earlier phases, the
world will open up its wonder t rain, assimilating everything in the
surround like a vacuum. An ex e experience of this liquid (urethral)
phase could be found with one o reflected, "Boy, this feels different,
I feel like I'm floating around : as scary as before when I felt that
bottomless hole. I don't feel e. I feel okay. I just like hanging out—
being in the pool with my th Occasionally I find myself doing things
that I never did before, I o future plans" (beginning presence of
Erikson's phase of initiati of libidinal rhythms, which dominate in
this phase, was clear in nich sounded as if she was slowly, softly
pouring her words into pace, giving both of us a sense of timeli-

ness. I put on some new age music and she floated into free association. The role of the mother/therapist is to ensure extended boundaries, to collect the patient if they drift too far off, and to help them enjoy this liquid sense of being.

Once individuals feel their sense of self, they may then receive from their own unconscious, through dreams, free associational play, authentic movement, and other expressive arts, connections to where to place their productivity and operational drive. The therapist's role is to sit in centered stillness and help create the time and space for the newly formed sense of self in the patient to decide what he or she wants to do. This three-year-old liquid (urethral) indulgence allows for the suspension of boundaries to ponder all the possibilities in service to eventual initiative in the next phase of pleasure in doing and also supports further development at age four in service to the identification with the mother as creative.

It is not always so easy, however, to separate from a devouring mother who's message was that if you leave, great harm or even death will come to you.

These individuals, frequently identified as borderline or codependent, suffer through what has come to be known as an abandonment panic. Their experience of floating endlessly that others describe so pleasantly feels deeply fearful. One individual described it as being ejected into outer space, alone, without any hope of finding terra firma. Here the therapist as whole object may need to coparent the emergent child self in the patient. As whole object, the therapist confronts the individual's fears of emptiness and any acting-out behavior. Frequently the rapprochement phase is rechoreographed by the patient, reaffirming their capacity for independence and wholeness. At times, the therapist may need to move forward in the sagittal plane to catch and provide limits to the drifting patient, helping him or her make the transition to a capacity to start and stop the flow of self and self-expression, thereby discovering self-motivation.

The abandonment depression, which comes when the patient can leave the wish for union with the abandoning mother and risk the guilt and maternal rage with the smothering mother, is a significant step toward growth and requires a major shift in psychic energy distribution from old childhood survival patterns. With many, a real struggle ensues, an example of which could be found with a woman who kicked and punched my mat, turning her head from side to side in a toddler tantrum, yelling, "I don't want to take care of myself! I want to be taken care of!" Sessions later, she brought in a picture of a dream in which all her female ancestors encourage her. She depicted herself a fully functioning professional tapping her foot impatiently (in a urethral sadistic rhythm). Her unconscious had provided her with an image of herself capable of acting with initiative.

The capacity to locate and care for one's inner child self is crucial in this phase. I frequently ask my patients to go inside their body and find their inner

child self. The age of the inner child will often tell when the child was abused and thus needed to go into hiding. Some individuals find tiny creaturelike selves or little ones that feel so shamed that they are sure they are not lovable, touchable, and should never show themselves in the light of day. But once the little self is found, both I and my patient can imagine or actually support the child by holding and encouraging him or her. One middle-aged woman brought in a tiny doll which looked like her as a toddler. I took the doll and placed her legs in a seated position and held her in my hands facing my patient for the hour while she pulled off and separated herself from a black shroud placed on her shoulders. This cloth symbolized her mother's repression, shaming, and physical abuse of her.

Writing a letter to the child with the dominant hand and having the child respond by writing with the nondominant hand has proven very powerful in their location and beginning communication. Photographs of infancy and childhood can also be invaluable. A mother's lack of providing a loving, holding environment is frequently captured forever in these visual reminders. Embodying these pictorial images of the child and talking from his or her experience can reconnect individuals with themselves.

If an individual has taken over the role of the mother or parental shamer, the inner child may not trust the adult's judge-possessed ego as ever being able to caretake. Here is where the countertransference role of the therapist as good parent continues to be vital as a surrogate parental advocate.

I may ask, "How is little _____ today? Is she here with us? Have you allowed her here? You know I insist that she be here and heard. She can sit in my lap or play if she likes, but she's not going to be imprisoned any more. _____, are you here?"

At times the patient is so aligned with the negative internalized parent that I role play his or her inner child and express my/his or her hurt, fear, or anger at the patient. With one woman, I said, "You deserted me. You went with her. You believed her when she trashed me and made me feel bad for wanting and having fun. Without me you will never learn how to feel or play or be creative. I am your core essence and hold your soul and life force." The woman cries quietly for the first time in the presence of another. She had come home to a place where she could be free to be.

Gradually the experiences with the negative mother will be remembered and confronted with my help. These abuses will be peeled away and the power of the negative mother lessened. Slowly, my intercession as the good supportive mother gets internalized and acts as a safeguard against the witch mother.

During this time of obtaining object constancy, patients describe feeling protected from the mother judge-shamer only in my presence. But gradually they can internalize me for longer periods. Transitional objects are requested at this time. I have given patients jewelry of mine to wear or selected sand-tray

FIGURE 7.1 **Picture Poem: Transitional Object. Therapist Feeding Squirrel Captioned by Patient, "Pioneer/Mother, Wilderness Guide/ Exploring the Darkness"**

(Source: Private collection)

FIGURE 7.2 **Picture Poem (continued). Squirrel with Cracker, Captioned: "Through the Tangled Vines Finds Hope"**

(Source: Private collection)

figures to take as long as they need them. One patient took a blanket from the therapy office for a trip back home to visit her Medusa mother.

Upon termination, one patient took several pictures of me and cut and arranged them in what she called a picture poem (see figures 7.1 and 7.2).

Gradually, the good mother/therapist gets internalized. After three years in treatment, a schizoid patient said, "Now when I'm at home, I can imagine your pillows that I sat on and I feel held; and when my mother comes inside me to fill me with worthlessness, you stand in front of the little one in me like a warrioress."

A series of pictures drawn over a two-and-a-half-year period in therapy depict another woman's experience of the inner transformation of her as-yet-unborn self through the internalization of a good-enough mother within the

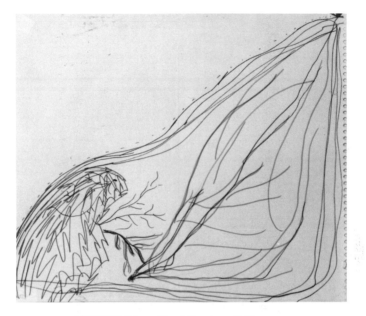

FIGURE 7.3 **Feral Creature Self**

(Source: Private collection)

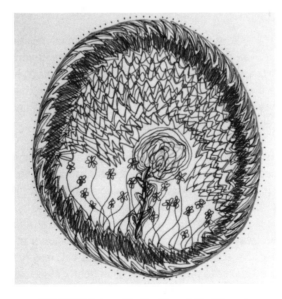

FIGURE 7.4 **"In the Eye of the Storm"**

(Source: Private collection)

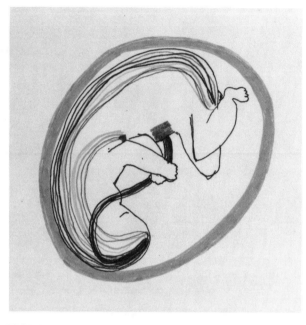

FIGURE 7.5 **Self-Nourishing Through Consciousness**
(Source: Private collection)

transference. The lack of nourishment from the original negative mother produces a creaturelike feral self (see figure 7.3). Over several months, the therapist aids in transforming a portion of the self–object orbit. Now a flowering self begins to grow, although it is still surrounded by the remaining unneutralized raging chaos of the mother (see figure 7.4). Now, in the final picture in the series, she is capable of self-nourishing the developing healthy self (see figure 7.5).

Another patient placed a long net over her head and body and requested me to move with her. I placed another net over my head and reflected her movement. Encircling, covering and uncovering, seeing and hiding, progressed into directional reaching and grabbing and letting go of my net. Ambivalently wanting to see what is in shadow (i.e., the potential hidden good/bad object) and wanting to move away began to shift. Gradually she took her net and mine and rolled them up into a sphere. She then drew the ball into her solar plexus. Finally, she moved closer to me. I put one hand gently at the base of her spine and the other cradling the bottom of the sphere.

Mothers who continue to maintain an attachment to the child, in order to soar in the child's greatness, impede their offspring's development. Their chil-

dren remain forever the girl or boy (the *puella* or *puer aeternus*). They are the mothers who incessantly brag about "my son the doctor" or "my daughter the dancer." The price for the adoration of the inflation instilled by the mother may not always be clear at first.

The plight of Icarus depicts the full disastrous fall of such a figure. Jung writes, "The human ego can be exalted to experience godlike attributes, but only at the cost of overreaching itself and falling to disaster. This is the meaning of the story of Icarus, the youth who is carried up to heaven on his fragile, humanly contrived wings, but who flies too close to the sun and plunges to his doom" (1964, pp. 122–123). This myth was manifested in one man who soared with inspirational greatness, dancing about and sounding out his voice in an authentic movement and drama group. What entered me through the somatic countertransference was his archetypal narcissistic engulfing mother, so prevalent in many men's psyches.

I said to him, "Come with me. I will make you powerful and wonderful, soaring far beyond anyone else. The only price is that I own everything you create, and you cannot commit yourself to any work or relationship."

He moved over to me as I engulfed him. Another man remained immobile in a closed position. Two women kept moving away, while a third said to him, "Fuck you, I know your kind!" Only one woman, embodying his Amazon fighting side, moved toward him, provoking him into wrestling.

I then said, "Come back to me, she can't promise you flight—only I can." He then moved back to me as negative mother, realizing his bind. He would have to give up the dominance of his high-flying self, so identified with the archetype, come down to earth, and in a soulful way claim his capacity for human suffering and mortality.

He then picked up a foam bat, placed it at his groin, and paraded himself about the room. As the negative mother, I responded, "You can keep that as long as everything you do is mine—all creative acts are mine. You can continue to fly but you must remain under my domain."

Eventually he elected spontaneously to trash everything, dumping all that he had soared with into a large pyrelike heap. Words, ideas, acts of so-called greatness were sacrificed in service to a more realistic sense of self. This loss resulted in much dark depression as he awaited an experience of his true separate self.

Chthonic Phase and Creativity

Once there is a sufficient presence of a sense of a realistic self, the preschooler begins a rudimentary civilizing process of his or her instincts in order to be able to socialize with others.

From roughly age two and a half to the oedipal triangle, the symbolic world awakens in the child. Still under the realm of the maternal object, dreams and fantasy play of monsters with overwhelming aggression or destructiveness appear. Instincts and their expression through animal manifestations prevail. In civilizations where the chthonic phase dominated, sexual orgies in service to the fertility goddess could be found. Here, individuals identified with the Great Mother as creative.

At this time, a child's dramatic skills naturally awaken to aid in this creative process within the *mundus imaginalis*. Nightmares begin around age three and a half. Here the realm of the night stalkers emerges from the earth and sea (mother realms) and bats, devils, witches, and zombies manifest and seek to devour, smother, or poison their prey.

A number of years ago, my youngest daughter, at the time about three and a half, awoke distressed from a nightmare. There was a monster in her room, he was very loud and wanted all her toys. It was clear she wasn't going to return to her unconscious until we had addressed this fellow. I asked her to draw his picture and tell me what he said. I then wrote his words in cartoonlike captions. This was to be a first page of a storybook about him. I asked if I could role play her. She agreed. I looked at the now visually contained monster and said, "You can't have all my toys. Didn't anyone teach you about asking and sharing?" My daughter role played him as we drew and enacted this story. "Well, no," he/she said, "I don't have any friends. No one will play with me." Then I responded as my daughter, "Well, it's no wonder, I'll tell you what, you can play with me and I'll teach you how to share." It was then agreed between us and contractually sealed with a final picture drawn of her inner monster and herself playing together. That was the last we saw of this "monster" nightmare.

In this phase, patients, too, enact demanding powerful shadow creatures who are ready now to be humanized. These embodied creatures from the deep can be engaged and dialogue can be created with them.

One male patient reported a recurring dream. "I am paralyzed and this zombie enters my room." Personifying his paralysis, he said, "I will keep you down so you won't get into trouble." As his zombie, he walked in a rigid Frankenstein-like gait. "I am dead, I want you, I'm going to kill you." As the dreamer, I asked, "What have I ever done to you to merit killing me." The zombie responded, "You have forgotten me and banished me."

Reversing roles, I became the zombie and suggested a relationship. I told him he had been a victim his whole life without me and that he didn't need the paralysis anymore. As zombie, I affirmed that he was a man and could claim his authority.

Together we formed an alliance against his inner mother and father, both of whom physically beat him as a child. With dummies and pillows, he reenacted his childhood and killed off his abusive parents who he had projected onto relationships he had had throughout his life.

The need for the positive aspect of the instinctual was graphically portrayed in one woman's nightmare: "I am taking my son to a zoo where he can experience the animals. I get there and discover someone has chopped off all of their heads. At my feet is the head of a lion. I am overwhelmed by the intensity of this horror. I take my son away so that he does not see this wanton destruction." In active imagination, she discovered the identity of this killer of instinct. It was her mother's animus, which would cut any connection she had to her natural needs and drives. Bringing the inner mother into the room through her imaginal realm, she retorted, "If there is one thing I hate about how you raised me, it was your insistence that life was gray, cruel, and unfair. I was never allowed to feel deeply, have passion or joy in my life!"

The instinctual aspects of parental, shadow, and anima/animus complexes are frequently depicted in animal form in myths, fairy tales, and dreams, sand play, art, and dramatic improvisation. In Egypt, there was a goddess, lion-headed Sekhmet, who was called the mighty one, who breathed fire, spitting hot desert winds of horror and destruction.

A mythic story unfolds that one day Ra, the sun god, was displeased with humans who spoke words against him. He then sent Sekhmet down in her fire-spitting manifestation to ravage them. After she slew mankind, the god Ra beckoned her back. But she responded, "Thou gavest me life, when I had power over mankind, it was pleasing to my heart" (Budge 1969, p. 393). Having tasted human blood, she didn't want to return to her more loving nature. So Ra had to trick her by preparing a beer colored with ochre, so that she would drink it thinking it was blood, become intoxicated, and be wooed back to her kinder state.

The hieroglyphics tell us: "Came goddess this in morning, found she this heaven flooded, joyful was her face because of it, was she drinking, merry was her heart she came to a condition of drunkenness, not knew she mankind. Said the majesty of Ra to goddess this: Come, come in peace, O Beautiful One and there became she beautiful in Am" (Budge 1969, pp. 396–397).

An example of the devouring Sekhmet energy might be found in the unconscious of a man dominated by a mother complex, who needed to separate from her idealization in order to have a full intimate relationship with a woman. He related the following dream: "I am in a desolate place. There is devastation

everywhere. No one is alive. Buildings have been bombed out. I look around and I see cats, hundreds of them, approaching me. I see their eyes, they are hungry. It becomes clear they want to eat me."

This man had a series of cat dreams over two years in treatment, the last of which was of the "domestic" kitten of a woman, who he subsequently married. In the dream, it tugged at his pant leg and his wife-to-be picked it up and shoved it out the door.

Initially, in treatment, he brought in his dreams all typed up and handed them over to me as if they were a present to me and not for himself. Once it was clarified that his dreams were for *his* transformation, he would bring in food and insist that I have some, too, or he couldn't eat. The message was clear. Whatever was his was also the mother's or her surrogate's. He couldn't nurture himself without giving to her. My exploration and reluctance to participate in these powerfully significant acts enabled a very different type of transference to unfold.

The Greek heroes were forever having to contend with and overcome the chthonic nature of the feminine. Odysseus, a hero of the Trojan War and an archetype for adult masculine individuation particularly in relation to the many animae, was challenged by the Sirens. The Sirens, half female, half animal, called men to their death as they sailed close to their island. Wooing them, imitating the voices of the women they loved, the men would steer their ships too close to the rocks and be smashed to death. Odysseus had his men put wax in their ears and instructed them to keep rowing, no matter what. But he had himself lashed to the mast so he could hear the voices but not be possessed by them.

In another incident in Odysseus' journey home to his awaiting anima, Penelope, he encountered the witch Circe. She was the most dangerous and chthonic of all, for she ensnared men into her lair and then turned them into swine. With the aid of Mercury/Hermes, he was made immune to her dark curses and was thus able to match her power, become her lover, thereby rendering this aspect of his psychology an asset rather than a hindrance.

Women, too, must contend with the unevolved chthonic feminine in all of its aspects. The victimization and possession by the negative mother complex was strongly evident in one woman's art work. In a kinetic family drawing, she depicted her ensnarement by a black widow spider who loomed over her whole family, caricatured as insects (see figure 7.6).

In these instances, the therapist's role can be very much equated with that of Hermes. Here, we can provide the needed antidote of trust, safety, and unconditional positive regard, in order for the patient to enter into the negative mother's lair and reexperience early personal memories for the purpose of transformation within the transference. It is not by chance that Hermes is

FIGURE 7.6 **Kinetic Family Drawing: Spider Mother and Family**

(Source: Private collection)

considered the god of depth therapy, as he conducted souls into the underworld and could transform himself into any image.

The Greeks had many gods that were theriomorphic (part animal, part human) and that remained related to the mother realm. Pan, part man, part goat, was never far from his instinctual sexual drives. The woodcut in figure 7.7 was carved by a patient who was beginning to claim more fully her sexuality. The same woman carved the feminine counterpart, oceanids (mermaids). Here, sensual pleasure abounds while her sexuality, still housed in fish scales and undifferentiated from the mother waters, awaited eventual transformation.

An example of my use of the metaphor of the mermaid evolved with one woman who entered the room and said she just wanted to go to sleep. "I'm on vacation," she reported as she slouched down on the mat. I pointed out that the mermaid in her who drew her in and out of relationships with little awareness, flowing with the tides of the libidinal oceanic unconscious, didn't want her to pick her head up out of the water and look into consciousness. Somewhat reluctantly, she arose and elected to work in sand play. She first buried her own instinctual masculine bull nature and then uncovered him. I placed a mermaid in

FIGURE 7.7 **Theriomorphic Pan**
(Source: Private collection)

the sand and suggested she explore their previous split-off relationship. She related the following story: "The bull stands firm, but the mermaid doesn't back off either. The scales begin to slough off her hips. She becomes a woman and he a man." This simple story provided a metaphoric itinerary, if you will, for her depth work. Authentic movement gave her the space to experience her shedding of these scales. Slowly she began to move her legs and sense her thighs and hips. She described an emerging awareness of sensually powerful internal (inner genital) sensations of subtle wavelike uterine contractions, which she later moved from in a "woman's dance."

Dionysus, the god of music, drama, and the vine, was known to be depicted as a bull or stallion. He has been identified also as Pan and Osiris. Whitmont, in *Return of the Goddess*, writes:

> His rites abounded with orgiastic and emotional rapture, with dance and violent abandonment. In the context of a dreamer's life, however, it is important to be aware that Dionysian rites expressed more than just an acting out of sexuality, desire and violence. Indeed, the Dionysian cults

used music and ritual as a means of integrating violence and desire into the whole personality. (1982, p. 6)

Thus, the cults may have provided one of the earlier expressive arts therapy vessels, if you will, for "harmoniously integrating the hungry and needy beasts and furies in man" (ibid.).

Here the feminine perspective and its relationship to the goddess and fertility gods such as Dionysus can be viewed as key and figural to human development. About this time in development, the four to four-and-a-half-year-old child gains a fuller identification with the mother as creative. Physiologically, wave-like contractions of the uterus, vas differens, and tunica ductus of the scrotum, identified as inner genital rhythms, dominate (Kestenberg and Sossin 1979). Archetypally, being in relation to the fertility goddess and Dionysus means that the child and adult who has appropriately integrated this phase is able to experience the creative cycles of nature.

Internally this means not disallowing needed destruction of old archaic patterns and relationships, nor blocking passion and sexual eros-relatedness to the creative. Externally, it means not raping Mother Earth through wanton pollution.

One woman's relationship to the earth goddess unfolded from couples' work in which she powerfully began to reclaim her creativity and sexuality. In an individual hour, she brought in a painting of a powerful monumental female figure, thigh deep in water. In front of her was an exuberant young girl. My suggestion that she embody this maternal figure brought an awareness of a disklike block at her diaphragm. I then suggested she personify this swirling disk. As the block, she responded, "Don't descend down into that earthy place. Stay up in your head." This disk began to sound a lot like her mother, who had little or no connection to the archetypal feminine. After some time, we convinced the "mother disk" to ascend into her head while she descended into the great womb of the earth goddess to reclaim her own powerful sensual creative self.

When this identification with the feminine as creative occurs in men and women, community concerns are balanced with idiosyncratic self needs, and the value of embodied experience, intuition, and inner gnosis coreigns with intellectual consciousness.

Unfortunately, Western culture has inhibited this natural joining. For, with the emergence of the patriarchal Judeo-Christian tradition came the oppression of the I-Thou relationship to the fertility goddess. The Hebraic story of chthonic Lilith is a telling one. In this tale, Yahweh first created Adam and Lilith. When it came time for sexual union, Adam directed Lilith to lie down so that he could be on top—the so-called Christian missionary position. Lilith argued and said that Adam should be on the bottom. Angered, Adam went to Yahweh and complained. The patriarch reassured him, banned Lilith forever to

FIGURE 7.8 **Lilith**

(Source: Baked clay plaque, Old Babylonian
period, Isin and Larsa dynasties, Warburg
Institute, London)

FIGURE 7.9 **Wild Woman of the Wolves: The Menstrual Hut and the Power of the Feminine**

(Source: from "The Curse," *Swampthing* (New York: D C Comics, #40, September 1985), p. 1. Reprinted by permission.)

be feared by men and women split off from her power, and created a seemingly more receptive Eve (see figure 7.8).

Women's capacity to reclaim their inner repressed powerful chthonic feminine out of darkness means being able to lay claim to feminine creativity and sexuality and being "capable of independent thought and action, especially in the realms of love" (Hall 1980, p. 151).

FIGURE 7.10 **Wild Woman of the Wolves: Transformation and Rage in Relation to the Devaluing Patriarchy**

(Source: from "The Curse," *Swampthing* (New York: D C Comics, #40, September 1985), p. 10. Reprinted by permission.)

The unassimilated Lilith aspect was powerfully compelling with one married woman who came to treatment because she had a sex addiction resulting in overwhelming uncontrollable urges to seduce men. She related that she loved to have "control over men, to straddle them," and frequently had the fantasy of clawing them to pieces. Once she began to embody this instinctual rageful part with me, she realized the repressed anger of her abused and devalued feminine

ego. Another woman, in the process of claiming her power, brought in a comic book in which the heroine, upon beginning her menstrual cycle, is mocked by her husband and sloughs off her demure, passive female role to become a wild woman she-wolf, destroying everything chauvinistic in her sight (see figures 7.9 and 7.10).

Summary

Whatever her manifestation, the powerful chthonic feminine must be attended to and integrated. Men, as well as women, need to revalue the chthonic creative split-off side of their feminine nature lest they lose the capacity to create and value the organic nature of existence.

One male patient who successfully separated from a smothering mother was free to claim a direct relationship to the fertility goddess. He came into the session saying, "I want more women on my staff." He himself had just given birth to a revolutionary idea in his company. Midwifing some of his discovery afforded me a real opportunity to see how instinct, object relations, play, and work come together in health and wholeness.

With self and object constancy, an individual is able to care for and support the inner child. She or he will have a constant experience of a central core from which needs, wants, and personal decisions emerge and are encouraged to be expressed without shame, judgment, or guilt.

Chapter 8

THE MAGIC WARLIKE AND MAGICAL CREATIVE PHASE

*A*t the magic warlike and magical creative stage, spanning the resolution of the oedipal crisis through latency, the power of the chthonic mother must be actually confronted by the masculine and mediated by the feminine. In this way, the young boy can begin to claim his manhood and the girl can establish a relationship to her feminine ego separate from an identification with her mother.

Eric Neumann (1973) delineated male stages of development, but he decided that the ego was also masculine for the female as well. I disagree. I believe, as did Jung, that there are contrasexual aspects to both male and female psychologies, i.e., men have an inner feminine complex called the anima and women have an inner masculine called the animus. I feel that a woman's ego is feminine and that her quests and development are centrally different than that of the male's. However, both men and women must undergo developmental stages for both their ego and animus/anima with both moving toward the goal of androgyny in later life. I have, therefore, added the female stage of development "magical creative" to Neumann's male ego stage, "magic warlike."

Magic Warlike Phase

In the magic warlike phase, it is vital for the male to kill off the inner mother, no matter how wonderful she may appear to be, in order for the oedipal crisis to be resolved and for him to have access to his anima or inner feminine side. Without this act, a man will forever project his mother onto the women he is with, fearing commitment and control or symbiotically clinging, depending on whether his mother was smothering or abandoning, respectively.

Here, I believe, is a rather lovely but telling picture of the infant Cupid, or

Eros, with his hetaera mother, Aphrodite (see figure 8.1). He appears at closer look a bit forlorn and certainly old enough to fly into space with his bow and arrow. The beginnings of the myth of Amor and Psyche can be recalled in which Amor/Cupid's sexuality was under his mother's power and not his own. He was to do her bidding and not allowed to seek his own relationship to his anima, depicted as Psyche. Clinically, it doesn't surprise me that this picture is a mirror cover, because it was Aphrodite's vanity that brought about her jealous wrath at the lovely Psyche. She is a typical narcissistic mother in this depiction, wanting Cupid to remain an extension of her, her phallus, her consort.

I had been working in depth analysis with a creative innovator for some

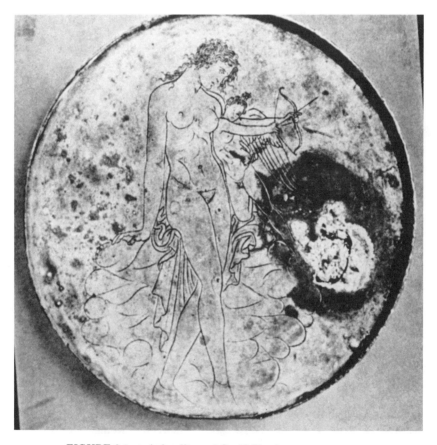

FIGURE 8.1 **Aphrodite and Cupid (Eros)**

(Source: Late Classical Greece mirror case,
Musée du Louvre. Reprinted by permission.)

time. He had come to understand that his goddess mother complex had been subtly taking all of his accomplishments for her own benefit. From boyhood, he had been psychologically trained to be in service to the feminine. Now, well into adulthood, he realized the negative influence this had in his relationships with women and his capacity to own his own productivity. Instead of transferring onto me his initial image of an Aphrodite to be adored, which was characteristic of the beginning months of the depth work, he began to have a very different view. Synchronistically, about this time I came into an hour wrapped in a huge shawl and reported "sneezily" that I had a "cold." It didn't take his imaginal transferential sphere long before having a cold was translated into "being cold," and my shawl symbolized how unavailable and withholding I was. After exploring his associations fully, I "unwrapped" the symbolic shawl. Now eros energy filled the room, followed by anxiety, then fear, then rage. He imagined embracing me, then slapping me around the room. Still in active imagination, he saw my face change to that of his mother's. I encouraged him to give words to his rage. He yelled, "I'm not going to take your inattention to me any more." He imagined kicking me/mother and leaving.

Mildly horrified, he became concerned about his fantasies. I reassured him by reminding him of the fairy tales and myths, such as that of St. George, which relate that the hero must first kill the dragon before he can claim the maiden. First the male ego self must separate from the all-powerful mother and the incest pull before he can have a mature relationship to a woman as well as to his own inner feminine side.

I related the story of St. George to my patient. In the myth, a dragon, living in a marsh, has to be kept from a nearby city by periodically sacrificing maidens. The lot fell to the king's daughter. St. George was passing by and heard the story. He mounted his horse and slew the dragon, whereupon he asked the king's daughter to put her girdle around the dragon's neck and the beast followed her meekly.

My patient then recalled his favorite story of the Arthurian legends. It was about a young knight who was left, to his chagrin, to safeguard the castle. A beautiful woman came to the door begging entry through seduction. He would not let her in. Each evening when all gathered at the round table, the shield of the knight who had performed the noblest deed would glow. This time, the young knight's shield glowed, for the woman at the door had been an evil witch in disguise.

Subsequent to this session, the muselike archetypal feminine emerged in his dreams. In two dreams, Mother Earth revealed her riches to him through unlimited oil and magnificent landscapes. In another, a woman muse proved helpful to him in his work by leading him to limitless knowledge. Unlike his usual lively response to symbolic material, he remained resistant to exploring these powerful archetypes. He realized as well that his refusal was "uncharac-

teristic." Finally, he entered my office and said he felt there was a hiatus in the work and then proceeded to report some "imaginal homework" I had given him. I had asked him to take the woman in his last dream and fantasize about her as a helping resource. He reported that she had suddenly become a vagina that had then continuously opened like petals of a beautiful flower. He seemed untypically disinterested in this compelling archetypal image. Mentioning the themes of his prior dreams, I suggested that his feminine was revealing herself to him for acceptance and relationship. I then suggested to him to imagine putting his phallus into the flower.

At this point, I allowed his image of the flowering vagina to enter me. I imaginally placed the core of the flower at my body center. Although I did not mention this to him and we neither moved nor spoke, there was much that was occurring in the bipersonal imaginal realm. Eros energy filled my office. I began to feel penetrated and gradually the image of a manchild evolved in my womb container.

I suggested he embody and claim this new baby self which came of the union between his masculine ego and feminine side. He wrote later of this time, "I put myself in the baby and looked at her and I experienced this powerful and growing surge of feeling inside me. I thought I was going to burst."

At this time, he asked if he could embrace me. I said, "You would only be embracing me. You need to take this feminine part of you that I am holding and take it back into you where it belongs."

He wrote later, "I did not know exactly what to do, but I wished myself open and she continued to look at me. After a while she said something like 'keep on' and I felt a surge of joy." He then said to me, "I am having an image of my infant self being with this new feminine self."

Now, after months of isolating, tracking, and killing the dragon mother, which had surrounded his relationship to his inner maiden-feminine, he could begin to accept his anima and join with her in the birthing of a greater totality of selfhood.

He wrote of this experience, "I have been a different person ever since—a more complete feeling person. Some large reservoir of anxiety has disappeared and my mind is freer."

Another example of the struggle to eliminate the negative mother came with a man engaged in authentic movement. He remained in the horizontal and appeared powerless to achieve vertically. On all fours, he rocked back and forth. A deepening intensity of wavelike contractions emerged. He moved to his hands and feet. His mouth opened wide, his back arched, he repeatedly reached behind himself as if to pull something from his anal sphincter. It was clear from the emotional intensity of his breathing and bodily movements that something was vividly present in his imaginal realm. His yanking and pulling finally succeeded in releasing something, for he dramatically shifted into a

vertical squat position with full access to his assertive energy. Through imageful dramatic enactment with his body as container, he was doing battle.

Later he described having a snake through his entire alimentary canal. For him, he knew this was his inner primordial mother complex, which would possess his ego and keep him from digesting and claiming his own substance for his own use, and like some huge tapeworm, had previously claimed it for herself. Now more psychic energy could be metabolized by the starving ego (see figure 8.2).

Sometimes the negative mother is seen as having multiple aspects, such as with Hercules's battle with the twelve-headed Hydra. One man brought in a copy of the film *The Little Mermaid* and said that the negative killer witch was like his mother. In this Disney movie, an underwater witch is after the beautiful soul voice of the king's daughter. This evil one is half female and half octopus, with suction-cupped tentacles. The story unfolds with the hero prince killing her and rescuing the mermaid (his as-yet sexual anima) who then transforms into human form.

This man's mother had many ways of debilitating him through multiple forms of physical, sexual, emotional, and spiritual abuse. In my office, he took a pole as sword and repeatedly with penetrating force stabbed a life-size canvas

FIGURE 8.2 **Apollo Killing the Python**

(Source: Etching from J. M. W. Turner; personal collection)

dummy symbolically imbued with his inner toxic mother. Subsequently, he reported composing a musical piece in which a princess is rescued.

Yet another example of the release of the mother and the emergence of the anima came with one man who had a narcissistic mother who viewed herself as a goddess and required her son to adore her religiously. His final battle was of a different sort. As an adult, he had a series of dreams. In the first, he was encouraged to reenlist in the Army, i.e., to reassume his relationship to the warrior archetype. In the next scene, he yelled at his mother to shut up. He then had a dream in which he must separate from the "Mother Church." In one dream, the priest as shadow aspect complained to him that he was in conflict in that he had promised celibacy to the church. But in dramatic role playing, he discovered he wanted to experience intimacy with a woman.

A part of this man had been stuck in the magic warlike phase because he could not identify with his father since his father had been horrifyingly abusive to him and his sisters. I encouraged him as the shadow priest in his dream to defrock himself. He imaginally removed this black shroud of his dysfunctional abusive family. Shivering, he realized he was neither held nor buffered in relation to the world. About this time, he dreamed of a kitten holding on to his skin as he tried uncharacteristically to slough her off. As the kitten, he said, "I won't let go. I belong to you." This instinctual feminine then developed into a woman to be humanly responded to in subsequent dreams.

I have found with men, the more smothering and controlling the mother, the more rage they will feel toward all women and the more difficult it is for them to target and kill off the negative internalized mother. Because of the pervasiveness of an all-encompassing stifling mother who insists on remaining in emeshed symbiosis, there are no limits to her atmospheric contamination. These men metaphorically walk around surrounded by pollution from the toxic poisonous undifferentiated gas of the matriarch. Some men elect homosexuality, while others can only be with the same woman for short periods of time. Some can even live with a woman but need to choreograph "away time" or have difficulty sustaining erections, fearing the classic "vagina denta"—the castrating "biting" matriarch. Still others are able to get married but act out with numerous sexual liaisons or imagined affairs from afar. With the wife representing "the smother mother," they move farther and farther away emotionally, sexually, and physically, until the wife attempts reconnection and moves closer. When she does this, he typically points the finger at her and says, "I knew you were a controlling bitch all the time."

This dance is usually undertaken with a woman who has been abused in some way and is codependent. On some level, she believes there is something wrong with her and therefore deserves the rageful abuse and abandonment, so she stays in the relationship.

By far one of the most ardent battles in this phase was waged by Josh, who

had been smothered by an overanxious guilt-provoking borderline mother. Her pervasive contamination of his life was felt to be of archetypal proportions. He says, "She is in every cell of my body and is like some nuclear waster cloud that follows me everywhere. Every relationship I'm in is contaminated by her." Josh described his personified mother complex as a cross between Jabba the Hut from *Star Wars* and the alien from the movie *Alien*.

His inner toxic mother would attack repeatedly in full force. Like all complexes, this one had its own autonomy and will to survive. It siphoned off much of his psychic energy from his ego sphere and left him in a weakened, guilt-ridden state. I reminded him of Han Solo in *Star Wars* and I became Sigourney Weaver in *Alien*—both were engaged in killing their adversary and rescuing the feminine, be she Princess Leah, a kitten (*Alien* I), or a little girl (*Alien* II). Because the mother complex—like all complexes—lives in the imaginal realm between the conscious and unconscious, we needed to enter into this space to choreograph the battle. The battleground itself was inside my patient's body. She had fixed herself onto his spinal cord, leaving him spineless in his life. Prior to the battle, she attempted to distract us by appearing on both our faces as a distorted gargoyle. Both of us acknowledged this vision and reaffirmed our allegiance. Josh was not to be distracted from his magic warlike quest. He blow-torched her, while I, with Weaver's relentless determination, began prying her away from his rib cage.

This imaginal battle continued for many sessions during which time his body attitude changed from that of holding an S-shaped curve to one of a powerful heroic stance. His strong jaw shifted as well from a protruding position to proper vertical alignment.

In couples work, his wife became exquisitely adept at picking up the trace subtle gestural shifts in his body which would indicate that his mother complex was possessing his ego sphere, and through playfulness she could free him from her grasp.

Slowly and begrudgingly, his inner mother gave up on destroying his relationship with "the other women" and began to draw her armamentarium into his work life. Without hesitation, Josh and I approached this new battle in the imaginal realm. With this new assault came help from the archetypal. During one of our imaginal battles, the image of an erect phallus came to me. When it imaginally ejaculated, the sperm killed the inner mother. I reported this to him, and he began to imagine a huge phallus extending from the base of his spine out through the top of his head, ejaculating progenerative semen like a fountain. As I imagined this with him, the room filled with numinous energy. He had clearly connected to the Creator God within. He reported, still in this imaginal realm, that the mother had completely disappeared. "Yes," I said, "only a man can be in this type of relationship to the Father God. Your mother has no place here."

But like Sekhmet, who did not want to let go of her fury, his rage would not

quit. In the following months, Josh began attacking me. He would vacillate between imagining raping me and killing me to feeling saddened and expressing his acknowledgment of my genuine care and his love for me. The pent-up rage in him needed to be released. He was pinned and held by a group during a weekend of intensive therapy so that he could express and release his rage without hurting himself or anyone else.

After this experience, he began to see his rage as an addiction that would possess his ego, but he also realized that to fight it would be to intensify it. He knew he needed to "risk the shame" and open himself up to experience, "seeing and being seen without illusion." I, meanwhile, began to see glimpses of life and humanness reentering him through his eyes and their expression. At one point, he moved closer and sat tailor-fashion with his knees touching mine. He then rested his head on my shoulder. I reflected his breathing so he could feel the connection when we inhaled and natural separation when we exhaled. The rage subsided like a calm after a lengthy, brutal war. His ego both regained and maintained its centrality, and Josh was able to experience a truer reality.

An example of how this magic warlike phase was explored employing sand play can be found with another man. He would come into my office and separate the modular couch seat on which he would sit from the rest of the L-shaped sofa, so as not to be connected to me in any way. His mother, a devout Christian, would pass "last judgment decisions" on him daily in his boyhood. In one session, he elected to do a sand tray. He identified himself as the bear who was aided by a gold uraeus snake to kill off the death mother while the father as Aristotle looked on. Then both the mother and father were buried in the sand. He then selected female figures from the sand play shelves which were keys to his developing relationship to his inner feminine, freeing him from his creative (mother-perfectionist) block (see figure 8.3).

Not too infrequently, in groups two or more, individuals can facilitate the healing and transforming of each other through reciprocal engagement in each other's imaginal process. Such was the case with a man and woman who were members of an authentic movement and drama group. For one hour, the man rocked in a squatting position and from deep in his belly came a sustained bass growl.

I approached him and reflected his sound and movement. Through the somatic countertransference, I then began receiving a contorted, deformed, grasping, and decidedly female being into my body. I recall thinking "how ugly and detestable she is, like a Balinese deity." A noise came from me that I didn't even know I could make. It was like a gutteral hissing. Clawing movements emerged.

With controlled rage, he pushed me back to the wall and squatted over me, imaginally regurgitating. I lay flat and felt this being leave my body. After a period of time, I felt reanimated. My arms reached upward and with a deep

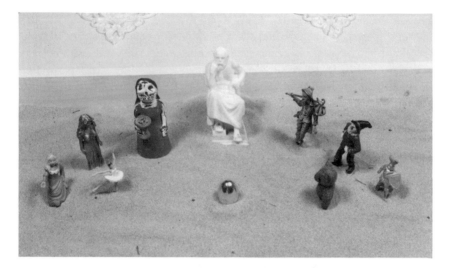

FIGURE 8.3 **Sand Play: Selection of Animae**
(Source: Private collection)

peace within me, I arose. I, as the transferred alchemical vessel in service to
this man's process, was able to experience in a very powerful way the evolution
of this magic warlike quest. Meanwhile, this man began to connect with his
anima and moved into a valuing of the feminine that he hadn't experienced prior
to that time.

Magical Creative Phase

With women, this phase, which I have called the magical creative stage, is
much different. She does not kill the mother, as they are of like sex, but she
must learn to mediate the powerful feminine and to experience the father not as
bestial under the power of the dark feminine as in "Beauty and the Beast" but as
human and relatable.

This relationship to the serpent mother appears over and over again and is
related to quite differently by the feminine aspect of a person's psychology than
by the masculine. The ancient fertility Minoan snake goddess clearly has the
relationship to the serpent's instinctual level in her control (see figure 8.4).

Similarly, in the Christian tradition, St. Margaret of Antioch, the patron saint

FIGURE 8.4 **Minoan Snake Goddess, ca. 1700** B.C.

(Source: Archaeological Museum, Iraklion. Reprinted by permission.)

FIGURE 8.5 **Medusa**

(Source: by Caravaggio, Galleria
Degili Uffizi, Firenze. Reprinted by
permission.)

of children, who was to be swallowed up by the dragon, emerged from it, and
has been depicted employing it as a means of locomotion for herself.

Another woman who was quite able to dance and explore via authentic
movement in other environs was frozen in my presence. The negative mother
complex had been transferred into me for mediation and transformation.
Through a long therapy process, she was able to bring in a rose, symbol of love
and wholeness, and a tape which she would dance to at home. Finally, she was
able to move with me in leaderless mirroring. She felt powerfully moved that,
unlike her withholding mother, I received her, responded to her, and could give
to her what she needed—a positive and caring mirroring experience.

An archetypal personification of the negative mother that frequently appears
in a patient's dream and expressive arts material is the serpent-haired Medusa.
Originally a beautiful maiden, she was transformed into a hideous monster
because she inflated herself to god status, having had intercourse with
Poseidon. She was punished by Athena, a father's daughter. Frequently, the
history of unattuned bad mothering goes back generations. Jealousy and envy
are key elements in pathological family systems. Medusa's fury would manifest
whenever anyone looked into her terrible fearful eyes, and her victims would
be immediately petrified into stone (see figure 8.5).

One woman drew her Medusa mother and, in sand play, selected and surrounded a Medusa figure and spider with danger signs. To the left side of the Medusa is a toilet with a rat peering out and behind her a telephone. "That's all she'd do is talk on the phone for hours and yell at me to bring her her cigarettes." Her mother's creation myth of her was continuously repeated to her. She would tell my patient that "a bird shit on the fence and the sun baked it and you were born." In drama play with the sand arrangement, she said, as the figure with the monkey and angel, "This rock protects me from you now, but I'll be back" (see figure 8.6).

This dark mother transformed gradually with the rechoreography of healthy object relations between her and me. At one point in the work, she lay down in authentic movement and asked me to hold her hand. She reported imaging a black vulture soaring upward in the sky. As it ascended, its black feathers sloughed off and a beautiful archetypal good mother emerged with wings. At about this time, she did two batiks: one of winged Pegasus with a unicorn horn, the other of this positive good mother. Of note is that, in the Medusa myth, Pegasus sprang forth from the blood of her beheaded corpse. Pegasus was the favorite of the Muses and a symbol of inspiration (see figures 8.7 and 8.8).

One woman was caught in a victimized abandonment complex evolved from a relationship with a narcissistic mother who was only interested in the daughter when she mirrored her greatness. To have stood up to her mother and confronted her would have surely meant she would have had to have given up all hope of getting any morsels of attention from her.

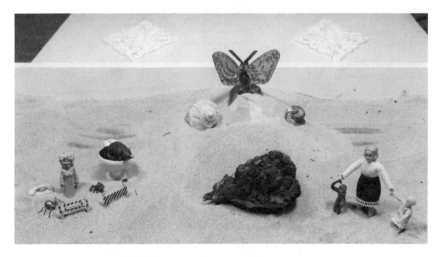

FIGURE 8.6 **Sand Play: Medusa Mother**
(Source: Private collection)

FIGURE 8.7 Batik: Pegasus Arising from the Blood
 of Medusa

 (Source: Private collection)

FIGURE 8.8 Batik: Transformation to Archetypal
 Good Mother

 (Source: Private collection)

She reported the following dream: "There is a very depressed girl who must confront the fire dragon. She is so depressed, she slits her wrists and turns white with the loss of blood. You find her and take her clothes off and put her into an octagon tub. There are group members around it who pour oil on her. You start a blood transfusion and the red color comes back in her. Now she can confront the fire dragon." The theme of death with the shaman-therapist assisting in bringing back to life is apparent.

Embodying this shadow aspect of herself in dramatic enactment, she lay passively down on the floor and felt her energy draining away. Embodying the fire dragon was a very different matter. With all his passion, she stood, moved in an undulating fashion, and fiercely roared from her belly. As the dragon, she lay on top of her imagined weakened self. She bellowed, "You must get up and lay claim to your life. Don't just be reactive. You're letting your life go by."

As the weakened self, she exclaimed she had no energy to do this. Reversing roles once again, the dragon became more manlike and started to breathe fire into her mouth to reenergize her. This frightened her but gave her enough energy to ward him away. This newly received libido in her gradually started to feel erotic, and she expressed that she wanted to make love to the dragon, now evolving into a man. She reported that unlike her usual repetitive narcissistic relationships in which people wanted her to be passive and reflect them, he wanted her to claim herself with all her strength and passion. Now she again lay down and felt a burning energy enter her both orally and vaginally, meeting at her body center.

Healing Sexual Abuse

Viewing the male as being less beastlike and more civilized is particularly difficult for women who have been physically, sexually, and/or emotionally traumatized by their fathers, stepfathers, brothers, mother's boyfriends, or any other significant male. Alcohol, sex, drug, power, or work-addicted fathers can inhibit their daughters' resolution of the Electra aspect of the magical creative phase.

When the father projects his anima onto his daughter, instead of projecting onto his wife or retaining an inner relationship to the feminine, the girl becomes "daddy's princess." This dubious honor results in the girl never having the experience of being seen by men. Such girls become anima women. They literally feel emptied of their own feminine identity and await being filled by any man's version of the feminine. They change their persona—their hair, dress, way of being, just to continue to be held in adored status. The price is their soul. One young woman abused by her father in this manner joined an ongoing therapy group that employed the arts in the imaginal realm. In one session, she

dressed herself as a queen with the materials and props I had available. She sat in the corner of the room and responded to no man. Her boundaries were clearly laid out. She was not going to receive any more projections. The quality of her relationship to her spouse began to change as well. She required more space, pulled away from being a caretaker, and claimed more of her instinctual sexuality for herself.

There is a wide continuum of incest and molestation perpetrated on young girls. Some elect never to be physically intimate with men, while others go to the other extreme and sexualize every relationship. Healing sexual abuse is crucial if the survivor is ever going to be free to choose sexual intimacy. Like other forms of abuse, the events need to be imaginally recalled, the child self rescued and placed in a safe place, and the perpetrator confronted. Art work can begin this harrowing process, as it allows for separation and containment on paper. Dramatic enactment is more powerful and the method of choice, providing the one abused feels safe enough to engage in it either through directing and observing or participating.

The use of other precipitating media could be found in one woman's decision to imagine writing a letter to her father perpetrator, now in recovery from alcoholism. At first a verbal letter in session, it became an actual letter confronting him. His positive response of accountability, remorse, and love resulted in her having a series of dreams. The first was of herself being massively pregnant. As she imagined what was growing inside her, she saw two gleeful baby boys. In a subsequent dream, her boys were growing up, and she acted to protect them from a negative male figure not unlike an introject of a stepfather. As these inner masculine aspects grew, so did her willingness to venture heroically forth in her life. She described loving to sing and expanding her pleasure at this form of expression to include lively spiritual songs. Her relationship to men also was rekindled but in a manner which strove to maintain her boundaried protection and well being.

At other times, the resolution of the Electra relationship with the father is impossible because of his emotional or physical absence or discomfort with having a daughter. One woman came to an awareness that every move she made, from getting up in the morning to going to bed, was tainted with shame that she was born a female and not a male. Many women bring in dreams in which grizzly male figures want to capture them, shoot them, or possibly rape them. Frequently they are beastlike, unshaven, or street bums. These inner masculine figures have not been allowed a relationship to their ego because of the unresolved issues with the father. If the father is absent or nondominant and mother "wears the pants," then this inner masculine side develops from the animus- or father-possessed mother. If her mother's animus or father is envious, sharply critical, analytically derisive, dryly intellectual, or simplistically

empirically mundane, she may have very little positive experience of the masculine realm.

One such example of the influence of a mother's masculine aspect could be found in one women's dream that her purse was being snatched by demons. Having experienced so much loss in her life, she passively let it go. I, however, was not so resigned about her plight. I encouraged her to go back into the dream. Dramatically personifying the demons, she found out they were her mother's attacking henchmen, who did not want her to claim her intimate feminine essence. Now, as her dream ego, she responded, "You can't have my purse." She grabbed it and sent her mother's attacking henchmen back to their source.

But more often than not, the masculine emerging in dreams and expressive arts figures are contrasexual aspects of a woman's own psyche seeking relationship and union. Once they are engaged and talked to, a woman may find them to be quite interesting fellows. They can guide her or give shape and form to her creative ideas.

Summary

In closing, it is important to remember that although masculine and feminine egos relate differently to the mother and father, both men and women have contrasexual sides which relate similarly to the egos of their opposite sex counterparts. The animus of women can be bellicose and sharply attacking if they are so called, and the anima of men can mediate and circularly redirect the other's power or force if need be. The yin aspect of going with the flow of the force of the opponent in some martial arts is an excellent example of this feminine phenomena. In any case, both are needed for further development toward androgyny.

Thus, the magic warlike and magical creative stages of individuals' egos and inner contrasexual aspects involve crucial rites of passage if an individual is to have an ego and self separate from the power of the matriarch and capable of further development. For the male, this means the freeing of his inner feminine side from his mother complex, enabling her to evolve from being a *puella* into more empowered feminine aspects such as are manifested in the Amazon/moon goddess; Athena/Sophia; Isis/Inanna; Ishtar, and/or Demeter.

For the female, the power of the matriarch must be mediated. Then, a relationship to and separation from the father or the mother's animus can allow

her inner masculine side or animus to evolve from a *puer aeternus* state into claiming a relationship to the archetypes of manhood, such as Hermes/Mercury as trickster psychopomp; Theseus/Hercules as hero warrior; Cupid/Eros as lover; and/or Apollo as bringer of order and supporter of the arts.

Chapter 9

LATENCY AND PUBERTAL RITES OF PASSAGE INTO ADOLESCENCE

Latency, Industry, and Gender Groups

Latency, which occurs in children roughly between the resolution of the magic warlike and magical creative phase at about age five and a half and the beginning of puberty, entails much learning, socializing, and mastery over day-to-day tasks. Fantasy life organizes itself in service to learning and exploring societal regulations and roles. Games dominate which require knowledge of specific rules. Same-sex peer grouping becomes important. In creative activities, children in this phase focus upon learning how to become skillful with the art medium or tools involved. A utilitarian emphasis is placed on what is created, i.e., an importance is placed on "making it useful." There also appears to be a greater weight upon "doing it well."

Improvisational drama and sand-play themes switch from the instinctual realm and story lines in which competitive and heroic engagements are played out to more domestic scenarios. In one sand tray of a latency-age child, animals line up for a "yard sale" (see figure 9.1).

By the end of latency, children have most of the cultural and familial rules under their belt and have become more independent. Their intimate other has shifted from within the family to their peer group.

With dysfunctional families, families that do not fit within the societal norm, latency-age children will frequently utilize any means they can to insure that their family appears to be "normal." Denial and minimization of problems are typical. A child's loyalty to maintaining the family secret, for example, that dad is an alcoholic or mom spends all day in bed in a depressed stupor, is paramount at this age. Sexual molestation and incest is high at this phase, I believe, at least in part because the pull for the child to be "regular" and not stand out through stigmatization forces them to maintain silence. Although some become inappropriately sexual at this age, the really overt signs often do not emerge

FIGURE 9.1 **Sand Play: Latency – "Yard Sale"**
(Source: Private collection)

until puberty or adolescence when the child's own natural sexual development compels them in one direction or another.

Other survival mechanisms such as isolation and insulation become firmly entrenched. I have heard individuals speak of this age: "It was safest just to go to my room"; "I couldn't bring anyone over to my house, I never knew what condition it would be in or what condition my mother or father would be in"; or "I couldn't go over to someone else's house; who would have taken care of my younger siblings?" In the later case, latency-age children, because of their interest in domestic tasks, are at a perfect age for others to abuse this learning and seduce them into becoming parentified children. Many patients speak of how they looked or felt older at this age. Playing was out of the question. These are individuals who literally learn how to play in the therapy container. Invoking my own inner latency-age child self, I spend many hours playing with the inner child of the patient. Creative arts groups are also wonderful vessels for healthy experiencing or reexperiencing of this phase. Learning to trust and spontaneously be with "the girls" or "the guys"—through art, improvisational drama, dance, music, or group sand play—helps rechoreograph this phase for

individuals who had never gone through this developmental stage because of abusive childhoods.

Pubertal Rites

Pubertal rites of passage herald the next phase in the development of ego consciousness. Jung felt that this was the time of "psychic birth" (1931, par. 756). For the boy as well as the animus in a girl, this means being separated from the collective, undergoing pain or deprivation, and undertaking tasks which entail empowerment and mastery over masculine instinctual energy. As boys develop, their bodies become strong. Their brute force can kill. It thus needs to be mediated. Control over drives and fears is rewarded with spiritual consciousness.

For the maturing girl and the boy's anima, rite of passage entails a descent and sacrifice of girlhood toward the search for empowered soulful wisdom

Engagement in these crucial rites of passage has slowly ceased and is disappearing, leaving a cultural desert through which pubescent youths search for vessels of transformation into adulthood. Even those rituals that still exist, such as confirmation in Catholicism and bar or bat mitzvahs in Judaism, have lost much of their meaning. One Jewish male responded, "Transition into manhood? Forget it. A watch, a pen set, some government bonds, and business as usual." Regarding confirmation, another man said, "It was something I did for my mother; not anything I was interested in. I remember the priest spent the whole time lecturing us on 'impure thoughts.' " Rather, this patient felt his rite of passage had more to do with getting drunk with the guys and seeing if he could drive his car at high speeds and not get killed.

Women are ill prepared as well. One woman reported, "My mother never talked about menstruation. A girlfriend of mine told me. Thinking I would begin soon, I wore a pad around for days."

Separation, Transition, and Incorporation

To understand pubertal rites of passage, our most valuable sources now are other cultures (Lewis Bernstein and Hall 1977). All pubertal rituals researched so far appear to follow Turner's (1969) scheme for the phases of ritual process, and all entail expression through art, such as dancing, singing, body painting, or

dramatic enactment. First there is a separation phase, then a liminal or transition phase, concluded by reaggregation into the society.

In Africa, the separation for Nias initiates consisted of practicing their jumps over an eight-foot stone, and they were incorporated into men's society through the hunters' dance. Bushman maidens were separated in a special hut, then carried to another hut where they were instructed, bathed, and dressed, and their faces were painted; they emerged with their elder teacher to be reincorporated through dance with the rest of the village.

Central African boys bathed together, then were separated from their mothers through a symbolic dramatically enacted death and funeral. They remained separate for three months in special huts, a transition phase during which they learned obedience and how to dance. They then underwent genital surgery in order to incorporate the feminine through "bleeding" and afterward were received into the men's society as they danced with the whole tribe. Central African females danced together in a circle with the whole society, then were separated for several months during which time they were instructed in specific symbolic dances. They then rejoined the rest of the village in a festival, wearing new grass skirts.

Nigerian males danced in the center of a circle of observers, with a drummer. One by one, they were called into the center of the *Soro* circle where, as a transition into manhood, they were beaten repeatedly on the same underarm area and not allowed to show any pain nor any change of expression. Through this ordeal, the boy was incorporated into the society of men.

Where the theme of pubertal rites has appeared in my work with groups, I have found that individuals similarly separate themselves from other group members. Some cover themselves or place pillows or other constructed barriers between themselves and the group. Still others move away with another or others of the same sex. Individuals then describe falling deeper into an unfamiliar unconscious realm. Many imagine entering a cave or going into a junglelike environment. Still others, particularly males, describe being elevated or climbing to a mountain top. Here is where individuals are confronted with that which they must integrate, claim, and mediate within themselves in order to achieve a relation to powerful soul wisdom and/or spiritual consciousness.

It is only after this has been achieved that individuals can return to the group and dance with the collective. If this is not achieved, they may remain loners and their developing self-esteem in relation to their identity as an adult may then continue in a wounded uninitiated state.

Incomplete pubertal rites of passage for men and for the animus in women can be seen in individuals who continuously put themselves in life-threatening situations, such as some forms of mountain climbing or piloting small planes in dangerous weather. For women and men's animas, incomplete pubertal rites can be seen when, for example, individuals have limited their identity to

"responsiveness, passivity and mothering" (Whitmont 1982, p. 189). It can be also picked up in some women for whom power and knowing are perceived as coming solely from the masculine realm. Such women are the "ball breakers" who compete utilizing their highly honed analytical animuses to climb to the top of corporate hierarchies. Thinking that solar rationality is god, they never seek a relation to the goddess. Perera writes of these women, in *Descent to the Goddess*: "Such women have all the more necessity to meet the goddess in her primal reality. This inner connection is an initiation essential for most modern women in the Western world; without it we are not whole. The process requires both a sacrifice of our identity as spiritual daughter of the patriarchy and a descent into the spirit of the goddess, because so much of the power and passion of the feminine has been dormant in the underworld—in exile for five thousand years" (1981, pp. 7, 8).

Lunar Cyclic Phase

For the pubertal girl and the boy's anima, the lunar cyclic rite involves a descent and sacrifice toward the search and retrieval of embodied feminine wisdom. The Egyptian ritual of the dance of Hathor was always executed by pubescent girls. As transformer, mother, and mortuary goddess, Hathor would descend into darkness and give birth externally to the golden disc of the sun as it resurrected from the land of the dead each morning. Embodying this aspect of the archetype also means acknowledging her as the goddess of love and teacher of sexual mysteries.

A possible example of the manifestation of Hathor's pubertal rites could be seen with one women, in her second year, who reported the following dream: "I am in a dance, the teacher is like an earth mother type, she is reading choreography from a tablet with Egyptian hieroglyphics on it. It is a dance of life. We dance in a group, but each one has their own dance, their own solo part, before we dance together. It is my turn. I begin my dance with my arms upward and outstretched." She then enacted her dream.

With some of my patients undergoing this pubertal phase, shamanic initiations have also occurred. One such woman continually envisioned me as a leopard. Immediately prior to the occurrences of these visions, the energy in the room would radically change. It became thick with the archetypal. I learned to sit very still, for I felt these manifestations enter me like a powerful shot of energy and then leave. Simultaneously, her eyes would open wide with amazement. "Oh Penny," she would say, "you became a leopard again!" The leopard, one of Dionysus's creatures, became her power animal, a messenger beckon-

ing her to the underworld. This pull to the underworld brought her through the doors of darkness. In authentic movement, week after week, she lay in gnarled contorted positions. She mourned the loss of her own girlish innocence and waited for she knew not what. Finally she felt some spirit energy fill her lungs. She brought in a tape a musician had composed for her. Gradually she moved into a standing position and finally reached upward toward the sky realm. She was no longer the same woman who had entered depth analysis. Like the goddess Inanna, she had descended to meet a shadow part of herself, her dark sister. In this myth, Inanna goes to visit Ereshkigal, the queen of the netherworld, goddess of the dead, and in doing so sacrifices what she had been to become what she would be.

Women's pubertal rites of passage have been related in many fairy tales, from the prick of Sleeping Beauty's finger to Cinderella's escape, but the Greek myth of Demeter and Persephone stands out as one of the most compelling archetypal road maps. In the myth, Persephone, daughter of the earth goddess, was meandering in her mother's meadows when the earth opened up and she was taken down to the underworld to be crowned goddess of that realm, alongside Hades, its king. Demeter then began grieving and searching for the loss of her daughter (this mourning process of the mother is frequently built into pubertal rituals). Meanwhile, Persephone, now crowned queen of the underworld, has moved from maidenhood into womanhood and has begun to claim the terrain below the earth, even as her mother had laid claim to the land above. Here, Persephone can be viewed as the shadow of her mother—the Ereshkigal to her mother's Inanna.

One woman participated in choreographing the myth of Orpheus, in which she embodied and danced Persephone in a performance. As the audience was repeatedly transformed by this compelling piece, so was this woman, who in the past had found herself more in her puella than claiming her "woman of wisdom." Subsequent to the performances, in an authentic sound and movement group, she found access to an opening of energy expressed through her tonal vibrations which emerged deep within her pelvis. This vibrational energy was filled with powerful embodied gnosis. In the next authentic group she found herself tending an eternal flame then joining with other women in movement.

The Embodied Feminine

The power of the feminine lies in a woman's hips and thighs (Harding 1971, Hall 1980). Here is where women's strength resides not only for the purpose of the birthing of humanity but also for standing firm and swaying with life's cycles. Many girls' puberty rites culminate in the teaching of pelvic movements

and dances. Such pelvic rhythmic movements have evolved in numerous authentic movement groups in which the men and women danced separately, engaging in spontaneous pubertal rites. In one such group, the women spontaneously encouraged each member to enter the center of the group and engage each of the other women in turn with her movement. One woman who, prior to this dance, had felt as if she had sloughed off mermaidlike scales that had kept her from claiming her feminine power now became catlike in her expression. Her leopard-tiger quality was reflected by the other women in playful acknowledgment and sparring.

Solar Warlike Phase

For males and the animus in females, this phase entails tasks that prove their capacity to subdue and mediate their own developing brute force and sexual drive. They must also confront fear in life-threatening proportions in order to receive solar intelligence.

This masculine task is demonstrated in Hercules' slaying the Nemean lion in the first of his twelve labors. This was a beast that no weapon could wound. The lion, symbolic of strength, courage, and solar consciousness, as well as cruelty and ferocity, needs to be subdued and modified.

Theseus, yet another Greek hero, is on a higher, less instinctual level than Hercules. However, he, too, must do battle with the solar instinct in its labyrinth, which represents the tortuous circumnavigations of life's journey. The passions of man's bull fructifying nature must be attended and subdued in his fight with the Minotaur.

The struggle to experience and claim one's bull nature can perhaps be shown with one man who reported the following recurrent dream. "I am twelve years old. I am supposed to be graduating but I'm not." Within a few minutes, he associated to being four years old, a time when his father would take him to see bulls. "He would stick me right in the pen with them." The implicit message was clear; don't claim your phallic potency, or you'll be killed.

Another man, a member of an ongoing dance movement therapy group of functioning, motivated young adults, found himself exploring his own pubertal rite of passage in an interactional group authentic movement experience. At first, he described his experience as one of boredom—not knowing what he should do. He felt he wanted to hide in some way and shrouded himself with a large black piece of material and waited. Then he related a sense of the present reality fading. He stated, "I began to realize why I was there . . . was that I was

a chieftain's son and this was my day of becoming. I had to prove myself—that I could be a man."

He said he had felt foolish. When his sense of silliness subsided, he felt a realization come to him in its entirety. "What I had to do was kill the beast and find a woman. It was a realization like, 'Oh, that's why I'm sitting here. I'm sitting here preparing for that,'" he related with some liveliness. He then became more serious. "The thing I'm most in touch with is that there was this overwhelming sense of importance; that I had to do it because a lot was riding on it."

Before he began this quest, he described killing the boy in himself. He did this by having a black cape represent his boy. He danced centrifugal spiraling circles around it. His movement became freer, and at last he released himself from his relationship to the cape/boy. He then related a sense of "staking out his territory." His movements had vertical assertive qualities to them as he confronted other group members, who related to him from their own psyches unknowing that they were to serve as various archetypes for him.

The wild beast (another male group member) approached him grabbing and pulling at his cape. At first, he let himself be dragged about the room. When he attempted to use strength, he was overpowered by other group members. Then he realized he would have to use guile or trickery. He related, "It required thinking, planning, and watching for the right moment."

Then the woman appeared in the rite. She was a group member with whom he had had a special personal connection. She danced around the two men with strength, lightness, and flow with her pelvis initiating the movement. He related, "I felt like we fought over her to a standstill, then after a rest, fought again." But finally his guile won out; he completely entwined the beast in a long, stretch cloth. The three of them, with the beast in the middle, still wrapped up, began prancing around the periphery of the other group members. They then collapsed on the floor. He separated himself and sat erect, facing them. He related his presenting the beast and the woman to his father (yet another group member who unknowingly was participating in his ritual). He commented, "Initially I was a proud, swaggering kind of warrior, a very animal-brute kind of warrior—almost totally instinctual; just wanting to boast and establish my territory. After capturing the beast and woman, there was a feeling of maturity. I was still a man, I was still victorious, but I felt bigger in stature and had gotten rid of the need to boast." The experience was discussed in the context of his life: his childhood, his recent past, related dreams, his present, and his future path.

In finishing, he commented, "In some way or other, everything that I've done since I had the choice, that is, since I left home and took responsibility for myself, has had the quality of a search for something. I'm not sure what I'm looking for, but somehow there seems to be something sacred about the

looking. There is something in the looking that provides meaning for me, purpose and meaning. Without that, there would be no point to my life."

The process this man described clearly points not only to the final separation from the matriarchy and boyhood, but more specifically from the patriarchal rule. Now a man, he is free to find his own ruling principles. He is not driven to be just like dad or to live up to his dad's expectations of what he should do with his life.

One such man succumbed to the relentless push of friends and wound up at my door. He reported that for months he had traveled, hoping to find something, although he didn't know what. He was aware, however, of a growing rage inside him which was starting to feel uncomfortable. He found himself going on small destructive rampages with bursts of slicing sarcasm particularly directed toward hardworking, idealistic individuals.

His aggression, which he needed so desperately in his life, was split off from his ego mediation and was attacking his own undeveloped, responsible, capable side and all those from whom he might do well to learn. Embodying and dramatically dialoguing with this out-of-control side of himself was like Theseus and the Minotaur. I made sure Ariadne's thread was present to help bring him back to the room. The most difficult task was cutting off dad's monied umbilical cord and progressing toward what he had always wanted to do in life—be a teacher.

Conquering Fear

Conquering fear is a vital part of a man's pubertal rite of passage. One man, having come from a violent family, was faced with fears concerning anyone who might penetrate his boundaries. Eye doctors and dentists were cause for much anxiety. He had dreams of rageful creatures who wanted to kill him. He had split these shadow parts off from himself, as he was afraid of being like his abusive father, but now they were coming after him and being projected onto these seemingly benign doctors. Embodying these dream creatures, he learned from his own voice that they only wanted to participate in his life. When his appointments came up, he now embodied these creatures and was able to fight off his fear. The last time he spoke of the dentist office, he reported enjoying the whole event. He said of the process, "I imagined my fangs were being cleaned and sharpened. It was fine."

Integrating the Instinctual Phallic

The integration of a man's developing instinctual sexual nature is a crucial part of the pubertal initiation. Although an integral part of the ethnographic descriptions mentioned earlier, these rituals are present only in subcultures in the West. Claiming one's phallus was out of the question and considered sinful in one man's Catholic confirmation ritual. "We were never supposed to touch ourselves. I guess I was lucky they let us piss in the usual manner." This splitting is characteristic of the Judeo-Christian tradition, which equates superior masculinity with intellectual knowledge. This perspective rejects the value of the physical, which is equated with the feminine.

The work of Robert Bly, Monick (1987), Wyly (1989), Whitmont (1982), and others have stressed the need for men to reclaim their chthonic instinctual phallic nature. The fairy tale "Iron John," one of Bly's favorites, depicts this split-off nature of men as a rough, instinctual man who lives in the bottom of a pool. In the story, villagers who are last seen by this pool disappear. Finally, a group determined to find the cause goes into the woods, drains the pool, discovers Iron John, and takes him captive. A pubescent boy sets him free and in return is initiated into the secrets of man's phallic nature. Monick writes:

> The issue of chthonic phallus is important to men who have a strong spiritual component in their lives and/or a dominant polar masculinity. What do they do with the sweaty, hairy, animal phallus represented by Iron John? . . . the father who had lost the power and raw energy of chthonic phallus would also deny it to the son . . . and often when the father experiences the return of phallic energy, he leaves the domestic scene to act it out. Either the son inches closer to Freud's feminization or he becomes prematurely solar in his life goals, adapting himself to a masculine stance devoid of sexuality – or both. (1987, pp. 96–97)

An example of how this Iron John aspect also lives in women's animuses can be seen with one woman who could not identify with her father due to his impulsive out-of-control rage. In one session, she embodied a male Iron John dream figure who had been living at the bottom of a deep pool because "someone had squeezed his fire breathing out of him." He was extremely reluctant to emerge from this repressed state in the pool. As him, she/he stomped around and berated humanity to leave him alone. I became a Mercurial trickster figure in this movement drama, prodding him to the task at hand. In the dream, a car with a male driver had fallen into the pool and needed to be retrieved in some way. Like the shadow aspect of her animus, this fire breather also needed to be reclaimed and related to by the female dream ego. Finally, the heroic emerged in him, and he carried the body upward into consciousness for resurrection. She was deeply moved by this experience within the imaginal realm. Subse-

quent to this, she began to have dreams which suggested a gradually transforming relationship to her inner masculine and a growing assertive intellect in her life.

An example of the emerging chthonic phallus in a man's psychology can be found with one analytic patient who complained of a lack of passion in his work. He had in the past described his mother as controlling and his father as quiet. His initial analytic dream was of a snake that a pubescent boy acquired for him which, when embodied by him, stated that he had "1,000 volts of energy." In a subsequent dream, he was standing at a man's sculpture showing. Both the pieces and the artist appeared staged, stuffy and not exciting. The dream ego with a Mercurial/Dionysian tricksterlike quality suggested in laughter that a huge, wooden, erect phallus be constructed and deposited in the middle of this dry dispassionate art.

I suggested to him that both he and I imagine being in relation to this phallus. I then embodied my animus. First laughing, he and I then felt reverence for and energy from this numinous totem.

Wyly writes:

> When phallic energy is denied to the conscious awareness of an adult male, it becomes split-off. The man's ego, feeling unmasculine or effeminate, compensates with inflationary fantasies and inflated personality in its efforts to establish itself in the world. These inflations always seem collectively determined, in that they are efforts to conform to an exterior standard in a way that will compare favorably with that standard, regardless of the actual abilities or personal characteristics of the individual. (1989, p. 105)

The man who had the dream of the archetypal Phallos was no longer interested in maintaining the staid collective view which curtailed the life force and creative passion of his phallic nature. Experiencing the physical power of the phallus ensures a man's capacity to inseminate and potentiate his life and his personal path as it unfolds. Job and career choices become clear and are infused with fructifying energy.

Adolescence

Healthy adolescence requires a real sense of manhood and womanhood within both males and females. Where pubertal rites have been successful within the *temenos* of the therapy vessel, men and women can claim the fullness of their embodied soulful and spiritual selves. Acknowledging and experiencing

the power of the lunar intuitive wisdom of the feminine and the solar intellectual cognition of the masculine, personal work and sexual identity become clearly defined. Clearly, it is easier in our society to elect heterosexuality as a sexual preference. Coming out as homosexual is far more difficult and anxiety provoking. Phase-related homosexual behavior during puberty is built into many cultures' rituals and has gained more acceptance in Western societies' mainstream values. These experiences offer potentially gay and lesbian individuals opportunities to explore their sexuality. Often, however, they do not fully come out until later in young adulthood, attempting at first to go along with society's push into heterosexual relationships. This process of claiming one's sexual preference requires its own unique rite of passage which results in the joining of a specific heterosexual or homosexual group. Separation from parental or collective values becomes necessary in order to affirm individual truths, ethics, and ways of viewing the world.

Depending on the length of schooling, this phase can extend into an individual's twenties, or for that matter, into the rest of his or her life. Frequently, individuals recreate adolescent dramas with lovers, spouses, and/or work environments while they struggle finally to separate and claim their power, independence, and identity. With adolescents themselves, this is a time in which borderline dysfunction can emerge or reemerge, as another large step from the engulfing emeshed mother or father into independence is required. Addictive acting out is common here, with these individuals redramatizing the toddler rapprochement phase. In adolescents, temper tantrums become violent rages, alcoholism, drug addiction, truancy, and shoplifting, and sex and love addictions come to the foreground with abuser–victim scenarios shifting constantly.

One codependent woman related, "If a man is abusive to me, I become his slave, trying to please him. If he is a nice guy, I trash him; I don't show for dates and become the victimizer."

Those stuck in the adolescent phase frequently need to transform parental abuse and rechoreograph the rapprochement drama first, before they have sufficient boundary formation for the selection of healthier modes of rebellion and the capacity to resolve the adolescent developmental tasks of identity formation.

Summary

From learning of the rules of society in latency, individual rites of passage which draw them from childhood into adulth_... For boys and the animus in girls, brute strength, sexual instinct, and fears must be confronted and mediated toward the attainment of intellectual solar consciousness. For girls and the anima in boys, a descent to retrieve embodied feminine wisdom, often culturally unacceptable and split off, must be reclaimed. Once this ritual process is undergone, final parental separation and identity formation can occur in adolescence.

The arts have been vehicles for these initiation rituals since recorded time. They are now also being employed within the therapeutic vessel for the healing and transformation within these rites of passage.

Chapter 10

THE HEROIC AND HEROINIC QUESTS

The Evolution of the Shadow

With the rite of passage from childhood to adulthood, a whole vista opens to the growing adolescent and young adult. Aspects and characteristics of their ego and self emerge from the unconscious to be assimilated and integrated into their personality. These so-called shadow complexes appear in dreams, expressive arts material, or projected onto another person or group about which the individual has strong positive or negative feelings. Adolescents can be seen tacking up posters of idealized figures in their rooms or wearing clothes, talking, and literally enacting these idols. In psychotherapy, these shadow aspects are also frequently transferred onto and into the therapist for future reidentification and introjection.

When same-sex subpersonalities first appear from the unconscious, they are often less civilized, immature, or "rough around the edges." Because they have not been under the maturing auspices of the ego, they don't always appear to be initially easy to incorporate into the person's life; however, the more they can be explored and embodied by the individual, the more they become age-appropriate, polished, and understanding of the rules of the society in which the person lives.

These days, many bookstores have special sections on men's and women's psychology with literature which addresses archetypal aspects of these shadow figures. From Ester Harding's *Women's Mysteries* (1971) to the abundance of "goddess" books in the 1990s, women have been reading about and stimulating myriad repressed facets of the feminine. Men, having lived in a male-dominated culture for five thousand years, have had less need of these mythic universal images of manhood, but Campbell, Bly, Whitmont, and others have begun to demonstrate that there are equally repressed aspects of the masculine ego self.

The presence of a shadow figure in expressive arts or dream material usually points to an imbalance in a person's psychology. For example, one

analytic patient felt very connected to his male aspect of a romantic lover. This part of him, having evolved from the inspirational puer, was artistic and loving. His initial complaint upon entering therapy was that he had the experience of someone or some presence hovering around him. He found himself being uncomfortable with aggressive men and was starting to have anxious ruminations about being attacked. He reported he had no history of being hostilely abused by either his father or mother's animus or anyone else for that matter. I suggested he imagine and then draw a personification of the type of man who seemed to bother him. The next week he brought in a picture, and he and I began a dialogue with this shadow part of himself.

Opposite the lover-humanist with which he readily identified, this personification was more warriorlike. His focus was on defense, protection, and assertive action to get what he needed. When he embodied this shadow part of himself, he reported feeling very different, more sure of himself. He came to know that this process of individuation was not about getting rid of one part of himself for another, but rather expanding his own personality and having a greater repertoire of ways of being and adapting.

Another man defined himself as a powerful managerial executive. His life was entirely within his control. He was a caring and concerned husband and father. He certainly ruled over his realm. His reason for coming to see me was that he had had a strange experience while going some distance to a business meeting. Like the other man, he, too, felt as if there was another presence with him in his car. By description, this uninvited companion sounded like a trickster, coyote-type figure who completely turned his world upside-down— most disquieting to this man who seemed to have everything in order. This shadow side had a real sense of humor, but my patient seemed always to be the brunt of his ridicule. By the end of his work, his inner trickster side had evolved into a very wise shamanic aspect. More and more doors to different realities began to open; nothing was ever the same. Like the Shakespearean fool, his inner king now had a whimsically wise advisor through which to view his world.

Women as well continuously discover and integrate various aspects of their own feminine nature, from the wise and powerful Athena to the moon goddess Artemis whose one-unto-herself nature affords women independence and self-assuredness.

The following provides an example of one woman's introduction to a shadow figure. The woman, now outgrowing her codependent way of being, had been the dutiful daughter, attempting to control through obedience to her mother and then her husband. With less significant others, she became a "superstar," struggling to gain their approval via professional success (Leonard 1982). Now, while in analysis, she had left her husband and her good girl and was letting go of her superstar image. She felt herself to be without identity. About this time,

a huge, barroom, "hard-assed" woman appeared in her dreams, dressed in a "polyester leisure suit." This demure, almost anorexic woman was always tastefully dressed in upper middle class garb. The thought that this dream figure was a part of her was initially quite repugnant. Embodying this woman, she told the patient just what she thought of her ex-husband and what she should do with his manipulative abuse. As she wielded her weight around the therapy room, it became clearer to this woman how helpful this part of her could be in the divorce process. "She just needs a little refining—not a whole lot—just a little," the patient reported.

At times, these shadow aspects are present in consciousness but need humanizing. Such was the case with one woman who complained of having difficulty with a supervisor who viewed the whole world as being potentially abusive. Having been terribly abused herself, she acted toward my patient, a caring and highly responsible woman, as if she were going to commit a heinous crime at any moment. My patient found it difficult to let go of the unfortunate experiences with this woman, even though she was no longer working with her. She then began to realize that there was an inner hook. The woman was like a part of her that evolved initially to protect her and keep her safe from doing anything that would get her into trouble, but now it was keeping her from moving on in her profession. She realized this shadow part of her needed transformation. As her inner supervisor, she tensed her external musculature like an Amazonian warrioress or an Athena. She then imaged bringing her to a healing pool, knelt down, and bathed her in the water such that the external warrior persona sloughed off. Now her wounded vulnerable skin was experienced. She realized these were not her wounds but her mother's and grandmother's that she had carried and internalized. Imaginally sending these wounds back to their sources, she was left with a powerful supportive protectoress.

Coniunctio

The Developing Presence of and Union with the Contrasexual Sides

The quest of the heroic and heroinic ego/self commences with a relationship to both the masculine and feminine sides. Thus, a man must evolve a relationship and subsequently join with his anima and a woman's female ego with her animus. Frequently, the contrasexual sides are projected onto a lover for an embodied experience of the sexual union, but the libido, which belongs to the

inner anima or animus, must eventually be reowned and internalized or the individual will forever feel that she or he is only half a person without the other.

This is the case with many individuals who enter treatment at a time of loss of a spouse or lover. Supporting the rage and grief is only part of my role; helping them give themselves back to themselves is even more crucial.

An example of the needed reclaiming of projected parental complexes can be found in work with a couple. They struggled to be intimate; their inability to accomplish this stemmed from not yet having been able to feel their own contrasexual sides due to complexes that they thought protected them but in reality kept them from love.

I placed two sand-tray figures—a witch (an aspect of her inner mother) and two-headed dragon (a rageful aspect of his inner father)—between them on a pillow and role played these complexes when they would constellate in the work (see figure 10.1). The wife was kept from a relationship to the masculine by an inner witch mother who imprisoned her in a tower like Rapunzel. I would say, as the witch, "All men are selfish, demanding pricks who just want you to be their housekeeper and whore." The husband, who had been abused as a

FIGURE 10.1 **Sand Play: Couple's Witch and Dragon: Internalized Aspects of Their Parental Complexes**

(Source: Private collection)

child and abandoned through an early death by the mother, defended himself by becoming a two-headed dragon (his selection). "Torch her, kill the bitch! People will either beat you up or abandon you. I'll protect you. Don't be vulnerable, sensitive, or in touch with your feelings," I/the dragon would respond.

Many sessions were spent separating these, which I referred to as "shit throwing complexes," so that they could reach out to each other and themselves. When this occurred, there was a great deal of love and openness between them. At these times, the husband would become softer, more feeling connected, and the wife more empowered in a focused analytic manner. Thus both had also claimed more of their contrasexual sides hitherto negatively projected onto the other.

One woman dreamed of an animus figure who was associated to a warm, caring storyteller. In the dream, he held her and she felt quite wonderful, but the union between the two was interrupted. I encouraged her to engage in embodied active imagination and experience the union.

She reported, "He moves toward me and we become one. Mist surrounds us, then we become the mist, we are joined with everyone and everything." When the mist differentiated again, she reported that they were dancing in a huge circle of people.

An example of a man's process of claiming his inner anima can be found with one analytic patient who had fought and won the battle of addictions and codependency and had then experienced a pubertal spiritual awakening. Subsequently, he brought in the following dream: "A woman shows me limitless knowledge, then stands naked in front of me. I move toward her. She joins with me by blending into my body." I encouraged him to experience the union of this inner feminine with himself. Through my somatic countertransference connection, she also entered me. I felt her eternal beauty, serenity, and wisdom; I was deeply moved as was he. I encouraged him to maintain conscious awareness of this union during the week. He came back with much astonishment and related how people responded differently to him. People were drawn to tell him personal issues. He also realized he was responding from a very different place. He was aware of a capacity to confront with love, to stand his ground — not in an aggressive sense, but rather from a different place of powerful inner knowing. I explained that this is the realm of the feminine, whose power resides in her hips and her grounded connection to the earth. This was the place of soulful gnosis rather than the masculine realm of spiritual logos. Although this experience felt quite wonderful to him, he was fearful that she would not fit in with the "good old boy" mentality at work. Backing off, he had the following dream: "I'm at a corporate meeting. I and my colleagues are milling around. I see this woman, she is kneeling on the floor. I bend down to help her. She looks up at me and says, 'Are you ashamed of me?'"

It took this man several months to join once again his masculine ego with his anima. Truly the male-dominated Western society in which he lived did not support an androgynous balance between the masculine and feminine sides. Our borderline culture split off the feminine when the goddess was suppressed and the male god of the Judaic culture began to rule. Women and the feminine in men were considered inferior, instinctual, and hysterical. To claim one's feminine side subjects a man to potential ostracism from frightened men.

Another man talked of how adolescent boys would admonish and scapegoat sensitive fellow students with terms such as *fag* and *homo*. In terms of ways of knowing, our culture has continued to support a solely Apollonian solar rational perspective over a joint relationship to the lunar intuitive. Apollo, god of order, purity, clarity, harmony, and maintaining, has turned the androgynous Christ and Christianity into a patriarchal religion, repressing the feminine and the Dionysian in both men and women.

One woman, raised in staunch Catholicism, engaged in authentic movement. Her own alchemical, instinctual feminine cycle had been blocked. She reported, "I am in a desert; the sun is beating down; I need soil to fertilize and be fertilized by, but everything is sand."

For women and men's anima, it is Pallas Athena who most clearly represents the solar rationale. She is a daughter to the father as she was born out of her father's head. She is the rational warrior and gains her wisdom from the patriarch, not from the embodied feminine. I see Athena women armed in the "yuppie" persona of the upwardly mobile businesswomen who compete with powerful men. Many of them have, by mistake, sacrificed their feminine lunar side to the flames of the rational and seek reembodiment. Perera writes of the needed "unveiling" of these women: "Such unveiling is immensely hard for a daughter of the fathers (and it is probably no accident that Athena was born in full armor), for it means giving up both defensiveness and illusion of identity provided by the regalia of the upper world. Those rules and marks of power and status earned from the patriarchy which serve as surrogate, personal identity to a woman who is handmaid to the fathers and the animus" (1981, pp. 59–60) Here "embodied being" thus needs to replace "split-off doing."

Alchemical Coniunctio

In the alchemical text, the *Rosarium Philosophorum*, polar contrasexual aspects of sol (sun king) and luna (moon queen) descend into the "stinking water" which contains everything it needs. Here the king stands for spirit and the queen, body-soul. Both must be united in order for the gold of selfhood to emerge. It is written in this alchemical text, "Merge and dissolve as they come

to their goal of perfection: they that were two are made one" (Jung 1946, par. 457).

In *solutio*, like the initial descent into the liminal realm, a regression or intoxication into the liquid unconscious is needed in order to fertilize consciousness. Such a descent occurred with one woman who, for months, lay on the blue rug of my studio floor, submerged in the liquid nature of her own inner life. In the past, she had lived a highly ordered patriarchal (sol, sun king) life with one event regimentally following another in a linear progression. Now she began to learn, through embodied immersion, about the joining with luna, the moon queen and feminine time—the time of circles and spirals, of recurring cycles, of death and rebirth.

With others, the struggle to claim and join with the feminine side has been impeded by an overdominant mother who keeps the male ego under her control. When she can be killed off in the magic warlike rite of passage, an anima ready to be related to and joined with naturally unfolds with adolescent and adult males.

The myth of Cupid and Psyche has been viewed from both masculine and feminine ego perspectives. From the masculine ego, it is the search for a relation to the anima which is not ruled over by the mother complex. We may recall that it was a jealous Aphrodite that commanded her son, Eros, to punish beautiful Psyche. If a man remains caught in his mother's power, all women are devalued.

Amor, of course, falls in love with Psyche but insists that the sexual union be an unconscious one, i.e., he would come to her only at night. This is the man who doesn't value the woman for who she is inside but rather as a sexual object.

Prodded by her shadow side, her sisters, Psyche seeks to know Cupid and see if, in fact, he is a beast as he has identified himself to be. "This forthright seeing is an act of love," Ulanov writes, and thus begins to humanize the god beast (1971, p. 225). Ulanov continues, "Psyche demands that Eros assume comparable heroic proportions encountering and relating to the feminine on an individual rather than a collective basis, that is to say, not to a woman, but to this woman, not to sex, but in a sexual response to this person, not knowing himself as a male, but as this particular man who knows his maleness in relation to this woman" (pp. 229–230) (see figure 10.2).

One man in one of my authentic sound, movement, and drama therapy groups enacted a separation from and killing of his mother complex with me (see chapter 8). After this dramatic movement process, he moved from a standing to a seated position. A dark-eyed female member sat behind him and put her arms around him in order, as she later expressed it, to "encourage him to love himself." He said of this time that he felt a wonderful softness coming over him. He said, "I just wanted to touch her hair—not like a sexual come-on, but just to feel its softness."

FIGURE 10.2 **Amor and Psyche**

(Source: from "The Story of Cupid and
Psyche," illustrated by Sir Edward
Burne-Jones, engraved on wood by William
Morris, Cambridge, 1974. Reprinted by
permission of the Society of Antiquaries)

Then the woman sat in front of him, and he put his hands at the base of her
spine, supporting her. She said, "It felt wonderful, this powerful support." Here
she began to feel the archetypal presence of the enabling masculine that sup-
ports and encourages a woman's feminine ego, so vital in the resolution of the
magical creative phase.

She continued, "I was weaving this huge tapestry." (Of note is the fact that
another female group member reported she was imagining herself spinning
threads prior to this.) At this point, the man's movements developed from
undulating swaying movements (feminine inner genital rhythms) into more
intense birthing contraction rhythms as he began to push her from him. He said
of this time, "I felt that I was giving birth to her." During this transition, another
woman had come to sit behind him and was supporting him. He remarked how
important this was. From this birthing movement, he could then help her stand
by raising her upward to receive inspiration.

Another man in a drama movement therapy improvisation joined with a
woman embodying his feminine side, who emerged out of an imaginal river.

From the perspective of the river woman, this union with her animus started her on a journey which brought her in contact with various aspects of her own feminine nature. From the medial, she became *hetaera*, mother, and Amazon.

If the Amor and Psyche myth is taken from the perspective of the feminine, Psyche, like this woman, now awakened into consciousness, must undertake numerous tasks to develop her feminine, whether it be a man's anima or a woman's ego self.

In many cases, the evolving animus or anima may need to be healed first in order for a union to occur. Here the story of Isis and Osiris and their shadow siblings, Nepthys and Set, pertains. Born of Geb and Nut, Isis and Osiris ruled in a complementary manner over Egypt. "When Osiris gave woman grain, she taught them how to make flour and bake bread. With her magical and medical knowledge, she assisted in the cure of his subjects" (Zabriski 1985, p. 48). But Set, like Cain, was jealous and killed his brother Osiris by hacking him to pieces and scattering his remains. Isis and Nepthys sought out the fragments from all over the world. Everything but his phallus was found. So Isis fashioned one, then transfigured herself into a bird and joined in sexual union with him. Frequently, it is the therapist who embodies Isis and Nepthys and gathers the fragmented pieces of the patient's masculine nature through the somatic countertransference and encourages the patient through reidentification to join with this healed aspect.

The healing of the inner masculine through a *coniunctio* process can be seen in one woman's dreams of healing crippled and deformed men through various forms of sexual union. As her feminine ego joined with them, their bodies would heal and they would be able to stand erect and claim their power. Experiencing these unions was not solely an erotic experience, but more importantly one which gave her a newfound wholeness.

Men, too, need at times to heal their animas. One man reported seeing his sisters being abused by his father. He felt helpless to stop the horror. In adulthood, he feared relationships with women, not knowing whether he would abuse them or they him. In session, he allowed an image of his anima to emerge and be personified by him. She/he reported, "I am wounded and hurt." Not unsurprisingly he began a relationship with a young woman who had been abused. (The level of anima or animus development or health can always be detected in whom an individual chooses to be their significant other. It does not matter if the relationship is heterosexual or homosexual, as contrasexual sides may be projected onto any sex). To return to this man, he then came in with a dream. In the dream, his anima said, "You have killed me." He responded, "Well, if I have killed you, then I can bring you back to life." By this time, the anima had become skull-like. Not deterred by this vision, he kissed the skull, and she was reanimated and became a beautiful woman. I then encouraged him to imagine embracing her at night, which he did.

He also began to compose a symphony to her, using a multitrack electronic synthesizer. The various movements of the symphony delineated the search and retrieval of the feminine from the evil sorcerer. Two lyrical thematic threads in the piece, denoting the hero and heroine, finally meet in a rhythmic and tonal union. He also wrote a poem about the longing and experience of this union, entitled "My Love."

> *I've been to Heaven*
> *I've been to Hell*
> *Where My Love is*
> *I cannot tell.*
>
> *The fires of Hell*
> *Would not keep me back*
> *If she were there*
> *For sure, for fact.*
>
> *A choir of Angels*
> *What a brilliant delight*
> *Yet I sit here alone*
> *Writing by candlelight.*
>
> *My heart is strong*
> *I long so much*
> *I desire your warmth,*
> *your embrace, your touch.*
>
> *The fullness of life*
> *is waiting for me*
> *Yet I neglect it for now*
> *Until I find thee.*
>
> *My Love, My Love*
> *Hear me now*
> *I will find you, I promise*
> *Someway, somehow.*
>
> *(His anima responds):*
>
> *My Dear, My Dear*
> *It is so clear*
> *You are forever looking*
> *And I am here.*
>
> *I tried to catch you*
> *but you were too fast*
> *If you only looked back*
> *I would be there at last.*

Orpheus and Lot
 Were both not to do
What was your answer
 Not for them, but for you.

Stand perfectly still
 And I will find you
Let me do the looking
 Let me come to you.

We are together
 One and the same
To be apart
 Is mad, insane.

The world is complete
 The universe is whole
My joy is overwhelming
 I cannot control.

Let there be festivals,
 Merriment, and song
Continue this praise
 A whole year long.

Let the world know
 We are together at last
We can never be apart
 Unlike the past.

From this day onward
 The world is at my command
With My Love at my side
 Holding my hand.

After having written this poem, he described the room filling with glowing energy.

Another man in depth work discovered and sculpted his anima, which had been encased in the larger container of the mother complex. His next sculpture he described as an androgynous union of masculine angles and the curves of the feminine in a spiral which rose and fell in a cyclic flow (see figure 10.3). In the course of treatment, the transference had evolved from me as the ever-hungry mother who must be fed with dream presentations and smiles to a mysterious anima filled with heroinic soul. He was also able to enter into a relationship with a woman who he subsequently married. Prior to this, he would deliberately sabotage his relationships.

In the next figure, the sand play of another man who sought a connection to his feminine side is shown, and the feminine is depicted in many of her aspects as maiden, dancer, luna, and spiritual angel of salvation. He said, "I've searched

FIGURE 10.3 **The** *Coniunctio*
(Source: Private collection)

for a middle point between my instincts and my fantasy but nothing comes yet." His shadow aspects struggled to join with his feminine side — still considered "fantasy" by him. His connection to the feminine was still under the control of the mother. For him, women were to use and steal from, for they, still shrouded by the inner mother, were experienced as controlling and powerful (see figure 10.4).

Coniunctio *in the Transference*

The alchemical philosophers recognized that varying levels of union were crucial to the process of evolving the gold of unified wholeness. Jung (1946) also explored these levels of *coniunctio* within the patient/therapist relationship. His model was limited to his perspective, however. Thus, the therapist was assumed to be male and the patient female, with her animus relating to his anima. This model can easily be expanded, however, as shown in Table 10.1.

One male patient in his sixties dreamed that we were engaged in sexual union. In the dream, he suggested I turn and he enter me from behind. I nod in affirmation. He associated to the dream the feeling of my becoming more trusting of him. The message to me was to relate to him through the back, i.e.,

FIGURE 10.4 **Man's Sand Play: Search for** *Coniunctio*

(Source: Private collection)

TABLE 10.1 **Models of the *Coniunctio* in Patient/Therapist Relationships**

Jung's Model

Male therapist Ego	Female patient Ego
Therapist's anima	Patient's animus

Other Models

Female therapist	Male patient
Therapist's animus	Patient's anima

or

Female therapist	Female patient
Therapist's animus	Patient's animus

or

Male therapist	Male patient
Therapist's anima	Patient's anima

through the somatic unconscious. Focusing on the somatic countertransference, I imagined emptying myself. He continued to talk but I was less conscious of his secondary process. I felt myself filling with his undifferentiated psychic energy. I reported to him that I felt something beyond what he was speaking about was occurring. "Yes," he said, "I feel like laughing. I feel my chest is filling." His eyes brimmed with tears. Then I commented on an earlier eroticization and desire by him literally to run away with me. I said, "Had I really gone away with you when you wanted me to, you would have thought you had this experience because of me. Now you know this is yours to put in me and take back when you want it." Having been a son consort to his mother and every other woman in his life, this new recognition of having his manhood and creative potency for himself was a "joyful" experience for him.

Death and Descent

Once both contrasexual natures have been differentiated out of parental complexes and join together toward a united purpose, the quest begins its most treacherous phase. Because of this, many are unwilling to pursue it and stay frozen in the solar realm. But if the hero and heroine take on the quest, there are many myths of gods and goddesses that serve as guides; and through this relationship to the archetype, individuals can feel deeply connected to all of humanity – past, present, and future – thus instilling meaning to their suffering.

The god of the grapevine, Dionysus, represented darkness, disruption, and death. Every year, the vines were crucified and cut back to bare stumps in the

ground. Dionysus, too, would be mutilated, only to be rejuvenated in spring and lead orgiastic rites. During these rites, this phallic fertility god would lead the Maenads, drunken with wine believed to be his spirit, to rampage the forests and eat the raw flesh of animals personifying his body. This early eucharist of a god destined to be relegated in Christian mythology to the devil is split off in modern society. Therapists using the expressive arts may frequently find themselves in the role of putting an individual back in touch with this powerful, compelling, instinctual force through a reclamation of embodied experience.

Whitmont writes,

> Psychologically, the world of Dionysus is the world of embodied raw nature and of passion in its double aspect of rapture and suffering. It expresses the primacy of longing, lustfulness and joyous ecstasy which includes raging violence, destructiveness and even the urge for self-annihilation. (1982, p. 59)

If these emotions are not attended to consciously, they will find other ways to emerge. An example of some "other ways" can be found with one woman patient who initially refused the pull to her own psychic death. Weekly she reported synchronistic events of physical trauma and difficulty with her car. This woman finally came into my office with a dream about a young man who had recently died. In the dream, she descended to find him in a temple by a lake. He instructed her that she would be dead in forty-eight hours. I reminded her that it was forty-eight hours since the dream. She lay down on the floor and was able to succumb to her own needed death and mutilation. She described dissolving into a mushlike state. This state continued for weeks.

By far the strongest heroic symbol of death and eventual rebirth is Christ. The picture of a treelike cross with the fruits depicting the stages of Christ's passion connects him to his Greek counterpart, Dionysus (see figure 10.5). In John 15:1, Christ says, "I am the true vine, and my Father is the vine dresser." It is the heroic Christ's conscious decision to suffer death upon the cross which so powerfully connected him to other suffering individuals. Here meaning to suffering was again bestowed on humanity through the Christ as an individuating Self figure.

It was Christ's conscious decision for the death quest in the Garden of Gethsemane which was reflected in a transference dream of a patient in which my name was changed to "Dr. Gethsemane." Another woman in her death phase reported from an authentic movement experience that she first found herself lying in a desert but then realized she couldn't rot there and was moved to grassy earth that was in the shape of a cross.

The process of death and descent was enacted in an improvisational drama

FIGURE 10.5 **Crucified Christ**

(Source: Florentine Workshop, School of
Pacino di Bonaguida, Galleria dell'Academia,
Firenze. Reprinted by permission.)

group which had been ongoing for several months. For close to two hours, one
woman remained immobile, self-shrouded in black. While still in death, other
group members projected onto her. Some related to her as that part of them-
selves that had needed to die; for others she became the archaic internalized
mother whose old ways of relating to the ego-self needed to die in order to be
transformed. The thought that "maybe she might come back as something else"
enabled the group to surrender to her rotting and to the final proclamation of

"She's dead!" During the processing time, the woman embodying the death experience described going down into a long tunnel in which she saw all the shades of the individuals she cared for now deceased. A spiral eventually brought her into a vacuum through which she was sucked back into the realm of the living. Weeks later, in her embodied myth, she bridged the gap between life and death. Her myth, dramatized in her native language, translates as:

Then the Lord God formed humankind of the dust of the ground
I abbreviate my body and bend down, submissive to brown existence
I become earth to myself
After I examined myself through the reddish burning fire
When the wind caresses my limbs
When I return to woman again
I become like earth fresh fertile who will know the right time to produce
When I return to woman again, I will be WO-MAN.

An example of a man's process of death and rebirth can be found with a man in analytic work, who had left his traditional role to begin the journey. Soon after the beginning of the analytic work, he dreamed that his wife ushered him into a labyrinth which ended in a circular room where everything was "softly feminine." Two plants dripped golden nectar from their veins into a vessel. He drank of this ambrosia. Reentering the dream, he experienced the results of the ingestion and connection with the archetypal feminine. He reported bodily sensations of "qualitative, timeless, spaceless being." He said as well that it was a "wordless place of wisdom."

In the following analytic session, he experienced a deathly descent. He felt a stillness and tears as if to mourn his own death. A dog sat at his side to let him know he could take as long as he liked. He said, "All of who I was is going." Countertransferentially, I knew there was nothing to be done but wait silently at the tomb. Week after week, he would bring in dreams of descent and of existing structures being systematically leveled. In one session, inspired by a dream, he moved sequentially in all four directions, then fell down and backward to the floor. He entered into labyrinths and discovered what had previously been imprisoned in him by his solar rational side. At times, he would wish to rise above the descent by leaping and dreaming of soaring with his puer-Icarus aspect; always I would gently through embodied stillness draw him back to his journey. In one dream, a mathematics instructor named Lewis gave him an equation to solve, the meaning of which pointed to this time as being one of introversion. In a series of dreams over time, he was taught certain movements akin to a synthesis of t'ai chi and the I Ching which, when he embodied them, facilitated transformation.

In alchemy as well, death or *mortificatio* follows the joining of sol and luna. The *Rosarium* depicts them as lying submerged and putrefying as their spirit and soul leave their lifeless bodies. This process, Jung wrote, "leads into regions of inner experience which defy our powers of scientific description. At this point . . . the idea of mystery forces itself upon the mind of the inquirer" (1946, par. 482). But to undergo this, one must be willing to experience death, defeat, and failure. Edinger writes of this: "Needless to say one rarely chooses such an experience. It is usually imposed by life, either from within or synchronistically from without" (1981, p. 37).

In a series of double-hour sessions over the period of a year, one woman structured her visits as follows. First she would draw and talk, then engage in authentic movement, then explore in sand play.

Initially, in authentic movement, she began to experience her body covered with garbage in a dark space deep within the bowels of the earth. She reported she was to be eaten alive by devouring vampirelike creatures. As she began to claim her own relationship to this death pull within herself, she systematically neutralized the inner negative mother and father through burials in the sand. Many skeletal pieces appeared in her sand work as she struggled through this process of mortification. She said, after many months, "I'm afraid a lot is dying in me and I might not have anything to replace it with" (see figure 10.6).

FIGURE 10.6 **Sand Play: Death and Descent**
(Source: Private collection)

Resistance could be seen in her weekly movement through upward directional shapes which split her from her own strength. At these times, I would often move with her and encourage her through reflection and body movement development to initiate downward movements reinforcing her experience of feeling strength and power in her own thighs and hips. Gradually, she began to claim a relationship to a powerful archetypal influence manifested through Native American lore and the goddess of the beasts. The claiming of and relationship to this wild woman meant she could move from being a father's daughter to experiencing her vital instinctual soul. At this time, she would ask for my hand, and she and I would walk about the darkened room imaginally surrounded by the powerful animals of the forest and jungle.

Archetypal Penetration of the Feminine

For women, the journey to death is at times preceded by a numinous rape by her deeper archetypal unconscious. In this act, she is impregnated by an individuating potential. Neumann wrote, "She is seized and laid hold of by a powerful penetration that is not personally related to a concrete male but is experienced as an anonymous transpersonal numen" (n.d., p. 13). A woman's body-felt experience is thus joined by spiritual penetration. In this way, women's soulful wisdom unites with solar spiritual consciousness.

The Greek god Zeus is a prime mythic symbol for such a penetration, whether as a swan with Lida, as a bull in the rape of Europa, as a cloud with Io, or as a shower of life-giving golden rays penetrating Danae.

One woman, in the process of claiming her own experience of herself as a sexual woman, lay supine on the blue rug in my office, her feet on the floor. A stillness preceded a numinous energy which filled the room. Her thighs opened to receive. After the experience, she described being penetrated by golden rays of light which illuminated her internally such that she felt deeply seen and known.

The Christian counterpart is, of course, Mary's visitation by the Holy Spirit, frequently depicted as a shower of golden light. This visitation was experienced by a woman who, in dramatic improvisation, called for her deceased father. What she received was an experience of being known by the Great Father through a numinous shaft of light which shot up her spine from her vagina like a shot of kundalini energy. This experience of being known, as in the Old Testament, is both a psychic and a bodily experience.

The Experience of Hell

Invariably when individuals descend into darkness and death, they experience a hellish place. The Judeo-Christian dualistic view splits the Taoist unity of opposites into Yahweh and Satan, Christ and the devil.

Three women in an authentic sound, movement, and drama therapy group were crouched on the floor. Like the three witches over a caldron, they cackled and chopped up what needed to die. Vocally they improvised a song as they danced arm in arm with downward thrusts, "Stomp'n on the bones, smashing on the bones, trash'n on the bones," until there was nothing but dust beneath their feet. They then gathered it in their hands and blew the imaginal *prima materia* in four directions.

One man in depth work spent many months in hell and came to comprehend a richer understanding than what his childhood religious training had provided him. Repeatedly, through nightmares and visions, he was cascaded down long shafts in which he saw many shades screaming and moaning at him. He had lived much of his life in fear having been abused as a child. Now, in an authentic movement and improvisational drama group, I was compelled through receiving from the somatic countertransference to hand him a sword. I had no idea why I did this until the sword reached his hands. I realized, as he later confirmed, that I became the Lady of the Lake to his Arthur. As the hero, he then actively pursued the hellish characters which entered into his personal quest.

He learned over and over again to overcome the fears that he had toward the creatures of the night. Rats and wolves became imaginal pals that he could take with him into his daily life, asking their opinion of individuals or situations. As being after being confronted him, such as wolfmen, Dracula, and zombies, he engaged with them and learned their secrets. Instead of, for example, viewing wolfmen as destructive, he began to understand their power of metamorphosis and its service to healing. He learned how to summon wolves and embody them and experienced "unusual power" to give him strength to overcome fear and help others (see figure 10.7). He found a quote from Paul in his letter to the Romans, "I know with certainty on the authority of the Lord Jesus that Nothing is unclean in itself; it is only when a man thinks something unclean that it becomes so for him" (Romans 14:14).

He realized also that, "By the same acts that cause some men to burn in Hell for thousands of years, the Yogin gains his eternal salvation" (Testani 1990, p. 59). This man experienced what I have come to know from over twenty-five years of working in this field: that the deeper an individual descends and the longer he or she stays, the more profound the ascent and the more spiritual consciousness attained.

FIGURE 10.7 **Empowered Wolfman**
(Source: Private collection)

Ascent, Resurrection, and Rebirth

Jung (1946) wrote of this alchemical process, "The black or unconscious state that resulted from the union of opposites reaches nadir and change sets in . . . the ever deeper descent into the unconscious suddenly becomes illumination from above . . . the preceding union of opposites has brought light, as always, out of the darkness of night, and by this light it will be possible to see what the real meaning of that union was" (par. 493).

It has always been a fascination to me that as long as my patients struggle to

get free from the dark places of their "night sea journeys" they are invariably continuously pulled back. It is only when they surrender to being in this place that they can eventually experience the light of resurrection.

The patient typically engages in very little talking at this point. Both of us experience the inertia and heaviness of death. If I did not know this journey and its cyclic timing, I might be apt to encourage them upward out of this needed depression prior to its nadir. But when that bottom point is experienced, neither my patient nor myself can move. Life comes only from the grace of the Divine. Subtly and yet so powerfully, life is brought back into the therapy vessel.

The alchemists of the *Rosarium* envisioned that process through the images of the soul and spirit reentering the now-joined bodies of sol and luna.

The experience of the "self that hovers" in the return of the soul/spirit to the body was experienced with a female patient with whom I was in the process of terminating. She had reported a dream in which she embodied her masculine and creative feminine sides (her personal version of the emerging birth of the hermaphroditic self). A deep silence filled the room. She looked out the large window behind my left shoulder and mentioned the wind, which was gently but powerfully making its presence known. The wind, frequently employed as a religious symbol of the breath of the spirit of life of the godhead, seemed to enter the room. Jung (1946) writes of the return of the soul during the alchemical process in "The Psychology of the Transference": "Here the reconciler, the soul, dives down from heaven to breathe life into the dead body" (par. 494).

I felt a compelling energy to maintain visual connection to her. She slowly moved her eyes from the outside to my eyes. Our eyes, like some awesome energy conduit, remained fixed. I felt my body seemingly disappear: it was as if my eyes were given over in service to an all-powerful objective psyche, and I was seeing through the experience of the Self. My eyes now riveted, I began to see a wavy flow of energy over her head. While it stayed over her, the room filled with a blinding light. When it returned to normal, I saw this energy enter into her body. In stillness, she then remarked, "There was more than just you and me in this room." I nod my head. She continued, "I felt like I or something was hovering over me, almost like an out-of-body experience. Then it entered me. I feel very full and peaceful." I, meanwhile, was experiencing a lighted space between each cell, each atom of my body. I, too, felt very clear and calm. For when the archetypal is constellated, it heals all in its presence.

The birthing of the union of opposites, powerfully sculpted by one patient, was a statement by her of her empowerment. From the birth canal came a yin/yang cresting into the light of day (see figure 10.8).

This rebirth or reanimation is a result of the higher union. Harding writes, "Ecstasis involves a loss of oneself in something beyond oneself. . . . The experience is not of union with the beloved, but a completely separate and

FIGURE 10.8 **The Androgynous Birth**
(Source: Private collection)

separating absorption in an inner happening of greatest significance" (1947, p. 149). One does not feel this to be a loss, but rather a gain, as though one were thereby renewed, or transformed, or made whole. "The ego is cured of its littleness and its separateness and is made whole through union with the nonpersonal daemon of instinctive life" (ibid., p. 155).

A batik done by a woman patient can be viewed as representing the higher *coniunctio* with the numinous union of the sun-spirit-sol and the moon-soul-luna representing the Taoistic union of all polarities. When this higher joining occurs, the deepest layer of the archetypal is opened to individuals for their healing and transformation (see figure 10.9).

Edinger (1980) speaks of the process of higher sublimatio in that it is "a translation to eternity" (p. 66), "an encounter with the numinosum" (p. 60), which releases the spirit hidden in matter.

Themes of upward movement including ascent, flying, buoyancy, weightlessness, and the climbing-up ways of the shaman for revelation are all part of this experience. I have seen and experienced this phenomenon over and over

FIGURE 10.9 **Higher** *Coniunctio*

(Source: Private collection)

again with individuals and groups who have been free to experience their journeys within the imaginal realm. When this energy fills the room, I am filled as well.

There have been times when my chest has become swollen with such pneuma from the spirit archetype that I cannot keep myself from ascending; my arms move outward and upward with ecstatic joy. There is no way for me to capture in the written word the numinous energy which archetypal movement can evoke and constellate. Its power can only be understood through the experience of it.

I have viewed over and over again the archetypal movement of the gathering of the soul of the earth and of the rising up to draw down the experience of

the eternal, universal spirit as patients achieve greater wholeness and self-hood. This is the gold of the alchemical opus, the *lapis philosophorum*.

Edinger (1980) selected a segment from the ancient *Emerald Tablet of Hermes* on this phenomena. It states:

> It ascends from the earth to the heaven, and descends again to the earth and receives the power of the above and the below. Thus you will have the glory of the whole world. Therefore all darkness will flee from you. (p. 73)

I found myself in one authentic sound, drama, and movement therapy group compelled through the somatic countertransference to consecrate a Tibetan bowl bell that I had in the room. Although I had no initial idea what or why I was doing what I was doing, I continued nonetheless.

The movement I was doing again reflected the same archetypal soul/spirit pattern described above. While kneeling, I made gathering movements around the bowl, then cupped my hands underneath it and lifted it toward the sky. I repeated this several times and on many occasions found it taken from me when I had completed its raising. I would leave my arms in an upward position and it would be returned to me.

At some point, I felt compelled to go over to one group member who remained huddled in a corner. A man who I later learned was the one who took the bowl from my hands came to her as well. We both knelt in front of her with the bowl between us and began anointing, cleansing, baptizing her with imaginal water from the bowl. Again, I felt a presence enter me but this time it felt very loving and deeply sad. I began sobbing and the man did as well, along with the woman. Now we began anointing each other as if we all had been through a hell together and needed to be healed and released to a new life.

At some point it became clear to me that I was her deceased mother and that the man beside me was her father, who had also died. This was the first time she had been able to mourn their loss and her pain as it had remained frozen in her since childhood.

When these powerful numinous experiences occur, I feel healed as well and humbled. Truly, archetypal themes move us from the core of ourselves in the dramas which make up the human quest toward individuation. When patient and therapist open themselves to a relationship to the Self, transformation follows.

This divine cycle of death and rebirth is reflected in cultures' gods, from Egypt to the ancient Mayans in Mexico. The Egyptian god Osiris, after the union with Isis, descends to become the god of the underworld. As the god of suffering, he is power in potentia; like the black earth, he is the *prima materia*

filled with all that is needed for eternal life. Osiris – now green – symbolic of his personification as the eternal fertility god greets the dead to the eternal realm.

In classical Greece, Dionysus's resurrection and Persephone's return were celebrated at mystery rites. Dionysus would lead the initiates in their ecstactic dance. Enacting Dionysus's dismemberment and burial, they were brought to Persephone in the land of the dead to commence the greater mysteries at Eleusis, in which rebirth took place. In the greater mysteries, the mystic pig was sacrificed and a ram's fleece was held over the candidate's head as a symbol of purification. Then the initiate caressed the great coiled snake of the enthroned Demeter and saw an ear of corn raised as symbolic of the new birth.

The mystery rites at Eleusis were unconsciously performed in a weekend movement group at a Jungian institute, culminating in an improvisational dance accompanied by a congo drum. Prior to this, the participants had offered up fragments of dreams for me to weave together to be enacted in a group drama. Themes of death and descent had brought us into caves far from home in search of the deeper Self.

Now individuals were dancing with abandon. In one section of the room, several women were in a frenzied state encircling a man. I quickly moved over and joined the circle. When I did the collective power of the Dionysian energy filled me as well. With my observing ego maintaining a distance, I let the rest of me surrender to the archetypal movement. The man dropped slowly to the floor in a deathlike stupor. Now the pattern changed radically. The women knelt down and shrouded his body with clothes and gently stroked his body as if to anoint him. Then slowly he was raised waist high and placed on his feet. While still resting on the erect bodies of the women, he reopened his eyes and from a stilled, centered stance, moved forward into the room.

From the Christian perspective, the resurrected Christ is the symbol of the possibility of individuated rebirth. He is frequently depicted standing above the abyss of hell. In one hand, he takes Adam and in the other Eve, the original Old Testament masculine and feminine, to join with him in the renaissance of wholeness.

Mary's resurrection is particularly relevant to feminine psychology in that, unlike Christ, whose "spirit" ascended into heaven, Mary was said to have ascended "*in corpora*" – in body. In the coronation of the Virgin, both her body and soul were assumed. She was triply crowned the queen of Heaven, mother of Christ, and wife of the Holy Spirit.

An example of the experience of resurrection from a deathlike descent can be seen in the individuation process of the man mentioned earlier, who spent months in hell. He had gradually moved from fear into comfort within this darkened place. At this point, his dreams made a powerful shift into *sublimatio* and ascension. It began with a dream in which his brother showed him the

meaning of Christianity. Through embodied active imagination, he inquired of his brother what the meaning was. As his brother, he responded, "You never die," but he also said that Christ wanted his ego/self/brother to "get closer to him."

In his next dream, he ascended up in an elevator. When the door opened, the gatekeeper said, "You can come out if you are schizophrenic." He protested and wouldn't come out. I suggested that he embody the gatekeeper and I would be him. In the drama, the gatekeeper came to understand that I/he had done my/his work, i.e., descended into hell, maintained good ego boundaries, and therefore could experience heaven.

He learned from the next dream that life is everywhere and that everything has a pulse or vibration. The following session, he reported having been caught in his dysfunctional family of origin again in an attempt to help keep a younger brother from being abused. In a dream that night, his deceased grandfather descended the stairs of his parents' house and turned him around several times saying, "You're on the wrong track. Let me put you back on." He went through what he called "a time/space warp" and was brought to a meadow with a fountain in its center. A huge, many pointed stag moved toward him. The fact that a stag is felt to be symbolic of immortality, purity, and Christ was clearly unknown to him by his blithe manner of relating this powerful archetypal dream.

I encouraged him to continue the dream in active imagination. He reported that the stag said he was home and brought him to a huge edifice that appeared to be constructed of light. Still innocent of the power of this image, I encouraged him to enter his home. It was at this point that the energy in the room dramatically changed. Numinosum filled the room and every atom of my being. Time and space disappeared. He left in a radiant state. That night I got a call from him. There was an ecstatic but peaceful joy in his voice. Like the old Irish prayer, he reported the road had come to meet him rather than he actively driving home. He described feeling a deep love for everything and everyone around him. He said as well, "I now know the real meaning of what I was taught as a kid. It can really only be understood through the experience of it. It was Christ's proclamation. 'I am the Light'" (see figure 10.10).

FIGURE 10.10 **"I Am the Light"**

(Source: Drawn for this dream experience; private collection)

Chapter 11

THE EGO-SELF AXIS AND THE STATE OF GRACE

O ne patient, after undergoing the heroic quest, brought in a dream in which he was at an archeological dig. People found pieces of something ancient which they gave to him. He, in turn, remembered them, and when he did this the object gave off a radiant glow. I suggested he bring this final part of the dream into the room. When he did so, both of us felt a powerful illuminating energy fill us. This experience remained with him at work and in leisure throughout the week.

He came into the next session and reported that something awe-filled had happened. He had been driving in his car, reflecting on the world condition. He thought that Christ should return, that he was really needed. My patient then said he heard a powerful voice—not from within himself but decidedly external—asking, "Would you follow me?"

Christ as an individuating figure who suffered death, descent, and resurrection, now as a figure of wholeness and spiritual consciousness, is calling upon this man to follow him. As this man moved more and more in relation to Christ, he did not suddenly become a born-again Christian, proselytizing religiosity; he came to know the real meaning of following Christ. He began to shift his attention from idiosyncratic personal events and petty concerns to a much broader perspective. It was as if he himself ascended so that he could see not only his life but all life from a larger view.

But this clearly is no easy shift to discover, for to follow the Christ, or the Buddha, or the Tao, or what Jungians call the Self, the ego must continuously be in relation to an archetypal organizing energy which moves the individual toward wholeness and consciousness. An analytic patient depicted her experience of her ego in relation to the self (see figure 11.1).

To be a seeker, an alchemist, whether patient or therapist, must thus with humility continuously maintain a relationship to the Self as source. Jung, in *Mysterium Coniunctionis*, writes of the process:

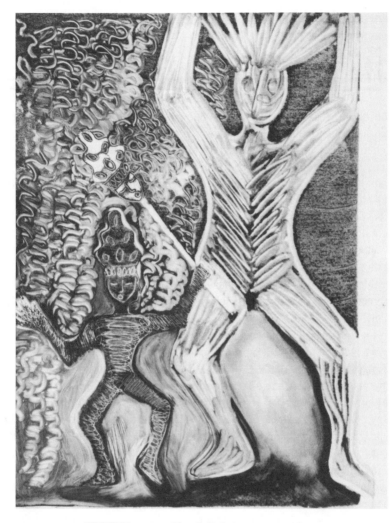

FIGURE 11.1 **Ego Self Axis**

(Source: Monoprint; private collection)

The Self in its efforts at self-realization reaches out beyond the ego personality on all sides; because of its all-encompassing nature it is brighter and darker than the ego, and accordingly confronts it with problems which it would like to avoid. Either one's moral courage fails, or one's insight, or both, until in the end fate decides.

The ego never lacks moral and rational counterarguments which one cannot and should not set aside so long as it is possible to hold on to them. For you only feel yourself on the right road when the conflicts of duty seem

to have resolved themselves, and you have become the victim of a decision made over your head in defiance of the heart. From this we can see the numinous power of the Self, which can hardly be experienced in any other way. For this reason *the experience of the Self is always a defeat for the ego.* (1955–1956, par. 778)

The ego-Self axis, as Edinger (1982) conceptualized it, is as difficult to sustain as it is to obtain. If an individual's ego boundaries are not strong enough, a paranoid psychosis might set in, resulting in the person delusionally thinking that he or she is the archetype. Others whose sense of self was never adequately formed and who were repeatedly abused, either by negative shame-producing attacks or by their primary care giver never relativizing their narcissistic omnipotence, may become inflated by the archetypal. This frequently occurs with so-called spiritual leaders or gurus who identify with the godhead and have needs to aggrandize themselves through amassing money, power, or sexual conquests.

By the same token, if an individual's sense of self pulls him or her into a less-than vector, they cannot shift close enough to experience this I-thou relationship.

This quest toward a relationship to the Self is a highly arduous journey, and even more difficult if the therapist does not have a sufficient connection to the archetypal Tao. Thus, the seeker must first be the therapist, because unless the therapist/alchemist has a relationship to the source, the Self as a guiding archetype of wholeness, a sacred space, or *temenos*, will not be insured in the therapy container. Working from a transpersonal perspective means that the therapist not only receives personal material from the patient's unconscious and conscious life, but also acts as a channel for the archetypal.

When the archetypal is awakened in patients with sufficient egos, the universal themes, images, and movements will infuse them from the inside out and compel them toward transformation and wholeness. Archetypal energy will break loose archaic resistances in patients and free them to proceed further in their individuation process. But this commitment to being a seeker, whether the therapist or patient, requires total consciousness.

One patient would come into session with puerlike, spirited energy. I, meanwhile, would imaginally send a tap root down from the base of my spine to the center of the earth. With a quiet, centered stillness, I would return him to his journey through his imaginal realm. In his final dream, he reported going to Georgia O'Keefe's home in the Southwest; finding a river, he walked slowly along its shore among others. O'Keefe to him represented androgynous power, centeredness, and grace. I encouraged him to go back to the dream and continue walking. A stillness entered the room. "These are pilgrims," he says, "we are walking toward the Source." He remained silent in this pilgrimage for

the rest of the hour with only one reflective comment at the end, "It's funny," he said, "you need to do nothing to be in this place, but it takes a lot to get here."

Being in this place means being in a state of grace. The transpersonal divine energy is not only surrounding and infusing these individuals but gives them access to eternal knowledge. With this knowledge comes a humbled sense of responsibility concerning the planet and the universe. Some claim their capacity as healers. Others work toward the survival of the earth; still others go back into their existing lives quietly emanating compassionate understanding and truth. One such man in a high tech job was approached by many of his colleagues one day, enlisting him to become their manager. "We trust you," they told him. "There's something about you, we don't know what it is, but there's something about you. . . ."

Section III

THE SONG OF SONGS

Chapter 12

CONCLUSION

*T*hrough the love poems of Solomon's "Song of Songs" can be seen a weaving of the personal with the archetypal in such a manner that both support and contribute inextricably to each other. So it is with the expression of individuals who have individuated and can sustain an I-Thou relationship with the divine. For it is possible simultaneously to be instinctually human and spiritually conscious. This means that both feet are firmly planted on the earth with both arms extended, infusing with the eternal.

A man in depth work was finally able to delve down into the deepest personal layers of his imaginal realm. There his inner child heroically watched the needed transformational burning of the home of his family of origin. Prior to this, he had killed off the bad parents, thus freeing himself from his subtle but devastating childhood horrors. We were both deeply moved by this dramatic process. The following week, he reported feeling more aggressively playful with his wife, more open, spontaneous, and alive. This hour he began to drop even deeper. He spoke of his spiritual seeking of his college years, scholarly exploration of various religions. He said, "I have had to throw out all of the religious institutionalisms – all the liturgies. I have also come to know that my intellect is useless as a means of knowing. What remained has become singularly important to me. It is the experience of the stories. For unless I have experienced it, it is of no use to me." He then spoke of a time of transition in his life in which nothing was usual and all things were possible. He, I believe, was in a state of grace in which he had surrendered his idiosyncratic ego stance in service to the Self, the inner Buddha or Christ which guides an individual toward wholeness. Now both he and I knew without words that he was beginning to reconnect to this divine state again.

To follow the path of transformation, both the patient and the therapist need to be related to that which delivers wisdom. It is clearly not the rational realm nor any understanding of concepts, be they spiritual or scientific. Jung (1944) wrote of this orientation utilizing the metaphor of the alchemist as seeker and the alchemical process as one's quest toward wholeness and spiritual consciousness:

> For, in the last analysis, it is exceedingly doubtful whether human reason is a suitable instrument for this purpose. Not for nothing did alchemy style itself an "art," feeling – and rightly so – that it was concerned with creative processes that can be truly grasped only by experience, though intellect may give them a name. The alchemists themselves warned us: "Rumpite libros, ne corda vestera rumpantur" (Rend the books, lest your hearts be rent asunder), and this despite their insistence on study. Experience, not books, is what leads to understanding. (par. 564)

I hope that this book serves the reader well, not as some kind of bible of information, but to stimulate your liminal space, your creative process in service to your healing and perhaps the transformation of others.

In telling others developmentally based stories, it is hoped that they, like the myths and fairy tales, will help you connect to the universality of the human journey and to the creative imaginal realm.

"The unconscious lies in the body," Jung proclaimed, and since it is the unconscious which guides the patient and therapist, the journey toward consciousness must be sought in and expressed through embodied experience. Transformation cannot be understood by "talking about" events and feelings whether their origin be external or internal. Campbell (1988) said the transcendent act could not be experienced through words but rather through the journey itself. For me, this is why I never had the desire to identify myself as an "analyst," as the concept "analysis" is totally antithetical to what occurs in my therapy vessel.

The patient or group participates in the ongoing process of individuation through embodiment within the imagined realm, while I serve this experiential process in any way I can. I do not kill it. By killing it, I mean such obscenities as talking about the expressive arts experience, or analyzing it or interpreting it.

The only time I would engage in the above would be if the patient had a weak or absent ego or loose ego boundaries, thereby requiring a "drying out" of the waves of the liquid unconscious. This rarely occurs in my work, since my patients by and large have the ego strength to engage in depth work.

My psychotherapeutic techniques are simple. I find the more complicated the technique, the more restrictive. The more restrictive, the more it can potentially attempt to control and/or delimit the full expression of the imaginal and its transformative power. I utilize authentic and improvisational movement, sound, and drama, embodiment of dreams, and other arts expressions within the transitional space, reenactment of past experiences, and rechoreography of that which heals and encourages normal development. I value not only external expression of the imaginal but inner journeys inside the body viscera, tissues, and organs within the liminal realm. The above techniques apply not only to my patients but to myself as well, as I believe the patient's unconscious can also

pass through and direct my body whether I am moving externally or internally engaging in use of the somatic countertransference.

In this process, the imaginal realm is constellated between myself and the other. In this transitional space both participate in the unconscious-to-unconscious drama toward healing (Lewis Bernstein 1985). The therapist can join in the patient's active imagination through personifying characters both personal and archetypal and embodying figures in art, sand play, poetry, or dreams. Through the enactment of transferred parental complexes or split-off aspects of the individuals' psyches, they may explore and eventually reinternalize these transformed parts.

When therapists sit in relation to the archetypal, transpersonal wisdom of wholeness can flow into and through their body and into the therapy vessel and help constellate the patient's own connection to the wisdom of spiritual consciousness. Embodied expression from both the personal and archetypal unconscious is needed in order for transformation to occur. The dance between the personal and archetypal is, thus, a crucial pas de deux in anyone's life who seeks the human quest toward consciousness.

Both these layers serve important functions for each other. The personal unconscious is needed to individualize the universal themes which emerge from the archetypal. It is vital that an individual has a personal layer to their unconscious, at least through their younger and middle years, as it not only personalizes them but also provides a buffer to the awesome power of the unconscious. Lack of the personal unconscious is seen in some psychotics, autistic children, and in sectors of individuals' psyches who had maladaptive mothering the first months of life.

The archetypal layer is needed in order to push through, shake loose, burn off, or in other ways transfigure rigid archaic layers of an individual's personal unconscious. Thus, overdominant complexes like a person's inner judge, abuser, or internalized smothering or abandoning mother may be transformed or repetitive childhood emotional patterns may be dissolved and new more adaptive ones evolve. Where there is no access to the archetypal, transformation cannot occur. This is found in individuals who do not feel comfortable experiencing the mystery in life. They frequently take everything literally and consider the only reality to be an empirical one. Myth, metaphor, and the intuitive have no value to them. For these individuals, there is a deep loss which is frequently blocked out through substance abuse or accumulation of material goods.

Thus, within the transitional space of the imaginal realm lies the possibility for healing and transformation. Within the vessels of the expressive arts, the patient's body, the therapist's body in the use of the somatic countertransference, the bipersonal field between patient and therapist, and the group, individuals move from chaos into clarity and from clarity to transformation through the

choreography of object relations and the heroic and heroinic quests. As men and women do battle and subdue powerful complexes and mediate and humanize their instincts, they claim more psychic territory for their ego/self. When descent and death of old ruling principles and patterns are surrendered to, they move further on their journey toward a relationship to the Self—the archetype of wholeness which guides each human with the power of knowing their unique truth.

Here the eternal *circulatio* of the Great Round can begin again. With each deeper descent, new parts of the self are claimed as the expanded self begins to radiate its unique golden hue. With sufficient wholeness, the ego/self can claim a sustained relationship to the divine and can then contribute to the Tao of the Earth in its struggle for survival and the universe in the experience of the simplicity of its truths.

BIBLIOGRAPHY

Bell, J. 1984. Family therapy in motion: observing, assessing and changing the family dance. In *Theoretical Approaches in Dance-Movement Therapy*, vol. 2, P. Lewis, ed. Dubuque, Iowa: Kendall/Hunt.

Brownell, A., and Lewis, P. 1990. The use of the KMP in vocal assessment. In *The Kestenberg Movement Profile: Its Past, Present, and Future Applications*, P. Lewis and S. Loman, eds. Keene, N.H.: Antioch University.

Budge, E. A. 1969. *The Gods of the Egyptians*. New York: Dover.

Campbell, J. 1988. *The Power of Myth*. New York: Doubleday.

Edinger, E. F. 1978. Psychotherapy and alchemy I and II. *Quadrant* 11,1:5–38.

_____. 1980. Psychotherapy and alchemy V. *Quadrant* 13,1:57–75.

_____. 1981. Psychotherapy and alchemy VI. *Quadrant* 14,1:23–45.

_____. 1982. *Ego and Archetype*. New York: Penguin Books.

Erikson, E. 1963. *Childhood and Society*. New York: W. W. Norton.

Fairbairn, R. 1976. *Psychoanalytic Studies of the Personality: The Object Relation Theory of Personality*. London: Kegan Paul.

Freud, A. 1966. *Normality and Pathology in Childhood*. New York: International Universities Press.

Graves, R. 1984. *The Greek Myths*. 2 vols. New York: Penguin Books.

Greenson, R. 1967. *The Techniques and Practice of Psychoanalysis*. New York: International Universities Press.

Grotstein, J. 1981. *Splitting and Projective Identification*. New York: Jason Aronson.

Hall, N. 1980. *The Moon and the Virgin: Reflections on the Archetypal Feminine*. New York: Harper and Row.

Hamilton, E. 1969. *Mythology*. New York: New American Library.

Harding, E. 1947. *Psychic Energy*. Princeton, N.J.: Princeton University Press.

_____. 1971. *Women's Mysteries, Ancient and Modern*. New York: Harper and Row.

Johnson, D. R. 1982. Developmental approaches in drama therapy. *The Arts in Psychotherapy* 9:172–181.

Jung, C. G. 1931. The stages of life. In *CW* 8:387–403. Princeton, N.J.: Princeton University Press, 1960.

_____. 1944. *Psychology and Alchemy. CW*, vol. 12. Princeton, N.J.: Princeton University Press, 1953.

_____. 1946. The psychology of the transference. In *CW* 16:163–326. Princeton, N.J.: Princeton University Press, 1954.

_____. 1955–1956. *Mysterium Coniunctionis. CW*, vol. 14. Princeton, N.J.: Princeton University Press, 1963.

_____. 1964. *Man and His Symbols*. New York: Doubleday.

Kestenberg, J., and Buelte, A. 1956. On the development of maternal feelings in early childhood. In *The Psychoanalytic Study of the Child*. New York: International Universities Press, pp. 275–291.

_____. 1977. Prevention, infant therapy, and the treatment of adults. *International Journal of Psychoanalytic Psychotherapy* 6:339–396.

Kestenberg, J., and Sossin, M. 1979. *The Role of Movement Patterns Development II*. New York: Dance Notation Bureau.

Klein, M. 1975. *Writings of Melanie Klein*. 3 vols. London: Hogarth.

Kohut, H. 1977. *The Analysis of the Self*. New York: International Universities Press.

Kohut, H., and Wolf, E. 1978. The disorders of the self and their treatment: An outline. *International Journal of Psychoanalysis* 59:413–425.

Leonard, L. S. 1982. *The Wounded Woman*. Boulder, Colo.: Shambhala.

Lewis Bernstein, P. 1980. The union of the gestalt concept of experiment and Jungian active imagination. *The Gestalt Journal* 3:2, 36–45.

_____. 1982. Authentic movement as active imagination. In *The Compendium of Psychotherapeutic Techniques*, J. Harriman, ed. Springfield, Ill.: Charles C. Thomas.

_____. 1985. Embodied transformational images in movement therapy. *Journal of Mental Imagery* 9,4:1–8.

Lewis Bernstein, P., and Bernstein, L. 1973–1974. A conceptualization of group dance movement therapy as a ritual process. *Writings on Body Movement and Communication* 3:120–133. Columbia: American Dance Therapy Association.

Lewis Bernstein, P., and Hall, L. 1977. Cross-cultural puberty rituals and Jungian dance therapy: A comparative study. International Dance Movement Therapy Conference, Toronto.

Lewis Bernstein, P., and Singer, D., eds. 1983. *The Choreography of Object Relations*. Keene, N.H.: Antioch University.

Lewis, P. 1981. Moon goddess, medium, and earth mother: A phenomenological study of the guiding archetypes of the dance movement therapist. In *Research as Creative Process*. Columbia: American Dance Therapy Association.

_____. 1984. *Theoretical Approaches in Dance-Movement Therapy*, vol. 2. Dubuque, Iowa: Kendall/Hunt.

_____. 1985. Myths of alchemical transformation in the development of ego consciousness in art, movement, and drama therapy. National Coalition of Arts Therapy Associations, Joint Conference on the Creative Arts Therapies, New York.

_____. 1986. *Theoretical Approaches in Dance-Movement Therapy*, vol. 1, revised. Dubuque, Iowa: Kendall/Hunt.

_____. 1987. The expressive arts therapies in the choreography of object relations. *The Arts in Psychotherapy Journal* 14:312–331.

_____. 1988. The transformative process in the imaginal realm. *The Arts in Psychotherapy Journal* 15:309–316.

_____. 1990. Recovery from codependency through the creative arts therapy. Washington, D.C.: National Coalition of Arts Therapy Associations.

_____. In press. A Jungian object relations developmental approach in drama therapy. In *Drama Therapy*, E. Irwin, ed. New York: Brunner/Mazel.

Lewis, P., and Loman, S., eds. 1990. *The Kestenberg Movement Profile: Its Past, Present Applications and Future Directions*. Keene, N.H.: Antioch University.

Mahler, M. 1968. *On Human Symbiosis and the Vicissitudes of Individuation*. New York: International Universities Press.

Mahler, M., and McDevitt, J. 1982. Thoughts on the emergence of the self with particular emphasis on the body self. *Journal of the American Psychoanalytic Association* 30, 4.

Masterson, J. 1976. *Psychotherapy of the Borderline Adult.* New York: Brunner/Mazel.

Melody, P., and Miller, A. W. 1989. *Recovery from Codependency.* San Francisco: Harper and Row.

Miller, J. B. 1984. The development of a woman's sense of self. Wellesley, Mass.: Stone Center.

Monick, E. 1987. *Phallos: Sacred Image of the Masculine.* Toronto: Inner City Books.

Newman, E. 1973. *The Origins and History of Consciousness.* Princeton, N.J.: Princeton University Press.

_____. 1976. *The Child.* New York: Harper and Row.

Perera, S. B. 1981. *Descent to the Goddess.* Toronto: Inner City Books.

Racker, H. 1982. *Transference and Countertransference.* New York: International Universities Press.

Schwartz-Salant, N. 1982. *Narcissism and Character Transformation.* Toronto: Inner City Books.

_____. 1983–1984. Transference and countertransference. C. G. Jung Institute of New York.

Searles, H. 1981. *Countertransference and Related Subjects.* New York: International Universities Press.

Stein, M. 1984. Power, shamanism, and maieutics in the countertransference. In *Transference/Countertransference*, N. Schwartz-Salant and M. Stein, eds. Wilmette, Ill.: Chiron Publications.

Stern, D. 1985. *The Interpersonal World of the Infant.* New York: Basic Books.

Surrey, J. L. 1985. Self-in-relation: A theory of women's development. Wellesley, Mass.: Stone Center.

Testani, D. 1990. *Hell!* M.A. diss. Lesley College, Cambridge, Mass.

Turner, V. 1969. *The Ritual Process.* Chicago: Aldine.

von Franz. M.-L. 1978. *Interpretation of Fairytales.* Dallas: Spring.

_____. 1982. *Individuation in Fairytales.* Dallas: Spring.

Whitmont, E. C. 1982. *Return of the Goddess*. New York: Crossroads.

Winnicott, D. W. 1971. *Playing and Reality*. New York: Penguin Books.

Wyly, J. 1989. *The Phallic Quest*. Toronto: Inner City Books.

Zabriskie, B. 1985. Egyptian mythology. C. G. Jung Institute of New York.

Zwerling, I. 1979. The creative arts therapies as real therapies. In *Hospital and Community Psychiatry* (December).

INDEX